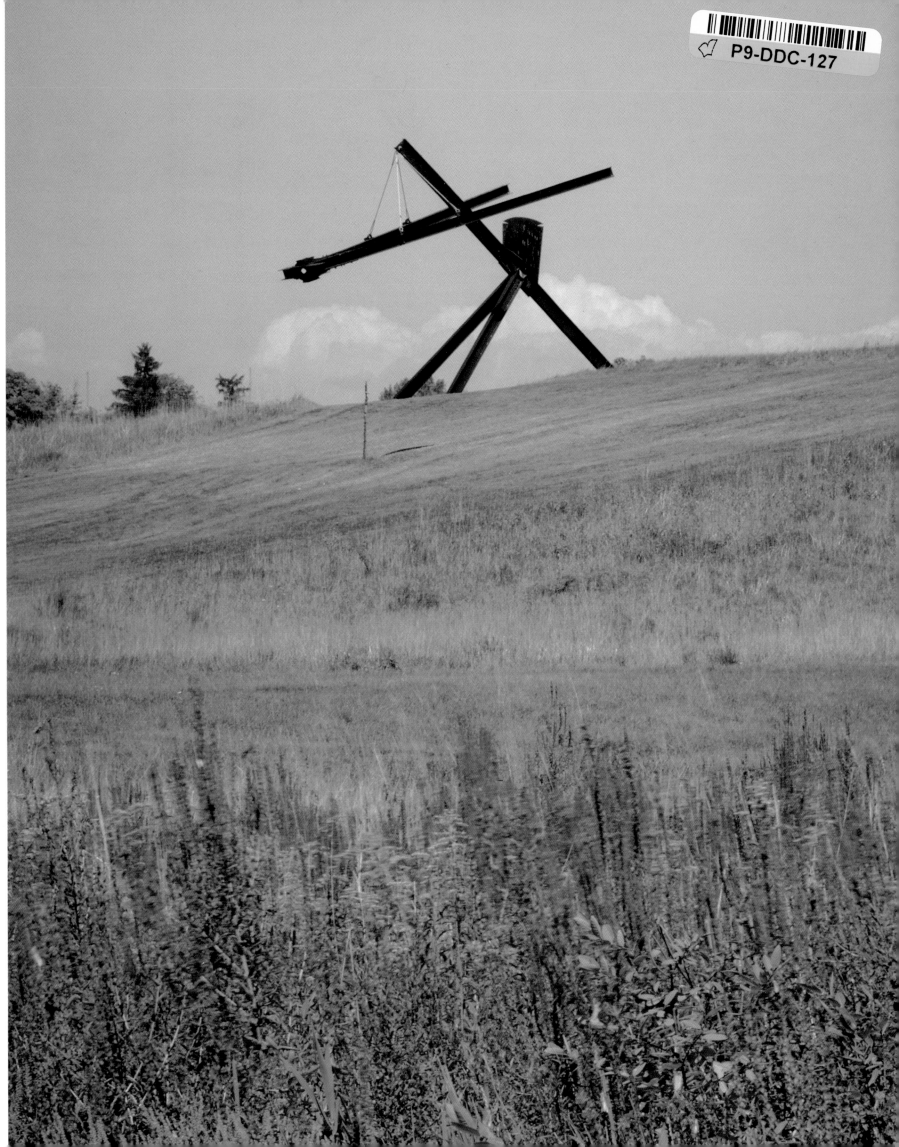

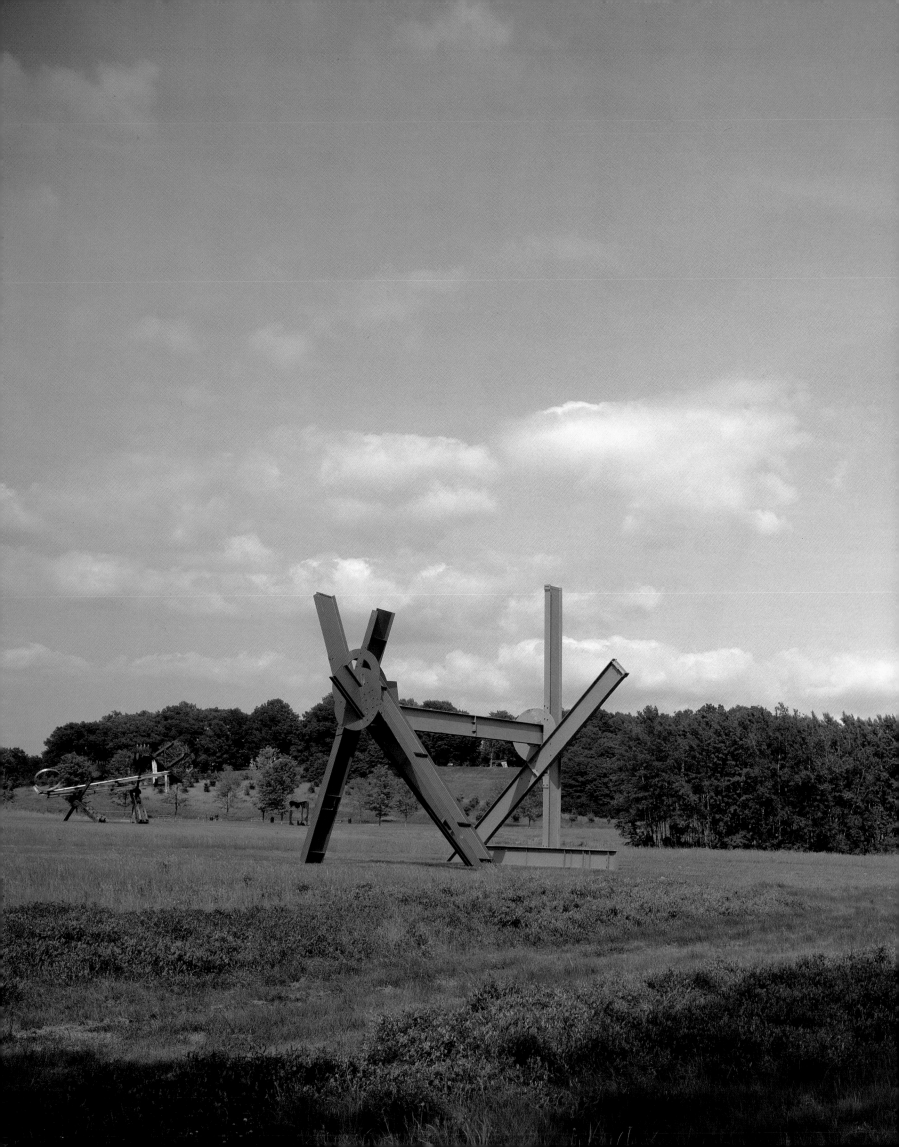

MARK DI SUVERO
AT STORM KING ART CENTER

Essay by

IRVING SANDLER

Principal photography by

JERRY L. THOMPSON

STORM KING ART CENTER MOUNTAINVILLE NEW YORK

in association with

HARRY N. ABRAMS, INC. PUBLISHERS NEW YORK

Published in conjunction with the exhibition "Mark di Suvero"
at Storm King Art Center, Mountainville, New York,
May 13–November 15, 1995—April 1–November 15, 1996

The exhibition and publication are generously supported
by the Ralph E. Ogden Foundation.

Additional support has been provided by
Adam Aronson
Daimler-Benz North America Corporation
Doris and Donald Fisher
Richard Florsheim Art Fund
Vera G. List
Nash Family Foundation
The National Endowment for the Arts
The New York State Council on the Arts
Jim and Mary Ottaway
The Howard Phipps Foundation
Mr. and Mrs. David N. Pincus
Mr. and Mrs. Thomas W. Smith
Bagley and Virginia Wright

Project Director, Fernande E. Ross
Edited by Susan H. Llewellyn
Designed and typeset by Greer Allen and Ken Scaglia
Printed and bound by Everbest Printing Co., Hong Kong,
through Four Colour Imports, Ltd., Louisville, Kentucky

Library of Congress Cataloging-in-Publication Data

Di Suvero, Mark, 1933–
 Mark di Suvero at Storm King Art Center / Irving Sandler
 p. cm.
 Exhibition catalog.
 ISBN 0–8109–3218–0 (Abrams : hardcover). —
 ISBN 0–8109–2614–8 (Storm King : paperback)
 1. Di Suvero, Mark 1933– —Exhibitions. I. Sandler, Irving, 1925– .
 II. Storm King Art Center. III. Title.
 NB237.D57A4 1995
 730'.92—dc20 94–35360

Published by Storm King Art Center
Old Pleasant Hill Road
Mountainville, New York 10953

Clothbound edition distributed in 1996
by Harry N. Abrams, Inc., New York,
A Times Mirror Company

TABLE OF CONTENTS

For more than twenty-five years Mark di Suvero has had a dialogue with, and been a presence at, Storm King Art Center. From the first both Mark and I were intrigued by the potential interaction of our open landscape and Mark's strong, protean outdoor sculpture. Neither we at Storm King nor Mark were satisfied with the more formal, more constrained placement of sculpture prevalent elsewhere. His work called for generous, subtly landscaped space and careful siting. In those early days Storm King's grounds were less extensive than they are today, and Mark's largest sculptures had yet to be made. We both sensed the need for—and craved—greater scale.

The artist and Storm King have shared many creative exciting moments, have grown together, and learned from each other. If I were to pick one seminal moment it would be November 13, 1975, the opening of Mark's exhibition at the Whitney Museum of American Art. As part of the exhibition five of his large works—*Are Years What? (for Marianne Moore)* (1967), *Mon Père, Mon Père* (1973–75), *Mother Peace* (1969–70), *One Oklock* (1968–69), *Ik Ook* (1971)—were exhibited in the five boroughs of New York City. When I discovered that there was no place for them to go afterward except into storage, I heard myself saying to Mark: "What about storing your sculptures on the fields of Storm King?" And so in 1976 they arrived.

When I visited Henry Moore in Much Haddam, England, in 1970 he stated emphatically: "My outdoor sculptures are seen best on a small hill from below." Most sculptors shared this view, perhaps influenced by the centuries-old tradition of statues elevated in public places. Although we had tried unsuccessfully in the early 1970s to induce some sculptors to place their works where they would be seen dramatically from above, none of our efforts had prepared us for the gargantuan scale with which Mark applied this very principle. He proposed, and we agreed, that he place his work in open fields 120 feet below our hilltop exhibition area, a good distance from our museum building. They looked magnificent.

BEPPE, 1978–95

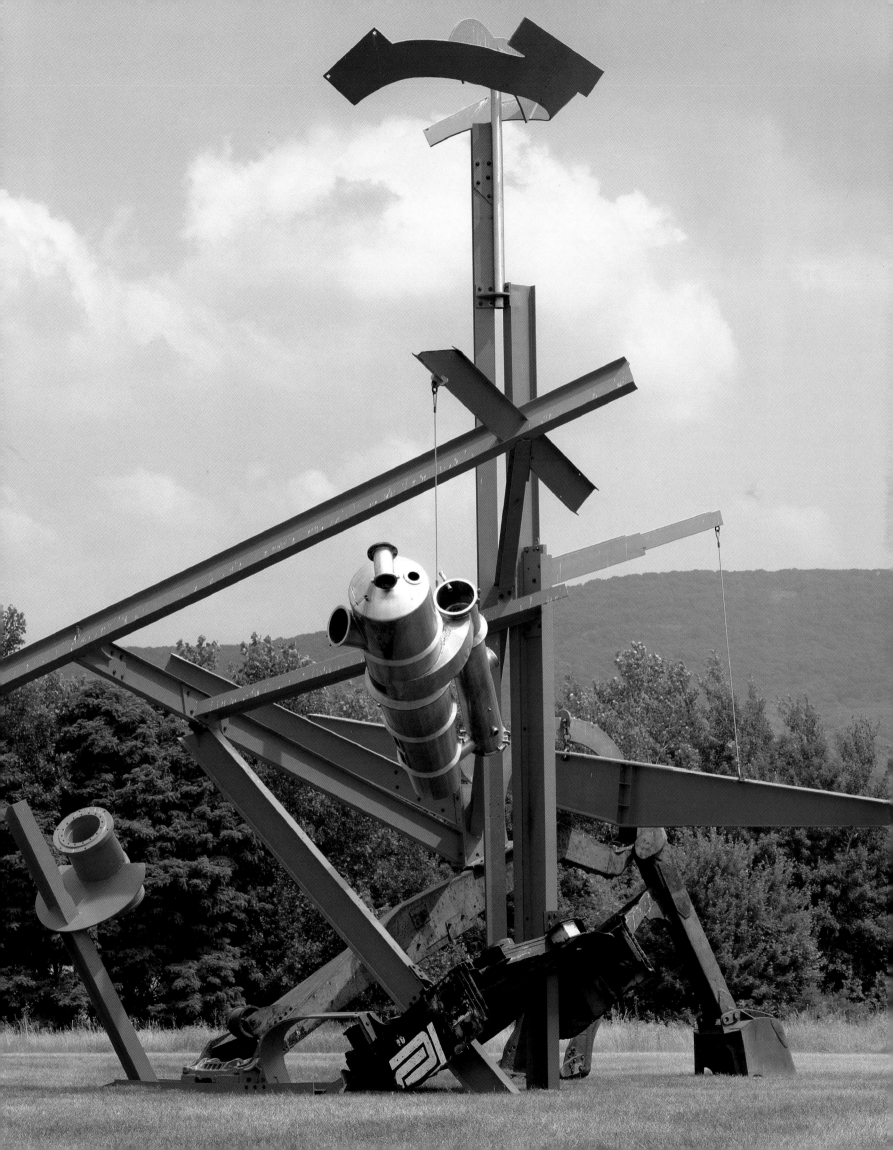

A few years later, as the Art Center expanded, we asked Mark to move the pieces even farther away (unthinkable in 1976). Our director, David Collens, and I carefully mapped out what we thought were the perfect sites. When Mark arrived I received a desperate call from David saying: "He is putting them in different locations." I raced over to the park. To my surprise I heard myself saying, "Great!" The sculptures were arranged in an arc; at one glance one could see them interacting. They formed, it seemed, one giant work of five parts.

The 1985 retrospective, curated by David Collens, was an explosion of large and smaller works over much of the Art Center's landscape, each piece sited with an eye to the hills, trees, and woods and in relation to the others. It was a community of sculpture, not competing for space but set contextually so as to create a visual dialogue. At the opening I took a photograph of Isamu Noguchi, Louise Nevelson, and Mark. Commenting on the usual competitiveness of artists, Mark said: "Only at Storm King would we all agree to be in one photograph."

In the intervening years some of the sculptures remained, some were moved to new locations. In 1981 Storm King purchased *Mother Peace* and *Mon Père, Mon Père*. And then came the 1995 exhibition with Mark's new work in Storm King's new landscape. While Mark's techniques and style over the years have evolved changed, and grown so has our landscape. The acreage at Storm King is double its 1985 size, and for this exhibition we reworked twenty acres of our farmland. The changes seem imperceptible. Gently flowing sculpture platforms have been installed, drainage put in place, low spots filled in, and connecting pedestrian paths carefully laid out. Our landscape architect of thirty-six years' standing, William Rutherford, has not been idle.

As president and chairman of Storm King since 1960, I have grown used to a last-minute rush before the opening of an exhibition. Not so in 1995: the splendid crew that has so long worked with Mark had everything in place three days ahead of time. Field, hills, and sky seem to embrace the artist's bold steel creations.

H. PETER STERN
President and Chairman, Storm King Art Center

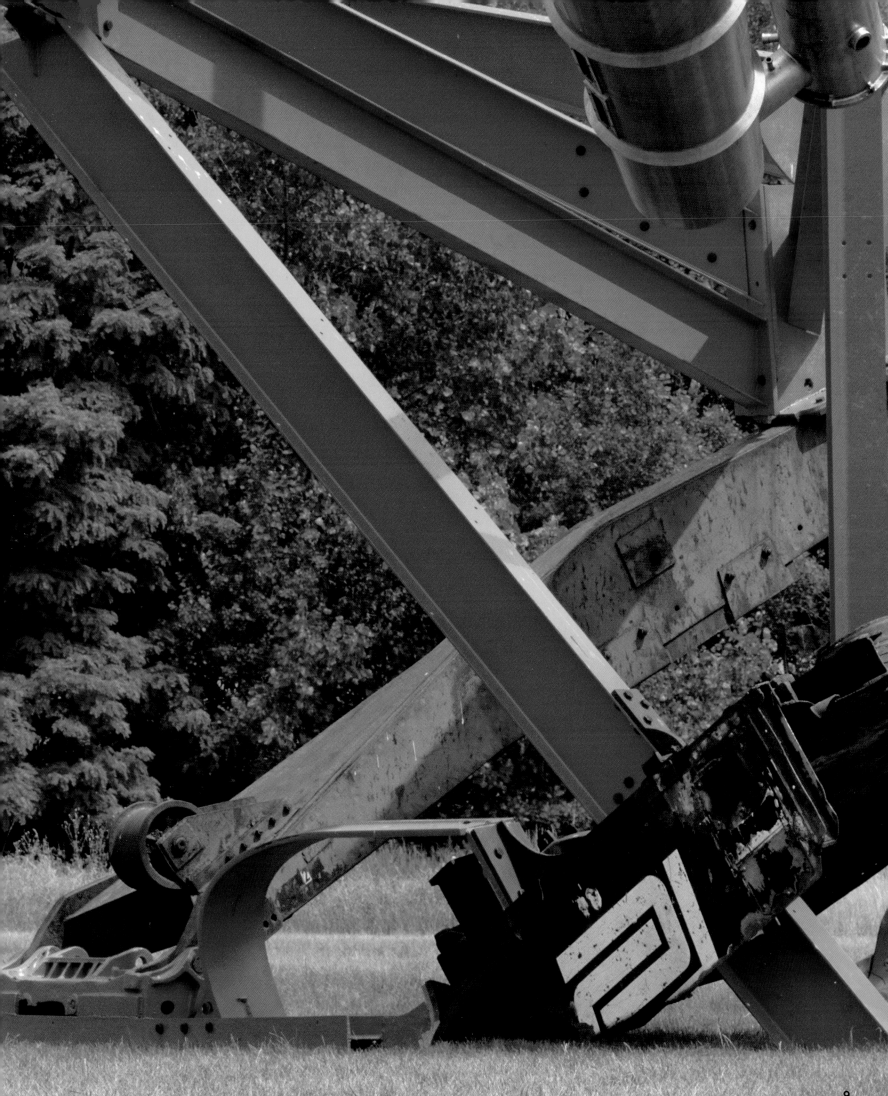

Detail of BEPPE, 1978–95

My friendship with Mark di Suvero and Richard Bellamy started more than twenty years ago. In 1975 Richard Bellamy telephoned Storm King Art Center with a special request to borrow *Pre-Columbian* (1965) for the di Suvero exhibition at the Whitney Museum of American Art. Storm King agreed to lend this important early sculpture, which was constructed of wood, steel, and a rubber tractor tire and turned like a merry-go-round. Although I was familiar with di Suvero's oeuvre, this significant and sizable retrospective further triggered my interest in the artist's work. During the Whitney show I took a tour of Mark's large-scale sculptures, sited in the five boroughs of New York. I felt exhilarated seeing them and could easily envision these works in the expansive fields at Storm King. I was delighted when Peter Stern, chairman of the Art Center, told me that he had invited Mark to lend five of the sculptures to us after the close of the Whitney exhibition and Mark had accepted his offer.

Over the years I have visited the Oil & Steel Gallery in New York; the artist's studios in Long Island City, New York, and Petaluma, California; and, on several trips to Europe, I have viewed important museum exhibitions of Mark's sculptures, paintings, and drawings. I have been greatly privileged to see the artist at work—to watch the creative process as Mark cuts, bends, folds, welds, and bolts large sections of steel. Mark's studios and their surroundings are familiar to me now; I always feel welcome and at home. Psychologically and physically it is relaxing and rejuvenating to visit the studios and involve myself vicariously with the creation of sculptures of all sizes and descriptions.

To celebrate the twenty-fifth anniversary of Storm King Art Center in 1985, I organized a retrospective of Mark di Suvero's sculptures and drawings. The galleries of the museum building contained fifty-one drawings, complemented by a selection of indoor sculptures. Twenty-one outdoor sculptures of varying sizes were located on the patio, lawns, and nearby hills. Many stood like sentinels in the undulating farm fields. From the Art Center's hilltop there were stunning views of twelve large sculptures, each standing from thirty to fifty

FOR CHRIS, 1991

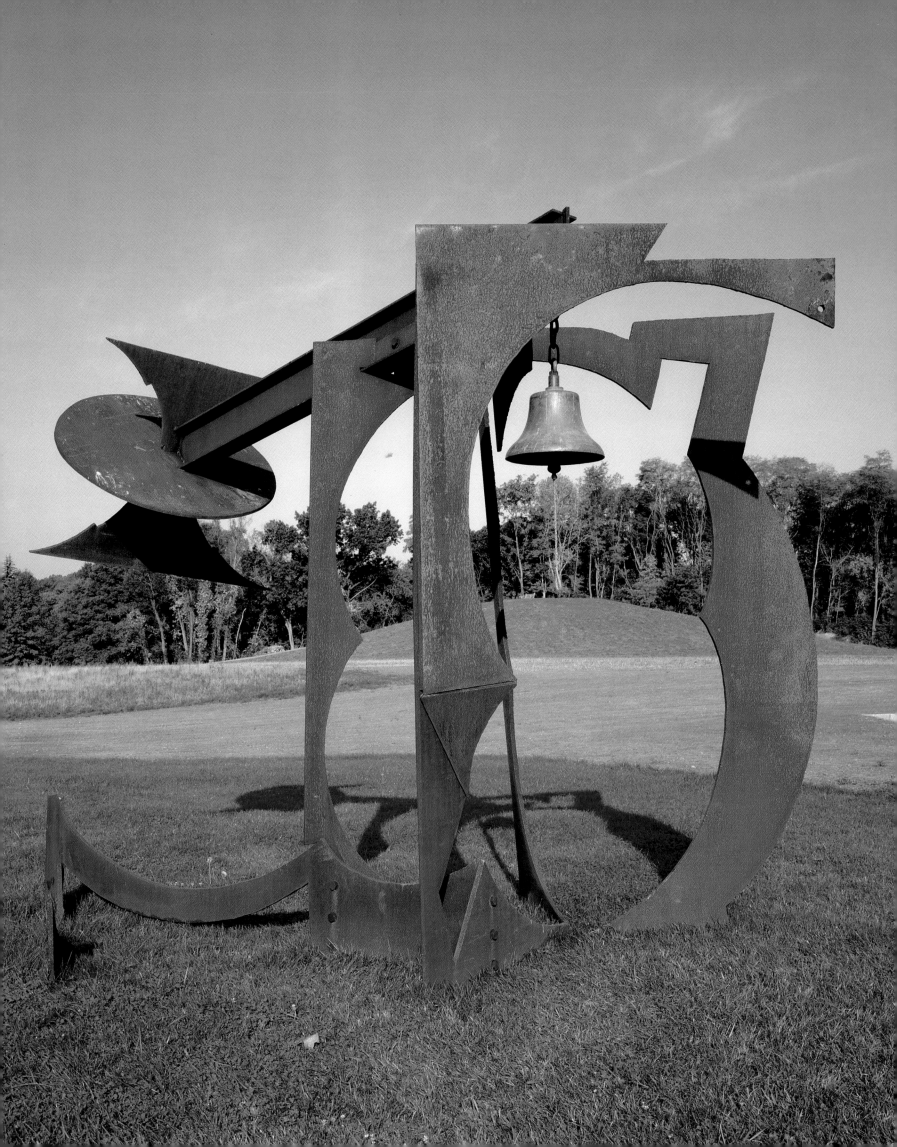

feet high. For this major exhibition the di Suvero team unloaded and installed fourteen tractor-trailer loads of sculpture, shipped to the Art Center from various U.S. locations. It was a labor of love for all the participants, who readied the works in only six weeks despite inclement spring weather. The May 18 reception took place on a beautiful warm day, with eight hundred people in attendance. The festivities included performances by country-western and classical musicians and modern dancers. What followed was a season of record attendance. Many of our visitors said they had "never seen di Suvero's work look better than at Storm King." Di Suvero's retrospective of 1985 proved to be a landmark exhibition for both Storm King and the world of contemporary sculpture. Several of the sculptures near the museum building had swinging platforms attached to them. These wooden "beds" could carry approximately twelve people, and I loved to watch visitors—from children to grandparents—using these swings. Their enjoyment was palpable and pleased Mark, who loves to have an audience interact physically with his work.

Since 1985 I have dreamed of organizing another exhibition of Mark's sculptures—those not previously on public exhibition. And finally the 1995–96 exhibition *Mark di Suvero* became a reality, the first showing of Mark's work in an American museum in ten years. Yet again it comes at an important point in the artist's career and the museum's history. *Mark di Suvero* features fifteen works dating from the past decade. The five largest sculptures, of monumental proportions, are displayed in a new twenty-acre field especially prepared for them that features broad walking paths and sculpture platforms. For more than twenty years the work of Mark di Suvero has been a formidable presence at Storm King Art Center. The linear elements of *Mon Père, Mon Père* and *Mother Peace* are now juxtaposed against the more complex pieces of the past ten years. The forms of these latest works, which incorporate large found objects like stainless-steel dairy-farm tanks and steam shovels, loom skyward. From whatever vantage point, Mark's sculptures are a commanding and striking presence in the bucolic landscape of Storm King Art Center.

DAVID R. COLLENS
Director, Storm King Art Center

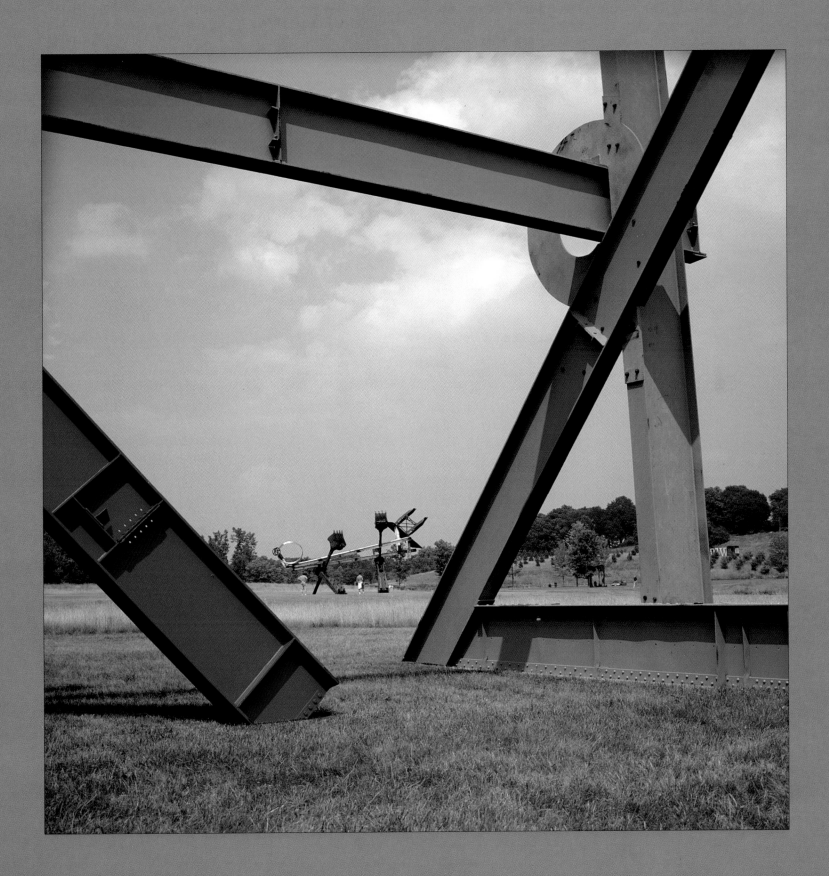

JOHNNY APPLESEED, 1989–93 seen through OLD BUDDY (FOR ROSKO), 1993–95

The exhibition *Mark di Suvero,* so complex and yet so accessible, represents a remarkable achievement for Storm King Art Center. And the publication of this catalogue amply documents di Suvero's longtime and happy relationship with Storm King. Our deepest gratitude goes to Mark di Suvero. He generously gave of his time to organize and install his work of the last decade. And not only di Suvero but his superb team from Spacetime Construct must be thanked: John Clement, Joel Graesser, Kent Johnson, Peter Lundberg, Rollin Marquette, Matteo Martignoni, Lillian Maurer, Lowell McKegney, Ivana Mestrovic, Robert Ressler, and Joyce Weiner.

H. Peter Stern, president and chairman, has enthusiastically supported the present exhibition and its accompanying catalogue and has been a champion of Mark di Suvero and his work since 1976. No small thanks are due David R. Collens, director, whose understanding of the artist's work is admirably reflected in his selections and gifted sitings in an extraordinary landscape.

Richard Bellamy has been di Suvero's dealer and friend for more than three decades during which his gallery represented di Suvero's work. Mr. Bellamy enthusiastically shared di Suvero's commitment to this exhibition. Much gratitude is owed him and his Oil and Steel Gallery staff—Miles Bellamy, Henrietta Blake and Denise Corley—who responded promptly to numerous requests for photographic material and information. Larry Gagosian, Ealan Wingate, and the staff of the Gagosian Gallery earn recognition for invaluable assistance and encouragement.

Storm King Art Center owes a debt of gratitude to Irving Sandler, whose lively and informative essay adds considerably to our understanding of di Suvero's sculpture. Much appreciation to Susan H. Llewellyn who ably and meticulously edited the text in a timely manner. Very special thanks are due Jerry L. Thompson, who so

Detail of MOTHER PEACE, 1969–70

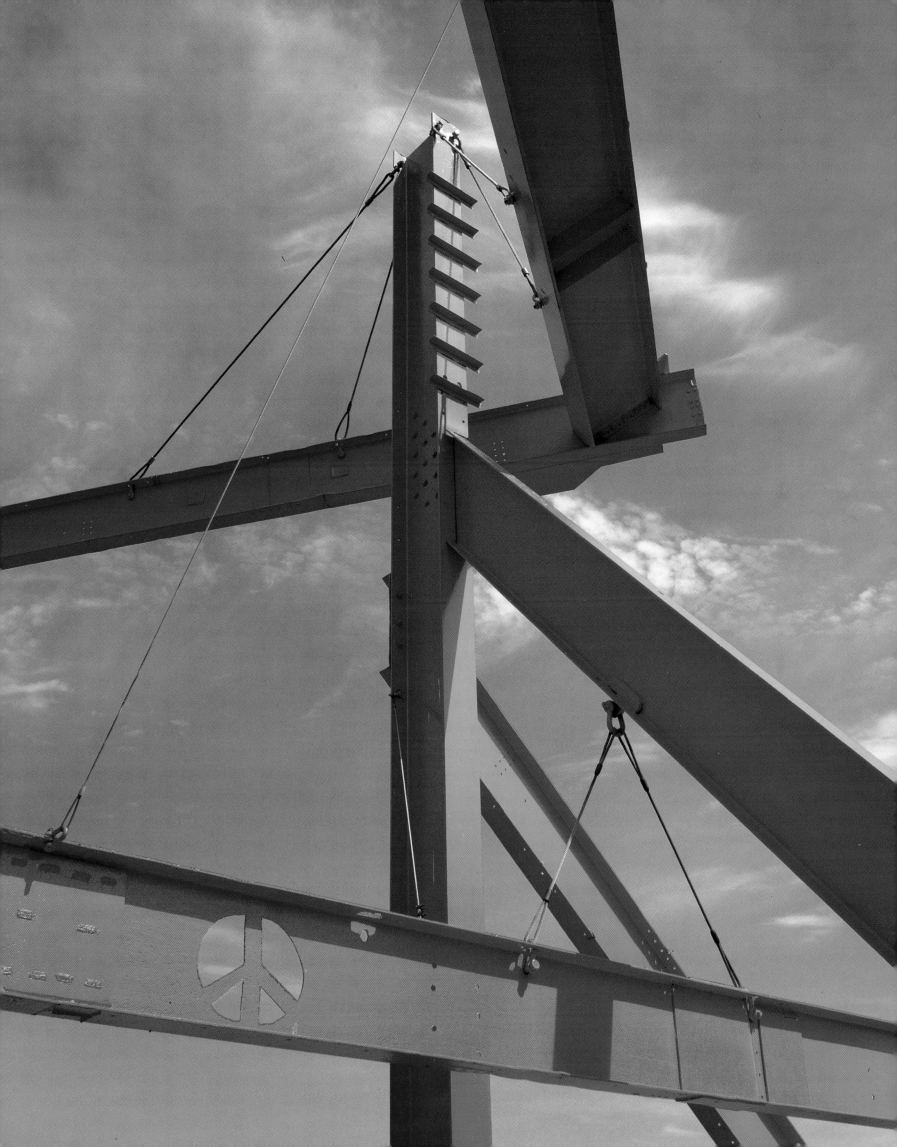

admirably met the challenge of photographing di Suvero's outdoor sculptures in the present exhibition. His sensitive eye and superb technical knowledge have engendered a dazzling array of illustrations that reflect the essence of the artist with captivating results. The catalogue gained from the dedicated professionalism of Greer Allen, who has designed a handsome book. We owe him a considerable debt of gratitude, as we do Ken Scaglia, who worked so diligently in typesetting the final layouts. Also acknowledged with appreciation are the museums and individuals who permitted reproduction of their di Suvero sculptures. Storm King Art Center is pleased to have the participation of Harry N. Abrams, Inc. as distributor of the hardcover edition, with special recognition of Marti Malovany, manager of co-editions.

Many thanks to the dedicated staff of Storm King Art Center, whose unfailing help and exceptional efforts greatly benefited the exhibition and the catalogue, especially Mary Ann Carter, who performed endless secretarial tasks cheerfully and efficiently. I owe warm and very special thanks to Maureen Megerian, curator, whose help and support have been crucial. From the very beginning, Ms. Megerian enthusiastically cooperated in the planning and research of the publication, and her intelligent contributions are appreciated.

The enlightened and generous financial support of individuals and federal and state agencies has contributed to the success of this ambitious enterprise. The exhibition and publication have benefited greatly from grants by the Ralph E. Ogden Foundation and, in part, from the National Endowment for the Arts, a Federal agency, as well as, in part, public funds from the New York State Council on the Arts. In addition, profound thanks to Adam Aronson, Daimler-Benz North America Corporation, Doris and Donald Fisher, Richard Florsheim Art Fund, Vera G. List, Nash Family Foundation, Jim and Mary Ottaway, The Howard Phipps Foundation, Mr. and Mrs. David N. Pincus, Mr. and Mrs. Thomas W. Smith, Bagley and Virginia Wright, and two anonymous donors. Their contributions have been significant and are gratefully acknowledged.

FERNANDE E. ROSS
Project Director

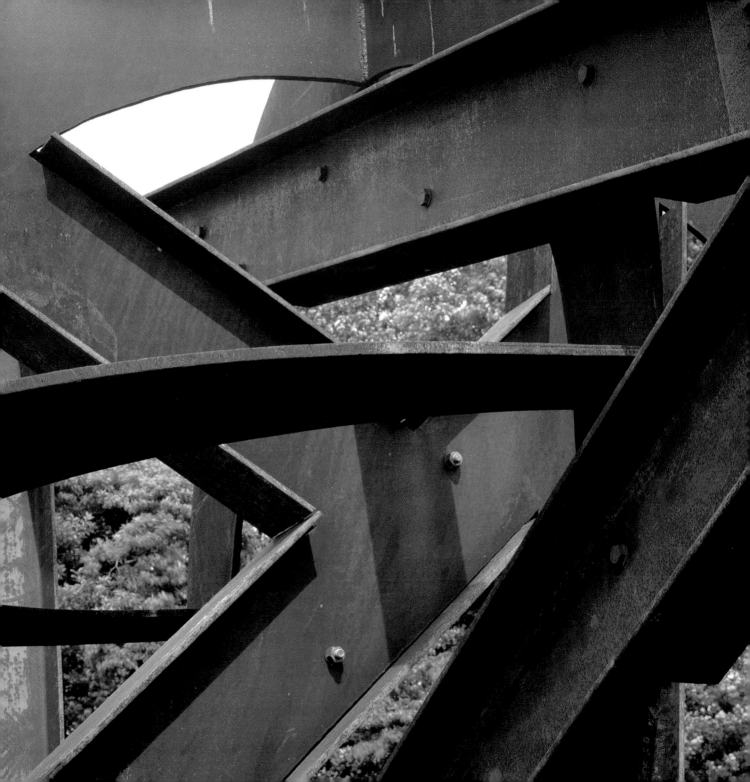

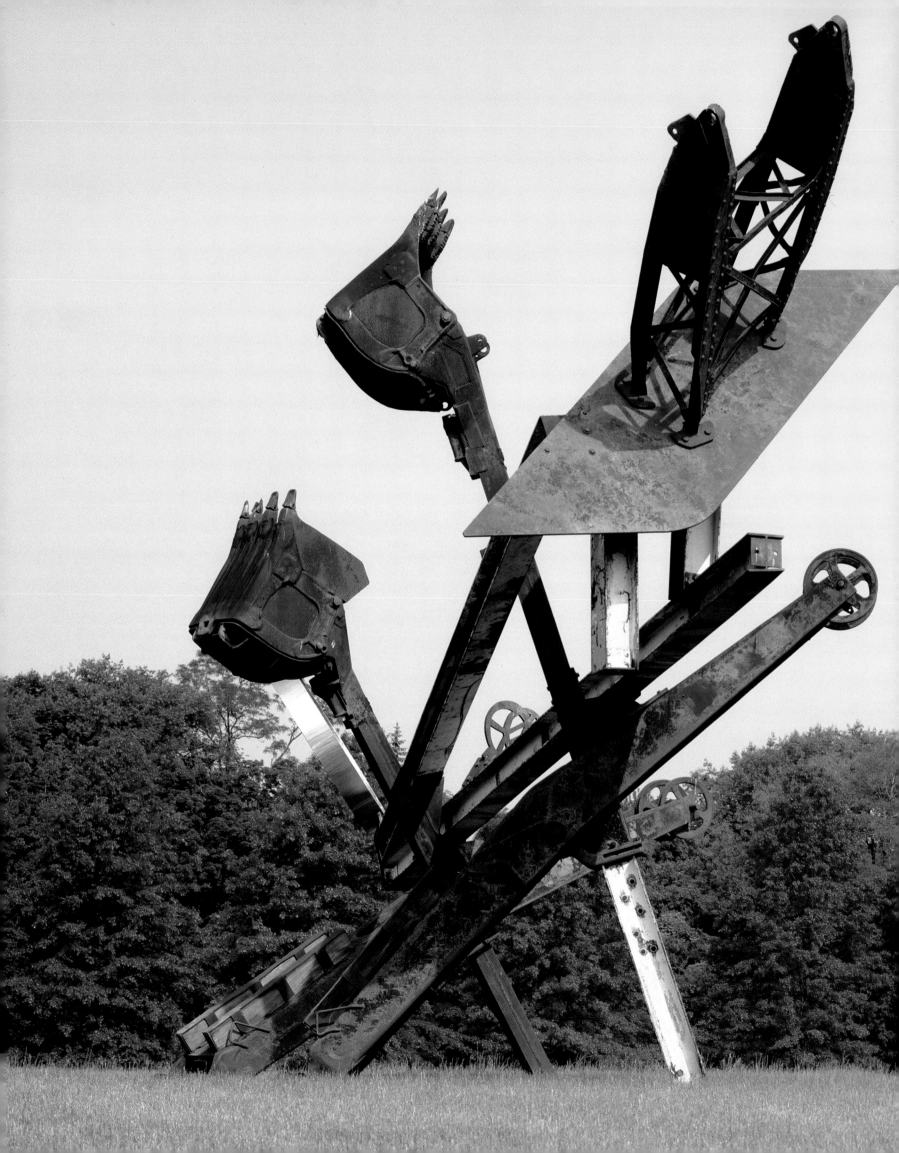

In the prison of his days / Teach the free man how to praise. —W.H. Auden, "In Memory of W.B. Yeats ..."

Mark di Suvero's large-scale constructions, such as *Beppe* (1978–95), *Old Buddy (for Rosko)* (1993–95), and *Johnny Appleseed* (1989–93), now installed in Storm King's open fields, look bold and grand, easily dominating this sizable public place. From a distance, particularly in silhouette, they seem simple and clear, but close up they are complex, their heavy, thrusting steel beams, of varying thicknesses, and massive discarded-metal components describing diverse vectors and creating diverse spaces—compressed or expansive, earthbound or soaring. Glimpses of the natural environment also add to the complexity. So does the salvaged material—parts of machine tools, notably steam shovels—that provides a curved counterpoint to the angular grid of girders. □ Despite the size of di Suvero's constructions and the bulk and weight of their industrial components, they are physically and emotionally accessible. Their spaces are open in all directions, inviting movement not only around but through them. Indeed, the sculptures can be experienced only in time by active engagement—entering them, walking, climbing, or swinging on a mobile element, and viewing the ever-shifting configurations of steel and space from every angle. □ Di Suvero's works are not perceived as fixed, and none of them can be comprehended as a whole. As one explores the spaces in front, above, or below and—by bringing into play peripheral vision—the surroundings, one retains only the memory of the changeable spaces just passed through. At the same time the eye is repeatedly drawn to details: hand-cut edges, strategically placed bolts, symbols cut out of steel plate, and above all, intricately torch-carved knotted-metal joints and sockets, from which steel beams stretch like fingers.

The joints and sockets are reminiscent of the first works di Suvero exhibited in 1958—freely modeled hands in wax and plaster, later cast in bronze. *Hand Pierced* (1959), its fingers contorted in pain, is impaled on a pipe

My special thanks to Dr. Monroe Denton, whose A Catalogue Raisonné of the Sculpture of Mark di Suvero
(Ph.D. dissertation, Graduate School and University Center, City University of New York, 1994),
includes reprints of articles and other material unavailable to me and was invaluable in my research for this essay.

JOHNNY APPLESEED, 1989–93

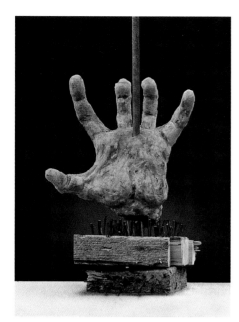

Hand Pierced, 1959

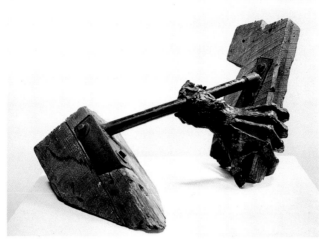

Raft, 1963

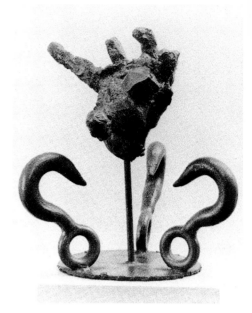

Hand, 1964

projecting from a bed of nails hammered into a wood base. The hand in *Raft* (1963), which extends from a pipe connecting two chunks of wood, desperately clutches one of them. Three metal hooks poised like cobras are about to strike at a clenched *Hand* (1964). ☐ Whose hands are these? Obviously the sculptor's, di Suvero turning in on his basic implement—the hand as the tool of the eye and of the mind but with a mind of its own—and emphasizing the primary role that artistic-making has played in his art and its development, both formally and iconographically. ☐ The clenching-hand gesture is found not only in the early plasters and bronzes but in di Suvero's subsequent abstract sculptures as well. It is suggested in the focal points of scavenged-wood assemblages that di Suvero began to build shortly after his early *Hands* and before his steel structures. Most recently it is called to mind in the buckets of steam shovels in *Beppe* and *Johnny Appleseed*.

The agonized look and gouged surfaces of the plaster and bronze hands are in the expressionist figurative tradition. The found-wood-and-steel constructions also have an expressionist appearance, or rather abstract expressionist, calling to mind the muscular swaths of paint in Franz Kline's and Willem de Kooning's abstractions of the 1950s. The rough-hewn wood and raw steel are the counterparts of unfinished-looking painterly facture.

OLD BUDDY (FOR ROSKO), 1993–95

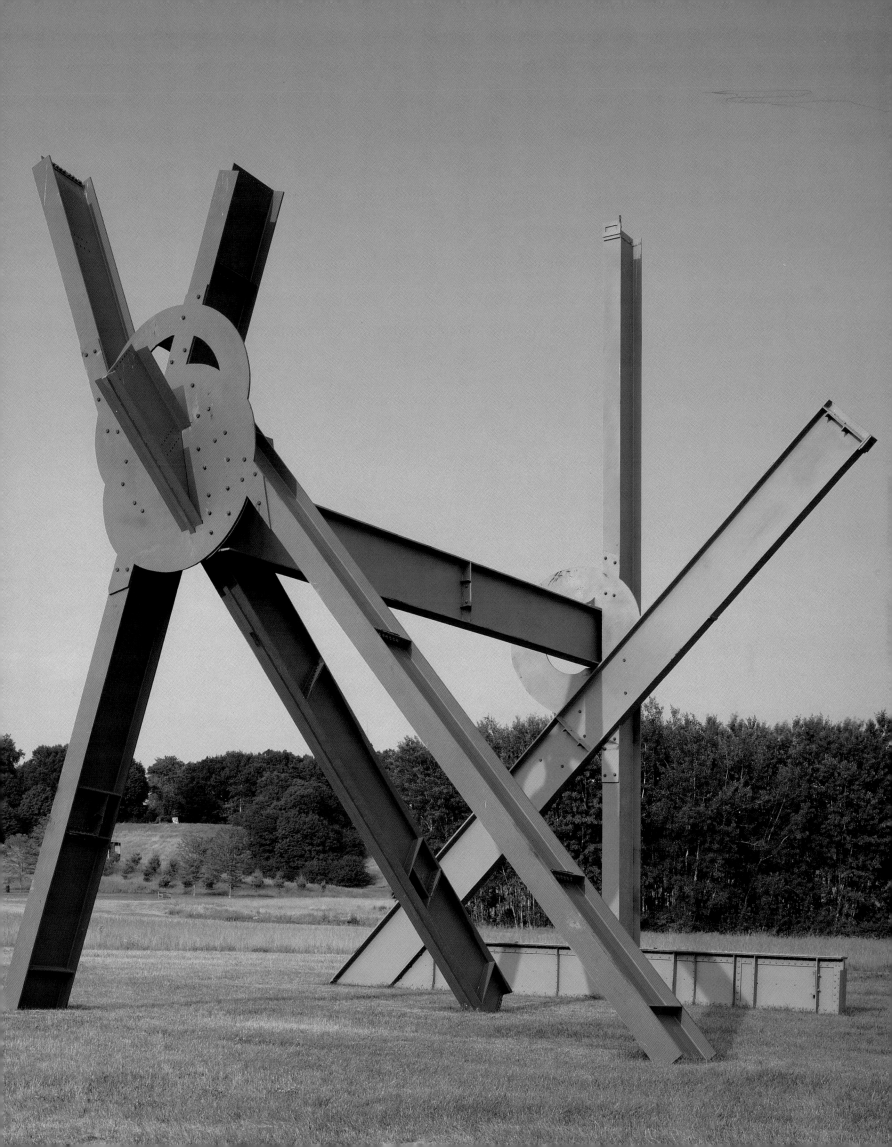

Much as di Suvero was affected by the appearance of abstract expressionist pictures, he was equally if not more influenced by the improvisational approach of the artists. To the abstract expressionists it was a moral imperative for the process of painting to be dictated by what Wassily Kandinsky had called "inner necessity." To be "authentic" they could not contrive an image but had to "encounter" it in the *felt* act of painting. Because of the difficulties of decision making, art making was fraught with anxiety. Di Suvero adopted this improvisational approach and shared the anxious mood it fostered, the mood of the earlier clenched hands. ☐ In their thinking about art, the abstract expressionists were influenced by the existentialist philosophy of Jean-Paul Sartre and Albert Camus, which engaged the avant-garde in the late 1940s and 1950s. The existentialists began with the premises that human nature was not fixed and that in the face of inevitable death, life was absurd. As William Barrett wrote, they focused on "alienation and estrangement; a sense of the basic fragility and contingency of human life; the impotence of reason confronted with the depths of existence; the threat of Nothingness, and the solitary and unsheltered condition of the individual before this threat."[1] Nonetheless the existentialists believed that one must not succumb to despair. Confronting one's situation, one had to construct one's own being—literally to create oneself, no matter how anxious and vulnerable one felt. And if one did, one became something of a hero—if a pathetic one. To partake authentically in the human adventure, one had to avoid subjecting oneself to fixed and habitual patterns, standards, or ideas and instead remain open to change and live in a state of expectancy, even joyful expectancy. ☐ I imagine that for most people, even those existentially minded, death is an abstract event that will take place in the future. Not so for di Suvero. In 1960 he almost died after his body was crushed while he was working on an elevator in a loft building. He was told by his doctors that he would never walk, much less work, again. Yet within months di Suvero went back to work in a wheelchair, and in time he willed himself to walk. Mindful of his courageous effort to overcome his disability, and familiar with photographs of the artist at work in a red hard hat atop a crane or on one of his epic constructions, art writers have often presented him as a romantic hero. Indeed, di Suvero *looks* romantic—he has piercing blue eyes, a flowing mane of reddish blond hair, and a grizzled beard—and has *lived* romantically.

Early in his career, when he was an impoverished artist, his home (and studio) was, as one writer reported, in "a crumbling, 19th-century Fulton Fish Market edifice, in which one climbs up creaking wooden staircases, mounts unsteady ladders, shrinks along sagging catwalks, and finally reaches a mammoth attic that resembles, with its canted eaves of timbers, the overturned hull of a wind-jammer."[2] The view was of East River docks, the Brooklyn Bridge, and the river traffic. ☐ Di Suvero can with justification be considered romantic, but that label has taken on connotations of the exotic and come to imply posturing, a kind of behavior of which di Suvero is incapable. Rather than romantic in the current sense of the word, di Suvero is existential, in that he has made himself what he is. In the face of death, he chose life, and he has chosen to live it and embody it in his art as exultantly as he can.

In making the hands, di Suvero looked to Rodin and the great tradition of Western carved and modeled volumetric sculpture at the moment of its transition into modernism. However, the pipe and nails in *Hand Pierced*, the pipe and chunks of wood in *Raft*, and the hooks in *Hand*—and the space they delineate and activate—are identified with modernist construction in space, pioneered around 1930 by Picasso and Julio Gonzalez and extended in new directions by David Smith and Alexander Calder. These revolutionary artists liberated sculpture from the traditional stone, wood, or bronze figurative monolith. They invented a novel kind of abstract drawing in space in which linear and planar elements define, charge, and encompass space, literally turning voids into forms and often making these "negative volumes" the primary components of the sculpture. ☐ The artists whom di Suvero called his "spiritual fathers," in homage even naming pieces after them, all wanted to "change space through a new sense of scale." Rodin was one. Rodin's *Burghers of Calais*, which impressed di Suvero as much as his body fragments, are life-size figures, not centered, but walking in extended space on the same plane as the viewers, interacting with them with an immediacy unprecedented in sculpture. Di Suvero also admired Louise Bourgeois's abstract arrangements of small cylindrical volumes placed directly on the floor, because like Rodin's *Burghers*, they spread out in space. Alberto Giacometti was another artist who changed "the size of the

space" for di Suvero,[3] both in his radically asymmetrical *Palace at 4 A.M.* and in his elongated figures ravaged by space. ☐ Above all di Suvero was inspired by the pioneer construction-sculptors: Gonzalez, who established a new aesthetic identity for iron; Smith, whom di Suvero called the "blacksmith artist," who changed sculpture from an "objet d'art type of thing, to something that is really strong, American industrial art";[4] and Calder. Di Suvero remarked that "Anybody who does motion in sculpture has to relate to him. . . . Calder's joy is real. He was able to take steel and make it balance. . . . Calder chose a dancing motion that had to do with a special kind of pleasure that human eyes need, which is the pleasure of leaves in the wind, of branches, a kind of gentle relationship to the human hand."[5] ☐ Di Suvero also admired the Russian constructivists, because they had "made the world look new."[6] He liked their use of iron, and plastics and other contemporary materials as well as industrial techniques, to build constructions in space; their embrace of abstraction; their introduction of science and geometry into art; and their social consciousness, which had led them to bring art to the people. ☐ In his regard for artists di Suvero was traditionalist, but the artists he esteemed were all in "the tradition of the new," to use Harold Rosenberg's phrase.[7] Like them, he aspired to make an original contribution, and consequently to renew and extend the grand tradition of modernist sculpture. His predecesssors were models for di Suvero in another way, too, providing him with standards of excellence and revealing to him that forms could become alive, a *quality* he has always strived for. It is significant that after he had achieved success, he joined in establishing a foundation to assist artists that he named La Vie des Formes, after Henri Focillon's book of that title.

Di Suvero achieved a new sense of scale in the early constructions he built from 1959 to 1966. They are composed of cast-off timbers retrieved from demolition sites and joined together with heavy cables, chains, ropes, bolts, and nails, interspersed with detritus, such as a discarded barrel, a ladder, a free-hanging chair, or an automobile tire. Extending as much as sixteen feet in any direction, these pieces were huge for their time, and because of their internal scale—that is, the way in which their components are related—they looked even

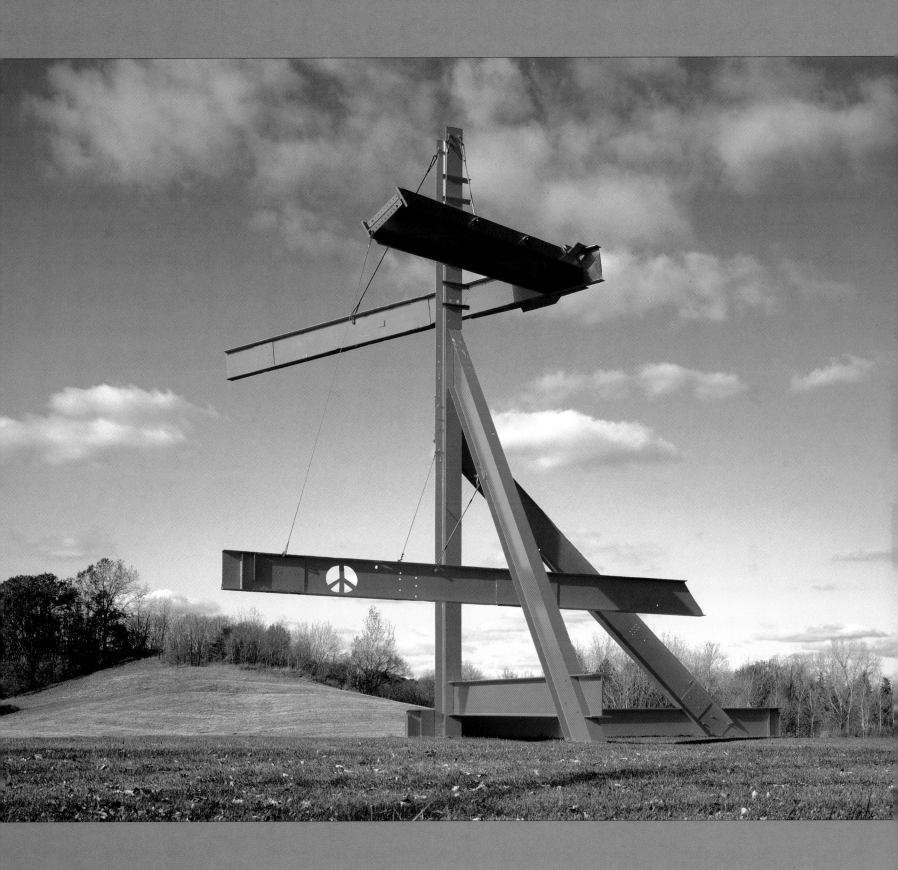

MOTHER PEACE, 1969–70

more immense. Di Suvero made his work large because he wanted to emulate the gesture and the immediacy of "big" abstract expressionist pictures. The scale was also prompted by his elimination of pedestals because they were sculpturally meaningless forms. To make pieces placed directly on the floor visible, he had to increase their size. Such works no longer fitted comfortably into the rooms of collectors or even museums, and seemed to call for public sites. ☐ Not only the scale but the sprawl of di Suvero's works made them new. Construction-sculptors, for example, Gonzales or Smith, generally composed their pieces centripetally around a single axis or core, in a kind of cubist design. In di Suvero's constructions, massive beams jut and tilt energetically into space in all directions. They branch out, at times seem *flung* out, not from one center but centrifugally from several asymmetrical foci. The heavy components often seem to be precariously balanced, but thrust is answered by counterthrust and equilibrium is achieved. ☐ The sprawl in di Suvero's sculptures might be thought of as "irrational," but he provided a "rational" counterbalance by introducing geometry, at times as a kind of infrastructure. In fact, the found materials he favored—a ladder, a tire—were themselves geometric in form. But, more important, di Suvero made geometry dynamic. He used the diagonal line as his basic vector: two diagonals form an acute angle, his basic unit; and three, a triangle, his basic form. (As Buckminster Fuller pointed out, the triangle is the simplest shape that is rigid.) Di Suvero also favored complex permutations of the triangle—parallelograms and rhomboids. Constructed in three dimensions, the triangle becomes a pyramid or a tetrahedron. These geometric figures and their variations would remain central in di Suvero's work. Di Suvero's use of salvaged materials also seemed novel. That is, novel enough to shock artists as avant-garde as the abstract expressionists, most of whom denigrated as neo-Dada—a new anti-art—work that included a beat-up ladder, crumpled automobile fenders, or rusty boilers. ☐ Di Suvero was not alone in using wreckage, however. John Chamberlain began to assemble junked auto-body parts at roughly the same time, and both di Suvero and Chamberlain had been anticipated by Richard Stankiewicz, Jean Follet, and Robert Rauschenberg. In one sense their use of detritus was not new at all. Picasso and Braque had introduced newspaper fragments and other found materials into their collages as early as 1912, and Kurt Schwitters had started to make his out of scav-

Barrell, 1959

enged bits of paper not long after. David Smith had incorporated old metal machine parts into his sculptures. But they all had assimilated their discarded materials into the formal fabric of their works. In a manner sufficiently different to look new, the assemblage-makers of di Suvero's generation risked making their cast-off objects stand out and declare their particular origin, playing down their formal role. □ Found objects that assert themselves direct attention emphatically to their interactions—in di Suvero's assemblages to the relationships among, say, the weathered timbers, a barrel sticking up like a thumb, and steel cable, reminiscent of ship's rigging or suspension bridges, of *Barrell* (1959). Such incongruous juxtapositions trigger psychological reactions and in this sense are in a surrealist vein. But, more important, the guts of disemboweled urban structures and the refuse of city streets, as di Suvero composed them, capture the dynamism of New York City—in a perpetual state of demolition and rebuilding—and in that sense could be called realist.

Art critics who reviewed di Suvero's first solo New York show at Richard Bellamy's Green Gallery in 1960 recognized that he had revived sculpture at a time when even avant-garde sculpture seemed to have become outworn. As Sidney Geist wrote in the first article on di Suvero's work: "From now on *nothing will be the same.*[8] The leading new sculptors of the 1950s were Herbert Ferber, David Hare, Ibram Lassaw, Seymour Lipton, and

Theodore Roszak. Their welded-metal constructions were relatively small and evoked biomorphic processes, already an overworked surrealist theme. Using the welding torch as a brush, they created surfaces that were bubbled, fretted, and pitted—in a word, "painterly." Consequently their work was regarded as the sculptural counterpart of abstract expressionist painting, and in a sense it was. However, it was generally too small in scale and too ambiguous and fussy to have the gestural power and immediacy of the best of the new painting. In contrast di Suvero's large, bulky, linear forms; clear, abstract configurations; and charged spaces were fitting analogues of the energy-packed paint swaths in abstract expressionist pictures. ☐ Just as the welded sculpture in the vein of Ferber, Hare, Lassaw, Lipton, Roszak, and their many followers had come to seem used up by the end of the 1950s, so had the gestural tendency of abstract expressionist painting—although the work of individual artists such as de Kooning and Kline continued to develop. The abstract sculpture of di Suvero and Chamberlain as a kind of painting in three dimensions appeared to be a vital extension of abstract expressionism. But di Suvero's muscular drawing-in-the-round was immediately recognized by leading artists and art professionals as a fresh outgrowth of construction-sculpture. Indeed, Geist aptly labeled it "Constructive Expressionism,"[9] and Donald Judd wrote in *Arts Magazine*: "The size and force of this sculpture are thunderous."[10] Geist concurred: "Here was a body of work at once so ambitious and intelligent, so raw and clean, so noble and accessible, that it must permanently alter our standards of artistic effort."[11] And I wrote in a more romantic vein that di Suvero's sculpture was "the cry of vengeance on the part of . . . the displaced artist, the last individualist, against the square, faceless monotony of concrete, steel and glass boxes that pass for modern architecture and the mass-men that inhabit them."[12]

Although di Suvero had arrived at the rudiments of his sculpture by 1960, in the following half-dozen years he would further develop them and clarify what he wanted his art to be. He did so in conjunction with a group of like-minded artists. In 1962 they founded the Park Place Gallery in Lower Manhattan. More than a gallery in the conventional sense,[13] Park Place was a countercultural artists' collaborative. Di Suvero was the leader both

artistically and conceptually; he and his friends read books and articles on mathematics and science and sought to introduce ideas culled from them into their art. ☐ The Park Place artists had a special interest in topology. With an eye to Max Bill, José de Rivera, and Alexander Rodchenko, they explored ways in which surfaces could be "warped"—that is, "twisted, bent, pulled, stretched or otherwise deformed from one shape into another." They preferred "flexible" shapes with double meanings, such as the parallelogram—which might be a square seen at an angle, or stretched, and hence is perceived as a figure whose space is warped. Because such a figure has multiple readings it is experienced in time, and the idea of "space-time" was critical to the Park Place artists. As Di Suvero said: "Space-time is the only way you can think since Einstein."[14] He himself experimented with "space-warp" in sculptures formed from single planes of reflective stainless steel. Nevertheless, despite their interest in science and mathematics, the Park Place artists were inspired more by David Smith than by the constructivists, and consequently their work was more intuitive than systemic. ☐ The Park Place artists also favored structures whose thrust was diagonal and that reached outward, toward the periphery of the work—and metaphorically into its surroundings. Because of their countercultural leanings, they also wanted to bring their art into the environment outside the art world—to the people. Understandably, then, the Park Place artists were responsible for organizing the first show of contemporary public art in the United States, *Art for the City*, in Philadelphia in 1967. ☐ Before Park Place di Suvero had already created large-scale structures whose logical venues were public places, whose vectors were centrifugal, and that incorporated geometric elements. His Park Place experience confirmed him in the direction he had taken.

In 1962 di Suvero first introduced movable elements into his sculptures, inviting viewers to climb into them physically. In *Love Makes the World Go Round* (1962–63), a double swing of rubber tires is balanced on a tripod whose base is another tire. Viewers could mount the tires and take exhilarating rides around the sculpture. Various reasons have been given for di Suvero's move into what he called "interactional sculpture." Robert Goldwater wrote that it made explicit what had been implicit in the earlier constructions: "To swing in

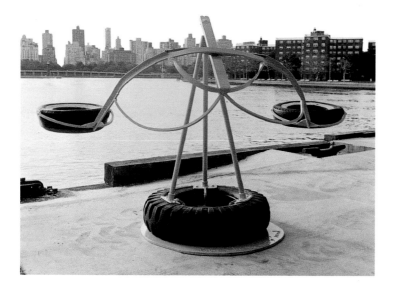

Love Makes the World Go Round, 1962–63

the tire . . . is only to activate the work's powerfully suggested movement."[15] ☐ Di Suvero wanted to break down the do-not-touch barrier between his art and the viewer. In this he may have been influenced by the countercultural demand for "participatory democracy." His intention was to make viewers *feel* a work physically as well as imaginatively and provide them with a sense of freedom that harked back to primordial man's swinging from trees. He also wanted to introduce an element of play in order to appeal to children and bring out the repressed child in adults. (Di Suvero would invite ghetto kids into his studio to test the "toys.") Interactional sculpture, which invited people *into* the work, was an innovative extension of public art. No other artist had transposed "spectators [into] passengers."[16] Ironically, putting real people into abstract sculpture made it figurative, more accurately, realist. ☐ It was Thomas Hess who suggested that di Suvero had a personal "need to incorporate play—climbing, swinging, seesaw games and exercises—into his work, and [to have] bevies of kids around him [as a result of his] experience with therapy, from the nightmare time when suddenly he reverted to helplessness, to babyhood, and had to re-experience the mechanics of learning to walk."[17] Di Suvero laughed off Hess's suggestion that after his accident he had regressed to an infantile state, but elswhere states that "most adults are deficient children; they don't know how to play anymore. The pure response is the child's response."[18] And the pure response in play is joy. ☐ Whatever the reasons, di Suvero would include a kinetic component in most of his subsequent sculptures, and invite audience participation.

Although the scale of the found-wood assemblages was gigantic for its time, it proved to be not large enough for di Suvero. In order to encompass even more space, he required a stronger material than wood and one that could be bent, twisted, and suspended in ways that timbers could not.[19] In steel girders he found the medium he needed, shaping I-beams with industrial cutting tools, moving them with a hydraulic crane, often in conjunction with a cherry picker, and bolting or welding them with oxyacetylene torches. ☐ Intuition led di Suvero to enlarge his work; his sculptural ideas have evolved in what he called his "dreamtime... pure music of the mind." But he did have in mind a public art that involved audience participation. And as always he wanted to expand the vocabulary of sculpture. Only in outsize constructions could he create diverse spaces that viewers could enter physically. And only in immense works could he emulate, as he said, "the kind of scale that is so normal in terms of architecture and yet so wonderful in terms of sculpture because it is not habitual." Indeed, di Suvero's scale seemed to relate less to other sculpture than to monuments, such as the Statue of Liberty, the Gateway Arch in St. Louis, or even the Eiffel Tower. He was not the first to dream of creating large-scale sculpture. As he pointed out, the Russian constructivists had had the same aims, but they "were never able to do forty- or sixty-foot pieces of sculpture; they were never able to handle twenty-ton pieces. They may have drawn them, but there is a difference between drawing a piece and achieving it."[20] ☐ Di Suvero recalled that the crane changed everything. Able to lift tons at a touch, it was like a superarm. However, arranging for its use had been difficult at first, on account of the cost. Occasionally di Suvero could trade his labor for crane-time, but it was not until 1967 that he was able to build his first all-steel piece using a crane from beginning to end, the forty-by-forty-by-thirty-foot *Are Years What? (for Marianne Moore)*. ☐ Despite the size, bulk, and weight of di Suvero's steel sculptures, he has always insisted on making his own pieces by himself, with the help of a few valued assistants. Nothing is given out to be fabricated. Moreover, he refuses to make models or maquettes and have them manufactured to produce what he disparagingly calls "designer art." He has learned through experience that the only way to get the scale of a sculpture right is to work in the actual dimensions. This direct method has also enabled him to remain open to new possibilities and to improvise from the start to the finish

of a sculpture: "I just draw on the beams. I bend the beams. I run the cranes. I set the pieces up, try them, turn them over if they don't work, cut something off of one, halve it, take something out of one piece and put it in another."[21] Even in his public pieces, whatever ideas di Suvero may have started with undergo considerable revision before they are completed.

Di Suvero's steel sculptures look simpler than the salvaged-wood assemblages because they are composed of a single material, steel, whose primary forms is the I-beam. In the late 1960s, critics linked his constructions to minimalism, then recently established in the art world. In actuality there is no relationship. Di Suvero's composition is relational; minimalist objects are unitary or modular—that is, nonrelational. Moreover, di Suvero is an artistic-maker whose process is trial and error, whereas minimalist artists preconceive their sculptures and give them out to be fabricated. Di Suvero disliked this practice, asserting that it eliminated "the most crucial part of modern sculpture . . . grappling with the essential fact that a man has to make a thing. [These] works which give me that sense of radiance which I find I need in a work are those that have been actually worked over by an artist."[22]

Despite the architectural size of di Suvero's constructions, they "always remain in that indigestible condition known as sculpture, and are never assimilated by the idea of architecture or place," as Geist wrote in 1960 of the wood pieces.[23] The same applies to the later steel ones. As a sculptor di Suvero has naturally been preoccupied with formal considerations that enable a work to take on a life of its own—the part-to-part-to-whole relationships of the metal components and the spaces they form. He has paid particular attention to details—as I commented—torch-carved edges, joinings, and boltings. (It often takes him months of contemplation to make even a minuscule adjustment.) Much as his huge works are powerful, they are also graceful, at times whimsical, and full of subtle surprises. ☐ Signs of the human hand found in the detailing point to the essential humanness of di Suvero's constructions. So do the organic-looking knotted joints. Moreover, despite their size and

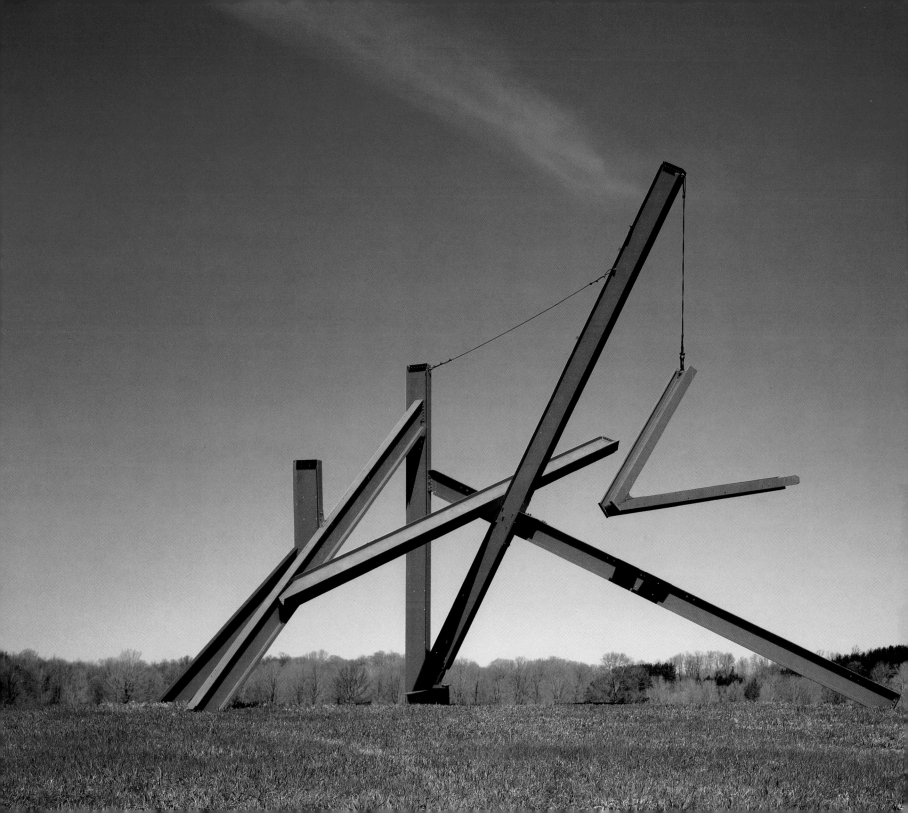

abstractness, they are never overwhelming. They are scaled to human proportions so as to enable viewers to connect their bodies to them. In addition their relational components simulate human gestures—such as gravity-defying soaring, a dramatic leap, or a playful hop—that educe involuntary kinesthetic responses.

As a material steel has a particular appeal for di Suvero. He likes the look of it and lets it look like what it is in his finished pieces. He also likes the heft of the metal and the process of working with it—coaxing it to do things it is not supposed to do, like cold-bending I-beams, a feat that has astonished veteran steel workers who have witnessed it. Di Suvero is also moved by the "aura" of steel—the backbone of the machine age and its consummate metaphor—but his works are not monuments to industrialism. As Barbara Rose wrote, di Suvero's message is that "if the artist can dominate technology and direct it to serve his own ends rather than vice versa, then humanity in general can control its great and dangerous technological apparatus, and rationally determine the goals for which it will be used."[24] ☐ Like di Suvero's constructions composed of found materials, his steel sculptures have urban references—for example, to skyscrapers in construction. The diverse spaces of the steel works are also reminiscent of the city. Harris Rosenstein reported that a sculptor friend of di Suvero's, Ed Ruda, "tells of how di Suvero gets you to walk along the city streets with your head up and your eyes focused on the top contour of the buildings to experience successive compressions and expansions of space and rapid changes of scale."[25] ☐ Because of the urban, industrial, and architectural connotations of di Suvero's sculptures, they fit comfortably into city spaces. But they fit equally well into Storm King's pastoral landscape. The steel structures and natural phenomena are seen through each other, the contrast enhancing both. There are also harmonious relationships, in winter, in the way the girders and the branches of trees echo one another; in spring and summer, the play of green against the rusts of sculptures such as *Johnny Appleseed* or the orange and rust of *Beppe;* and in the autumn, as Charles Miedzinski wrote of an earlier di Suvero show at Storm King: "The rust of changing autumn leaves and the earth red brick of the nearby buildings echo the coloring of industrial girders that have undergone the process of oxidation. . . . Using the materials of our age, di Suvero has succeeded in returning them to nature."[26]

What is the content of di Suvero's constructions? As he expresses it, on the most basic level they aspire to tap into structures that dominate our lives: "galactic forms, and subatomic forms, DNA forms that determine who we are—they remain a constant, like algebra, all the way through our lives."[27] These forms have a poetry, "resonances [that can] become objectified in sculpture," and when they are, "they can electrify our life."[28] Di Suvero will not illustrate these fundamental structures. He tries to sense them within himself, subjectively, as it were, but in the belief that his interpretation will be comprehended by others and become intrasubjective. □ To embody the constant, resonant structures that underlie our being, di Suvero builds fixed frameworks. But he also values flexibility and movement, and this is why mobile elements are incorporated into his sculptures. The kinetic parts introduce the element of time into an art of space, becoming a metaphor for space-time, which di Suvero sought to embody in his sculpture almost from the first. This concept is so significant to him that he named his Long Island City workplace "Spacetime Constructs." □ The fixed components of di Suvero's constructions are stable. Required to hold aloft the kinetic parts—which often weigh tons—as well as the adults and children who climb them and whose behavior is unpredictable—they are structurally rational. The mobile components are unstable. Wind-driven or moved by the viewer-participant, their movements are dependent on chance and hence irrational. They are also free as opposed to inflexible. In metaphoric terms di Suvero combines fixed, rational order with unfixed, irrational chance, a combination that makes his constructions truer to life than kinds of art that embrace only one or the other. □ The free-floating segments serve to release the tension of the rigid girders that support them, and continually change their appearance. They prevent sculptural stasis by providing a sense of animation—metaphorically, of life. Consequently the movable elements are humanizing. Those that sway to and fro are erotic, evoking the poetry of sex. In many of his works di Suvero has included hanging platforms on which people can sit or lie—or could make love. □ The suspended parts also counter the weighty appearance of steel beams. Indeed they seem to float, defying gravity. And they deflate the sculpture's often enormous size. As Paul Tomidy wrote: "To see a swing or tire dangle from a formidable thirty-ton steel piece, or a chunky form swivel about precariously on a balancing point alters the perceptual dimensions of the sculpture while adding a smile to the whole experience."[29] The kinetic elements

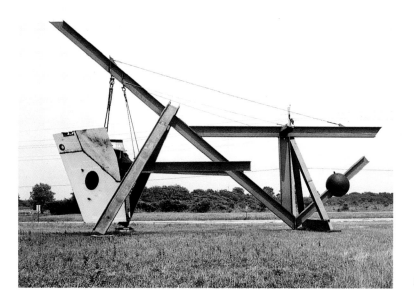

Isis, 1977–84

are play-inducing or playful, whether one mounts them or not, giving rise to feelings of lightheartedness and elation. At other times to observe their movements, which are slow and gentle, induces contemplation. ☐ Finally the stabile beams and cables that hold the kinetic elements function metaphorically like fingers. Di Suvero asked that a poem by Emily Dickinson "Of All the Sounds Despatched Abroad" be included in a recent catalog. "The Wind does—working like a Hand / Whose fingers comb the Sky—..."[30]

The basic geometric elements in di Suvero's constructions—the diagonal line, acute angle, and triangle, which in three dimensions becomes a pyramid or tetrahedron—seem to have symbolic or metaphorical connotations. For example the acute angle has sexual associations, both male and female. If horizontal it is phallic, particularly when it is a kinetic element, moving back and forth. As a vertical **V** it is vaginal. The **V** also resembles the wings of birds in flight. In addition it is the symbol of victory and the central form of the peace symbol, prominently cut into *Mother Peace* at Storm King. ☐ The horizontal **V** in the Hirshhorn Museum's *Isis* is actually a ship's prow, perhaps in memory of di Suvero's father's occupation (he was an Italian naval officer stationed in China) or the di Suvero family's roots in maritime Venice, or its trans-Pacific exodus to the United States from China,

where Mark, né Marco Polo, was born. ☐ One of di Suvero's favorite salvaged forms is the bucket of the steam shovel, a three-dimensional **U** that is a variant of the **V**. It is elevated in *Johnny Appleseed*, as if to grasp a piece of sky. Inverted, as in *Beppe*, it claws into the earth: sky and earth, heaven and hell. Clawing or grasping, the bucket resembles the cupped human hand, harking back to the first wax, plaster, and bronze sculptures that di Suvero exhibited. But then all machines, whose fragments he salvages, are extensions of the hand. In di Suvero constructions, obsolete or derelict tools are elegiac mementos of the precursors of his crane and cherry picker.

Although di Suvero's construction-sculptures are too diverse to classify, nonetheless a number of motifs recur. One is the linear structure with one or more free-hanging parts, which was predominant in the large-scale pieces of the late 1960s, like *Mother Peace* (1969–70) and also *Mon Père, Mon Père* (1973–75), both at Storm King. Another is the tripod that provides the basic supports of works, as in *Mon Père, Mon Père*. Knotted joints and sockets made their appearance at the beginning of the 1970s and in time have become increasingly "baroque." And there are cast-off machine parts, which were introduced in the middle 1970s. ☐ In di Suvero's large-scale sculptures in the current exhibition at Storm King, these components are combined in fresh ways. *Old Buddy (for Rosko)* and *Johnny Appleseed* are composed of two vertical complexes supporting a horizontal complex that bridges them. The ensembles call to mind the sprawl of di Suvero's found-wood assemblages. In *Old Buddy (for Rosko)* one of the vertical complexes is linear; the other features a massive knotted joint perched on a huge three-legged structure. In *Johnny Appleseed*, two horizontal girders, some twenty-three feet long, are propped on two vertical **X** components, each comprising the crossed elements of a steam-shovel arm. One diagonal of each **X** is topped by a pair of wheels, the other by a steam-shovel bucket, maw sky-up in a Whitmanesque yawp. At one end of the piece is a complex of circular shapes: a large stainless-steel hoop and two small rusted wheels whose spokes form peace signs. At the other end is an antennalike rectangular form from whose tilted surface a structure with two prongs juts up, as if to receive from, and transmit messages to, the universe. *Beppe* is the most complex of the works. It consists of a structure of thrusting orange **I**-beams, of

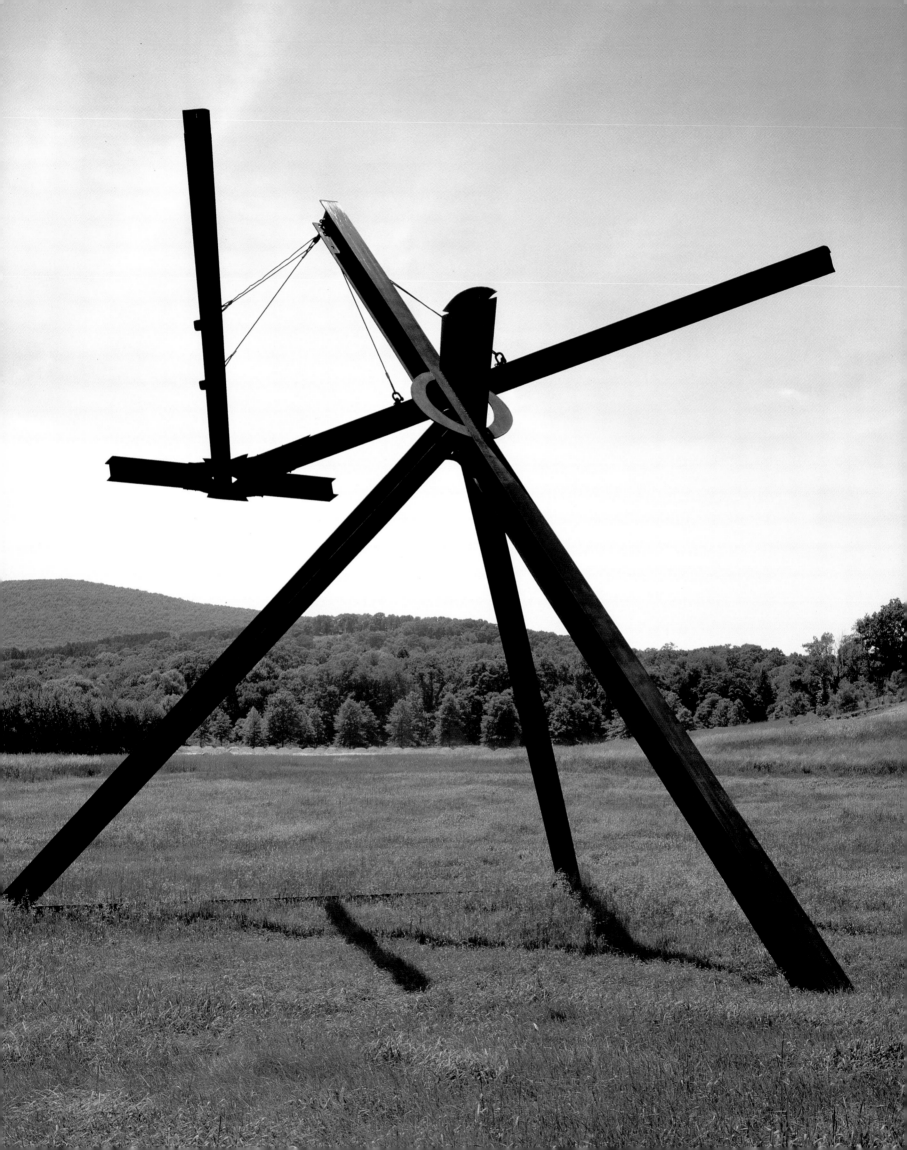

varying thicknesses, that rest on a foundation of rusty machine parts. The structure supports two massive kinetic elements: a stainless-steel tank; a contrasting elongated orange triangle, like an airplane wing; and on top of it all, an open orange horseshoe with pointed ends that reach out like welcoming arms. In another vein *Aurora* (1992–93) consists of a horizontal triangle that thrusts through three intersecting open disks supported by a **K** of **I**-beams.

Much as di Suvero is known for his epic constructions, he has made considerably more small sculptures—from tabletop- to two-times-life-size. Many have a baselike form, from which extends a vertical steepletop on whose point is balanced a kinetic element that the viewer can set rocking and/or spinning in a 360-degree orbit. The smaller pieces are the most varied, because instead of being built primarily of **I**-beams, they are composed of fanciful shapes carved out of thick steel plate, ranging from simple angular and curvilinear geometric figures to intricate filigree and abstract calligraphy resembling Chinese or Arabic script. Indeed, it is in these small works that the range of di Suvero's invention and poetry is manifest. □ *Square Root of Two* (1994), nine feet two inches high, consists of an angle of red **I**-beams pointing upward, one of whose arms is pierced by a contrasting stainless-steel arrow swooping downward. Both elements pivot on a stainless-steel column whose base is a cutout steel plate. The smallest pieces tend to be the most complex. For example, the bottom configuration in *Nux* (1988–92), fifty-three and one-half inches high, consists of two open, upright parallelograms joined by horizontal parallel bars, a medley of salvaged shackles resembling knuckles, and a cutout logogram spelling MARK. Hovering above are two kinetic forms, the lower one a free form, the upper one a pair of industrial tongs, open to the sky. □ In these pieces viewers are invited to push the kinetic elements. In other small pieces, called "variables," viewers can rearrange separable components according to their own desires, thus completing the artist's creative process. Rose wrote that di Suvero allowed viewers "to share the power of imposing order and the excitement of creativity equally, rather than dictating taste in the form of any immutable ideal order."[31]

MON PÈRE, MON PÈRE, 1973–75

Nux, 1988–92

Despite the essential privateness of his works, di Suvero wants them exhibited in public venues and, whenever he has had a say, in working-class neighborhoods. Because they are abstract and made of industrial materials, they have often generated controversy. This has troubled di Suvero, but he cannot compromise his vision. He hopes that his work may expand the artistic consciousness of the public, and has considerable evidence that it has. When, in 1976, the General Services Administration refused to accept a sculpture by di Suvero it had commissioned for Grand Rapids because the final version departed too much from the original proposal, the local citizenry waged a massive campaign against the federal bureaucrats and forced them to back down.

The construction of enormous pieces with huge cranes and other machinery demands hard work. Di Suvero needs assistants, and he has formed close friendships with Lowell McKegney, Matteo Martignoni, and others who have helped him for years. As he wrote in a poem: "What man makes/no man makes alone."[32] Because of labor he has shared with them, di Suvero identifies with workers and is proud to be a member of Local No. 3 of the Operating Engineers Union. The sense of physical effort contributes to the expressiveness of the sculpture. Geist observed that "one can feel the making man. And the great energy he has put into it comes

AURORA, 1992–93

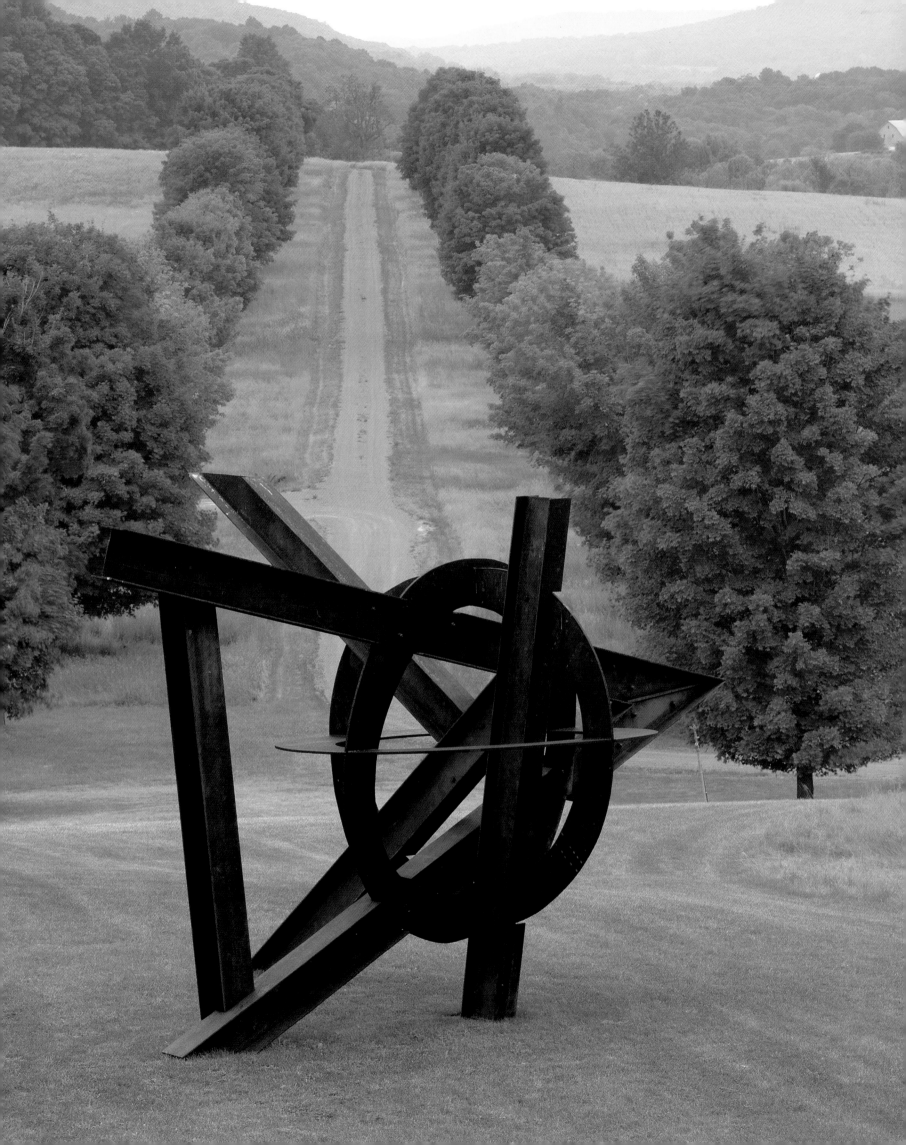

out; it is not merely energetic, it is energizing."[33] □ To hold aloft and balance heavy elements requires sophisticated engineering, particularly when those elements are freewheeling and must support people (roughly fifteen bodies to the ton), because points of stress keep shifting. It takes the finest of tuning to poise kinetic parts on a single tip or edge (or both) so that they rock up and down and pivot about *smoothly*. Di Suvero said: "When you pick up a large weight with a crane, you need a sense of its [invisible] center of gravity. This is something dancers understand, the way you can control a weight by shifting its center. Working near the limits of a crane's capacity, it's very easy to make a mistake. A cable can snap, the whole rig can tip over. So the process is delicate."[34] It requires even more delicacy because structural decisions must follow the dictates of aesthetic decisions. His sculpture must be structurally sound and visually meaningful. □ Di Suvero's basic sympathies are with workers; but in order to create large-scale public works he must assume the role of entrepreneur. "I have to sell the pieces in order to build the next ones. . . . You have to handle the money thing and you have to handle the marketing scene in the art world. The art market becomes something that you have to know just as well as the oil and grease in your transmission." From a countercultural point of view, accepting a commission from a corporation or a government agency is a compromise, but di Suvero considers the institution a "go-between. . . . the piece goes not to them but beyond them to the people."[35] Just as he has needed helpers, he has needed a coordinator and financier and has been fortunate to have Richard Bellamy, who for more than three decades has been di Suvero's dealer.

On the wall of his Petaluma, California, studio, di Suvero has a quotation from George Bernard Shaw that reads in part: "I am of the opinion that my life belongs to the whole community, and as long as I live it is my privilege to do for it whatever I can." As di Suvero himself said, art "is a gift which we give to others."[36] And creating it has been an intrinsic part of a wide range of activities on behalf of the public.[37] □ From the start of his career di Suvero participated in artists' groups. In addition to playing a leading role in the formation of the Park Place Gallery, he was a member of the March Gallery, an artists' cooperative in New York.

SQUARE ROOT OF TWO, 1994

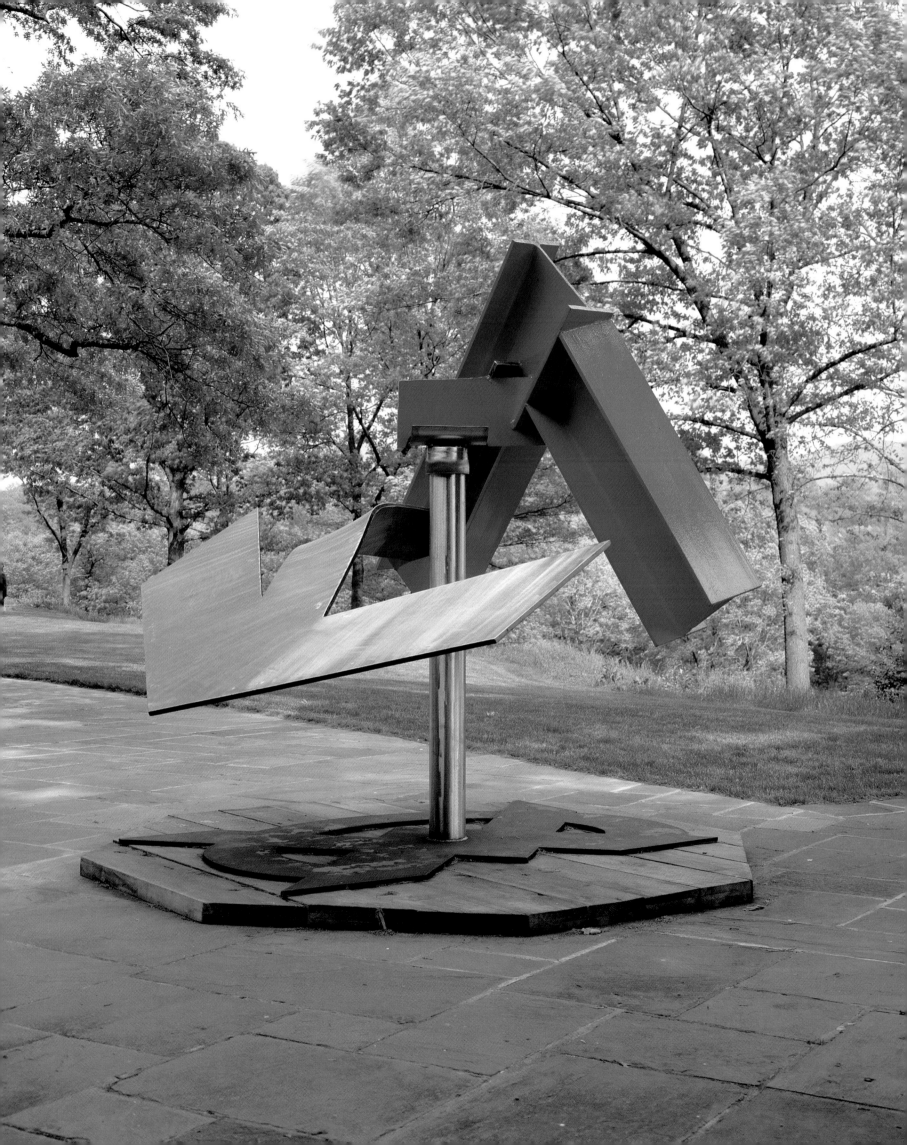

☐The Vietnam War appalled di Suvero, and he became an antiwar activist. In 1966 he joined with other artists to erect a Tower of Peace as a protest against the war. He designed a fifty-five-foot-high pipe-and-steel structure and, with the help of sculptor Mel Edwards, built it. Panels created by four hundred artists were inset into the structure. As he said: "This is the only way we can express ourselves. . . . This is a symbol of the cultural conscience of artists all over the world."[38] Di Suvero also participated in countercultural activities, helping to build a playground for a "people's park" in Berkeley in 1968, and in the following year creating three pieces for a ghetto playground in Chicago.[39] ☐ From 1971 to 1975 di Suvero's hatred of the war prompted his move to Europe in self-imposed exile. He lived and worked in Eindhoven, the Netherlands; Venice, Italy; and Chalon-sur-Saône, France. In Chalon-sur-Saône, via Barbara Rose, di Suvero was introduced to Marcel Evrard—at that time director of the Centre National de Recherche, d'Animation et de Création pour les Arts Plastiques at Le Creusot— who provided di Suvero with steel enabling him to work in a shipyard, with the understanding that he give a sculpture to the city. Six pieces were installed in different sites in Chalon, and the inhabitants chose one by popular vote. It is noteworthy that while living in Venice, di Suvero used his engineering skills to design a workable system of dikes and locks to control the flooding to which the city is subject. In 1975 he was the first artist to be honored with a show in the Tuileries Gardens in Paris. ☐ Upon his return to the United States, di Suvero was given a retrospective of sixty-five works at the Whitney, the largest show of sculpture ever mounted by the museum. Eleven of the works were exhibited outside in all the five boroughs of New York City. Di Suvero also resumed his countercultural activities. In 1975, with Anita Contini, he founded the not-for-profit Athena Foundation, which had two interrelated aims. One was to provide artists with working space and grants to create large-scale works in a noncompetitive communal setting. The other was to bring art to the community at large by founding a sculpture park. Adjacent to his studio in Long Island City, with a beautiful view over water to Manhattan's skyscraper horizon, were four and a half acres of rubble owned by New York City. Under the direction of Enrico Martignoni, the Athena Foundation got the local authorities to rent it this "garbage-land," as di Suvero called it. Unemployed neighborhood youths were hired to clear the lot, reclaiming

it just as di Suvero recycled detritus, and the Socrates Sculpture Park came into being, presenting works by recognized and unrecognized artists, not only to the neighborhood people but to an international art-conscious constituency.[40] □ Di Suvero might laugh at me for saying this, but there is a largeness, a generosity of spirit, in both his artistic aspiration and social imagination that can only be characterized as Whitmanesque.[41] Whitman also comes to mind because, like his poetry, di Suvero's sculpture is deeply rooted in the American experience—in our democratic ideals and civic-mindedness and in our industrial civilization and the art that exemplifies it.

Di Suvero had a miserable break in life, daily confronted with pain and his own mortality. And yet his art is essentially optimistic—in its its aspiration, gesture, and scope. For us who have lived in this miserable century, devastated as it has been by two world wars, Nazism, the Holocaust, Stalinism, rampant nationalism, population explosion, and ecological devastation, and who are pessimistic about the future of humankind, Di Suvero, who has suffered as much as anyone has, has aimed in his art "to give us the energy of hope, the embrace of paradox, the overcoming of despair."[42] Much as di Suvero dislikes the word "monument" (compared to what, he would say, the Brooklyn Bridge?), his constructions are unabashedly celebratory humanist monuments. They are at once grand and playful, elevated and elating.

IRVING SANDLER

NOTES

1 William Barrett, *Irrational Man* (New York: Anchor Books, 1958), p. 31.

2 Max Kozloff, "Mark di Suvero: Leviathan," *Artforum* 5 (Summer 1967): 41.

3 Mark di Suvero (comments made at The New Sculpture, a symposium held at the Jewish Museum, New York City, May 2, 1966, in conjunction with the *Primary Structures* show). Transcript on file at the Archives of American Art, New York. In Denton, *A Catalogue Raisonné*, vol. 1, p. 143. (The panel consisted of Kynaston McShine, moderator; Barbara Rose; Donald Judd; Robert Morris; and Mark di Suvero.)

4 Courtney Sale, *David Smith* (Direct Cinema Limited; A Cort Production, 1983) fifty-eight min. Transcription of comments by Mark di Suvero in the film, originally a segment of the series *Strokes of Genius,* broadcast on U.S. public television. In Denton, *A Catalogue Raisonné,* vol. 2, p. 836.

5 Deborah Solomon, "On the Waterfront with Mark di Suvero," *Journal of Art* (October 1990), "View" section: 9.

6 Barbara Rose, "A Return to the Heroic Dimension in Sculpture: Mark di Suvero," *Vogue,* February 1973, p. 203.

7 Harold Rosenberg, *The Tradition of the New* (New York: Horizon Press, 1959).

8 Sidney Geist, "A New Sculptor: Mark di Suvero," *Arts Magazine* 35 (December 1960): 40 (emphasis Geist's).

9 Ibid., 43

10 D[onald]. J[udd]., "In the Galleries: Mark di Suvero," *Arts Magazine* 35 (October 1960): 60.

11 Geist, "A New Sculptor": 40.

12 Irving Sandler, "New York Letter, *Art International* 4 (December 31, 1960): 24.

13 The founding artists of the Park Place Gallery were Mark di Suvero, Dan Fleming, Peter Forakis, Robert Grosvenor, Anthony Magar, Tamara Melcher, Forrest Myers, Ed Ruda, and Leo Valledor.

14 David Bourdon, "E=MC2 à Go-Go," *Art News* 64 (January 1966): 25.

15 Robert Goldwater, *What Is Modern Sculpture?* (Greenwich, Conn.: New York Graphic Society/Museum of Modern Art, 1969), p. 98.

16 Kozloff, "Mark di Suvero": 43.

17 Thomas B. Hess, "Art: Mark Comes in Like a Lion," *New York*, December 15, 1975, p. 94.

18 Diane Loercher, "Sculptures You Can Pull, Push, Sit In, and Ride On," *Christian Science Monitor,* December 29, 1975, p. 16. In Denton, *A Catalogue Raisonné* vol. 1, p. 500.

19 Barbara Rose, "On Mark di Suvero: Sculpture Outside Walls," *Art Journal* 35 (Winter 1975/76): 122.

20 Ann Wilson Lloyd, "Take Me to the River," *Contemporanea* 3 (April 1990): 74. Di Suvero does not think that his sculptures are particularly large. He said in Rose, "A Return to the Heroic Dimension in Sculpture," p. 202: "They only look big in relation to the bric-a-brac coffee-table sculpture. . . . Forty-story buildings are being torn down in New York so that sixty-story buildings can go up. Why are people so surprised at seventeen-ton pieces of sculpture?"

21 Solomon, "On the Waterfront": 8.

22 Mark di Suvero, statement at The New Sculpture. In Denton, *A Catalogue Raisonné,* Vol. 1, p. 143.

23 Geist, "A New Sculptor": 41.

24 Rose, "On Mark di Suvero": 120–21.

25 Harris Rosenstein, "Di Suvero: The Pressures of Reality," *Art News* 65 (February 1967): 64.

26 Charles Miedzinski, "Heroic Urban Totems," *Artweek,* December 3, 1983, p. 5.

27 Solomon, "on the Waterfront": p. 8.

28 Mark di Suvero, statement, in Richard Marshall, ed., with photographs of the artists by Robert Mapplethorpe, *50 New York Artists: A Critical Selection of Painters and Sculptors Working in New York* (San Francisco: Chronicle Books), p. 36.

29 Paul Tomidy, "Mark di Suvero," in Anne Ayers, *The Second Newport Biennial: The Bay Area,* exhibition catalog (Newport Beach, Calif.: Newport Harbor Art Museum, 1986), p. 20.

30 Emily Dickinson, "Of All the Sounds Despatched Abroad," in *Mark di Suvero: Open Secret: Sculpture 1990–92* (New York: Rizzoli, 1993), p. 62.

31 Barbara Rose, *Mark di Suvero: Spinners, Tumblers, Puzzles,* exhibition catalog (Houston, Tex.: Janie C. Lee Gallery, 1978), n.p.

32 Mark di Suvero, "ONLY YOU/can stop this war," quoted in W[ard] J[ackson], "Mark di Suvero," *ArtINow,* vol. 3 (New York: New York University Galleries, 1971), n.p. In Denton, *A Catalogue Raisonné,* vol. 3, p. 1136. Di Suvero aspires to visual poetry. Understandably he looks for inspiration to its verbal counterpart. In the Rizzoli publication di Suvero had a number of his favorite poems substituted for an essay on his work.

33 Geist, "A New Sculptor": 43.

34 Carter Ratcliff, "Artist's Dialogue: A Conversation with Mark di Suvero," *Architectural Digest* 40 (December 1983): 200.

35 Dean Fleming, "Interview: Mark di Suvero," *Ocular* 6 (Spring 1981): 44.

36 Mark di Suvero (comments made during a panel, Making Art in Adversity, Seventy-fourth Annual Meeting of the College Art Association, New York, 1986). In Denton, *A Catalogue Raisonné,* vol. 3, p. 960.

37 After his accident, during his long stay in the Bird S. Coler Hospital, New York, di Suvero developed a program of art courses for severly handicapped patients. He befriended a number of them and continues to see them, arranging for them to visit his studio, come to the openings of his exhibitions, and take part in other activities.

38 "War Foes Building Big Tower," *Palo Alto Times,* January 28, 1966. In Denton, *A Catalogue Raisonné,* vol. 1, p. 123.

39 See Denton, *A Catalogue Raisonné,* vol. 3, p. 1254.

40 The Socrates Sculpture Park was designated a public park by New York City in 1994.

41 See Hilton Kramer, "Sculpture of Whitmanesque Scale," *New York Times,* January 30, 1966, sec. x, pp. 25–26.

42 Mark di Suvero, *Sculpture: Walk On/Sit Down/Go Through* (Long Island City: Athena Foundation, Inc., 1987), n.p.

The Setting

*Storm King Art Center is the ideal site
for the harmonious, yet dramatic, interaction
between Mark di Suvero's sculpture
and the Hudson River Valley landscape.*

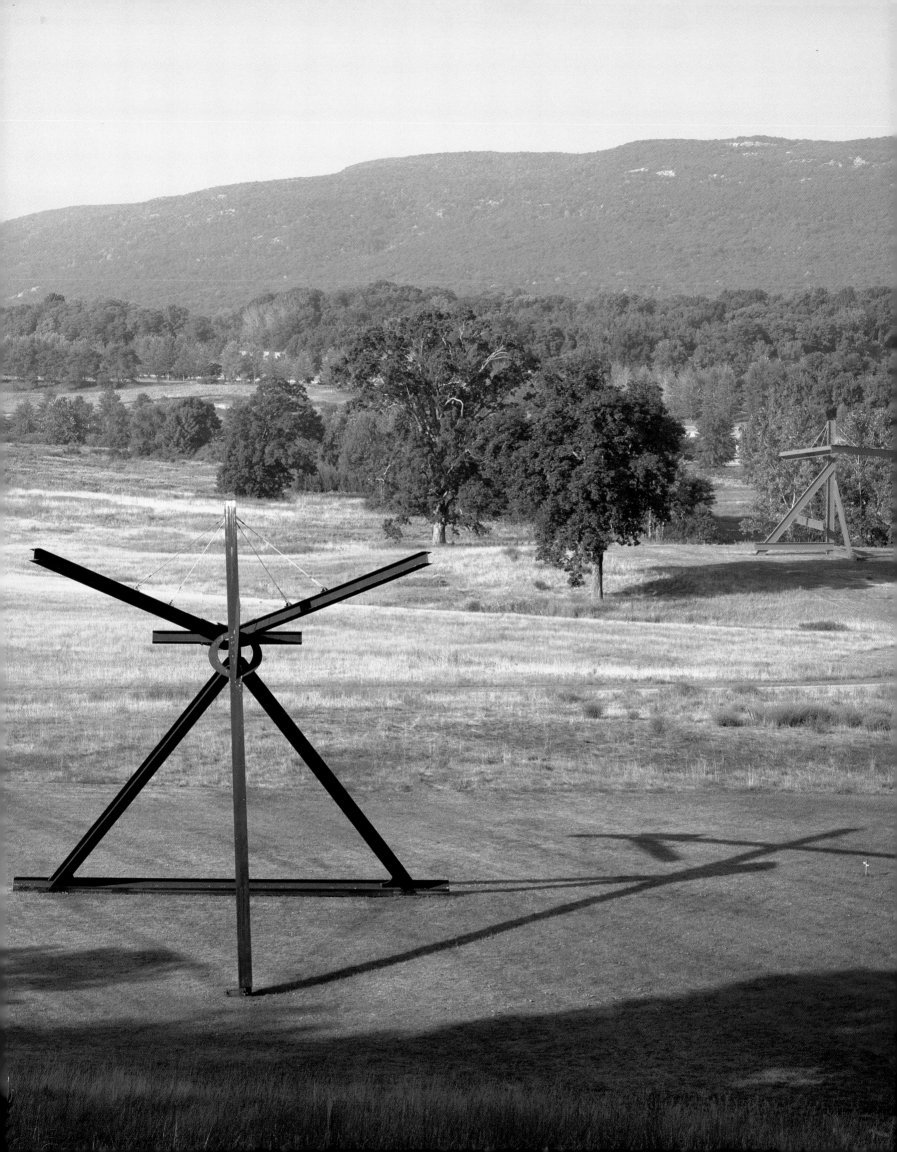

Choreography of Motion

MOTHER PEACE, 1969–70,
Collection of Storm King Art Center,
gift of the Ralph E. Ogden Foundation.

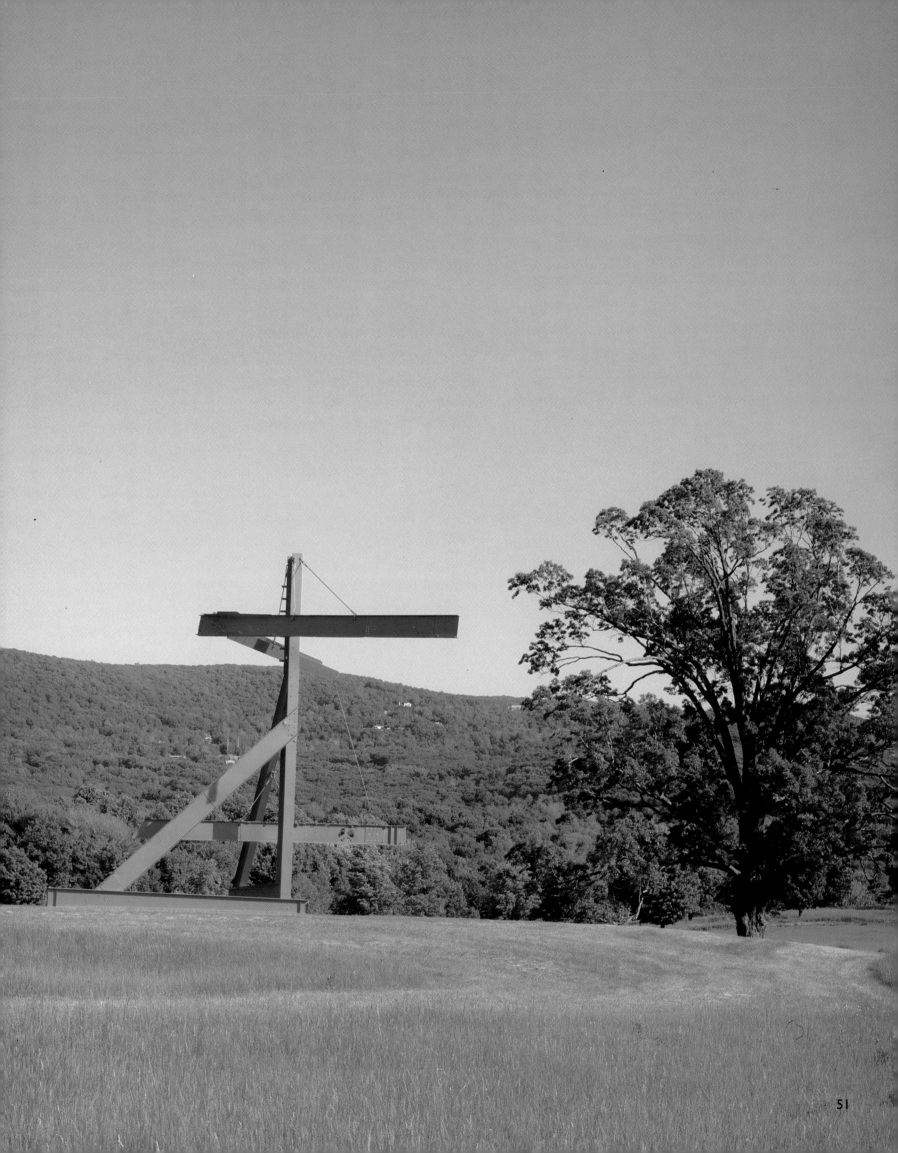

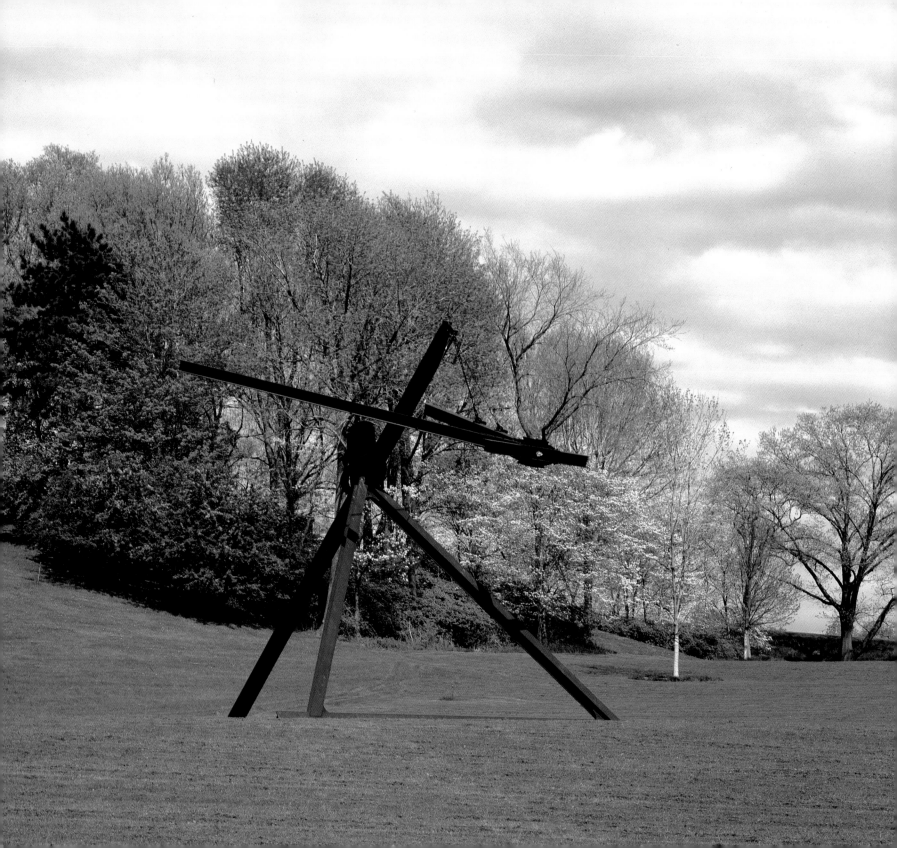

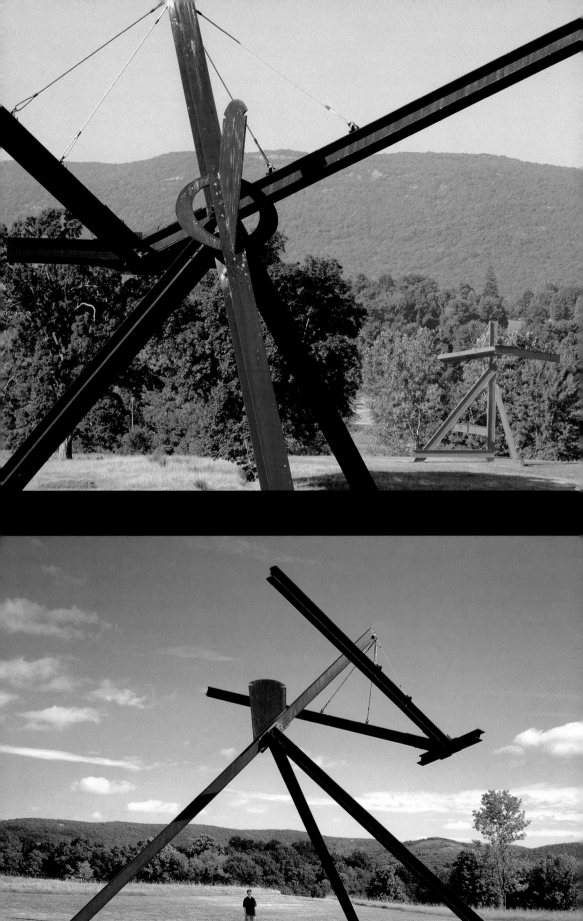

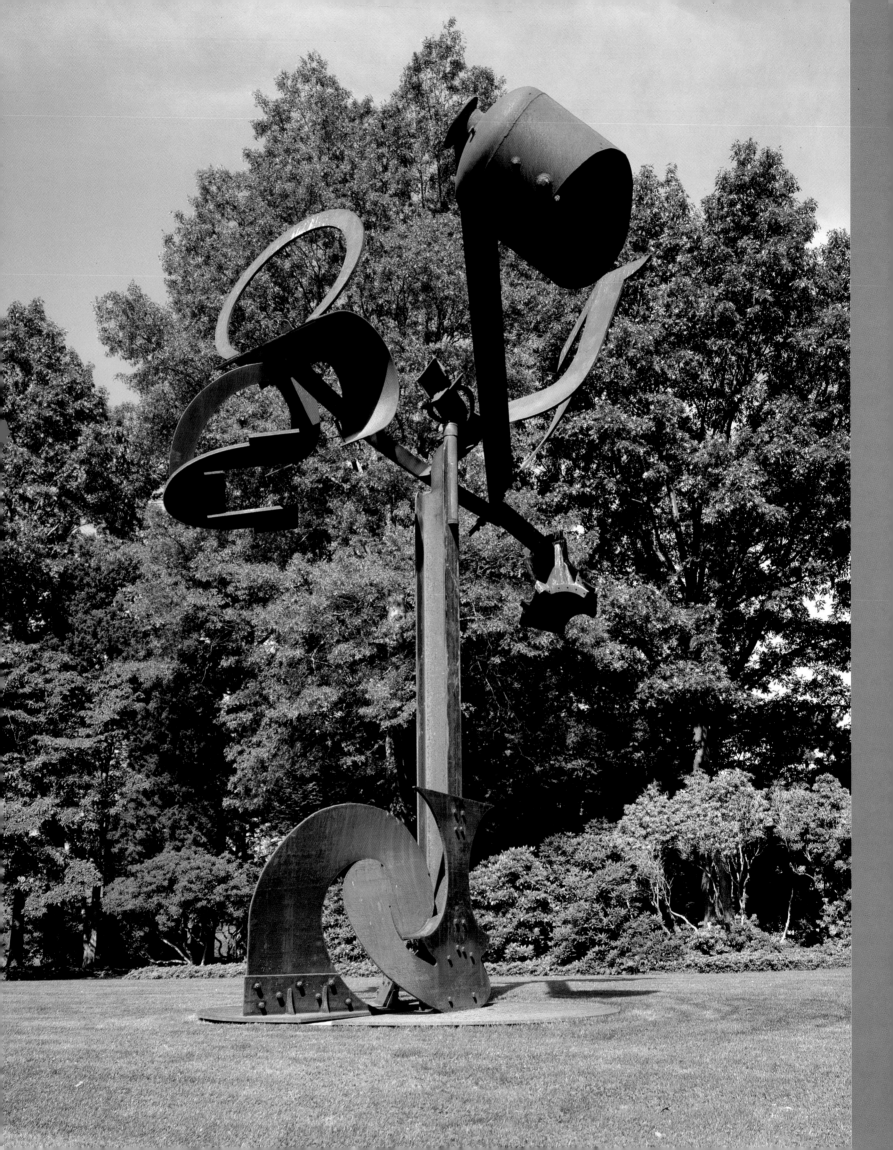

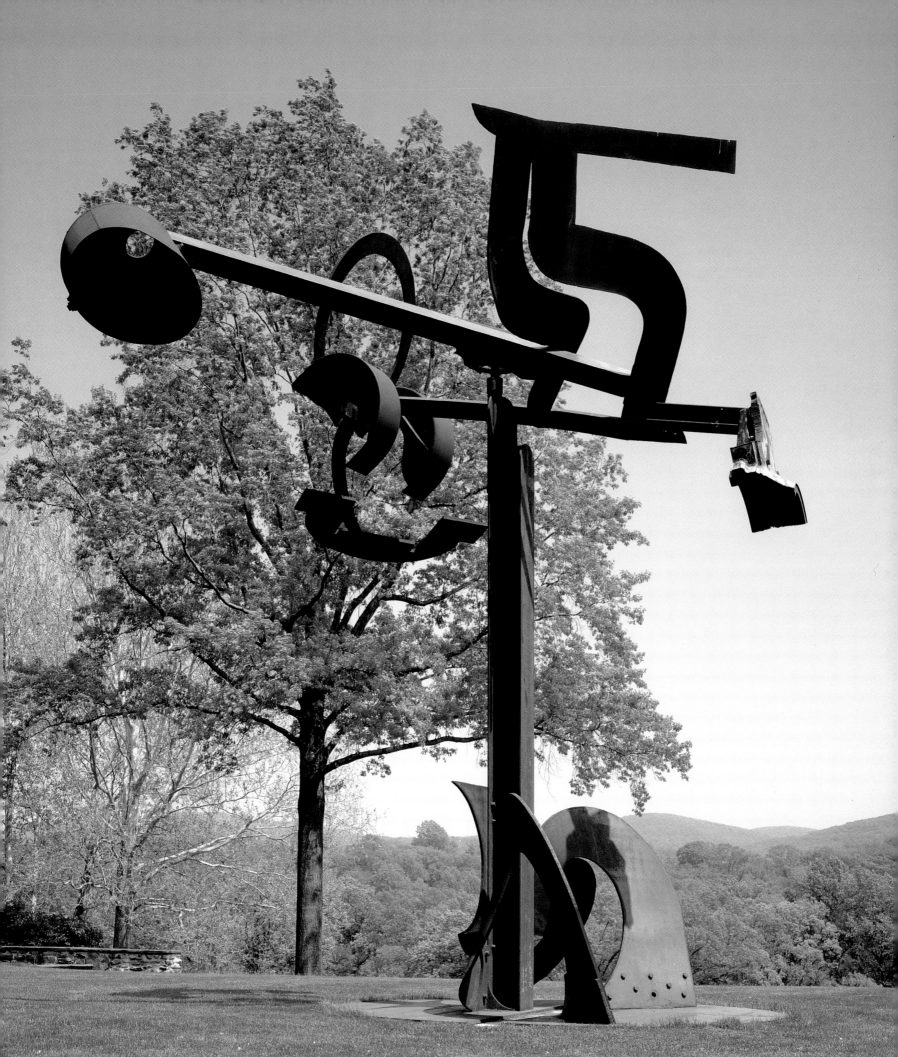

SCYTHIAN, 1978–95, has an immense top element
of found and cut-out steel forms, weighing 7,000 lbs.,
subtly balanced atop a slender I-beam column.

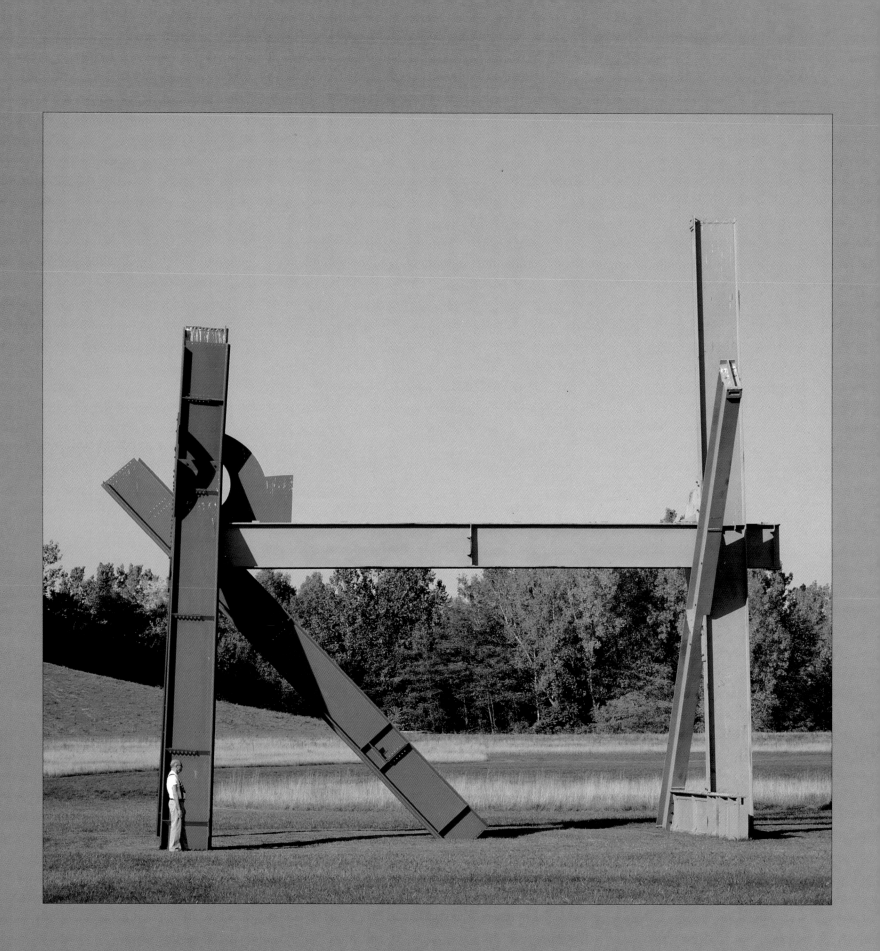

A combination of vertical and horizontal girders
animates OLD BUDDY (FOR ROSKO), 1993–95,
inspired by the memory of di Suvero's beloved dog.

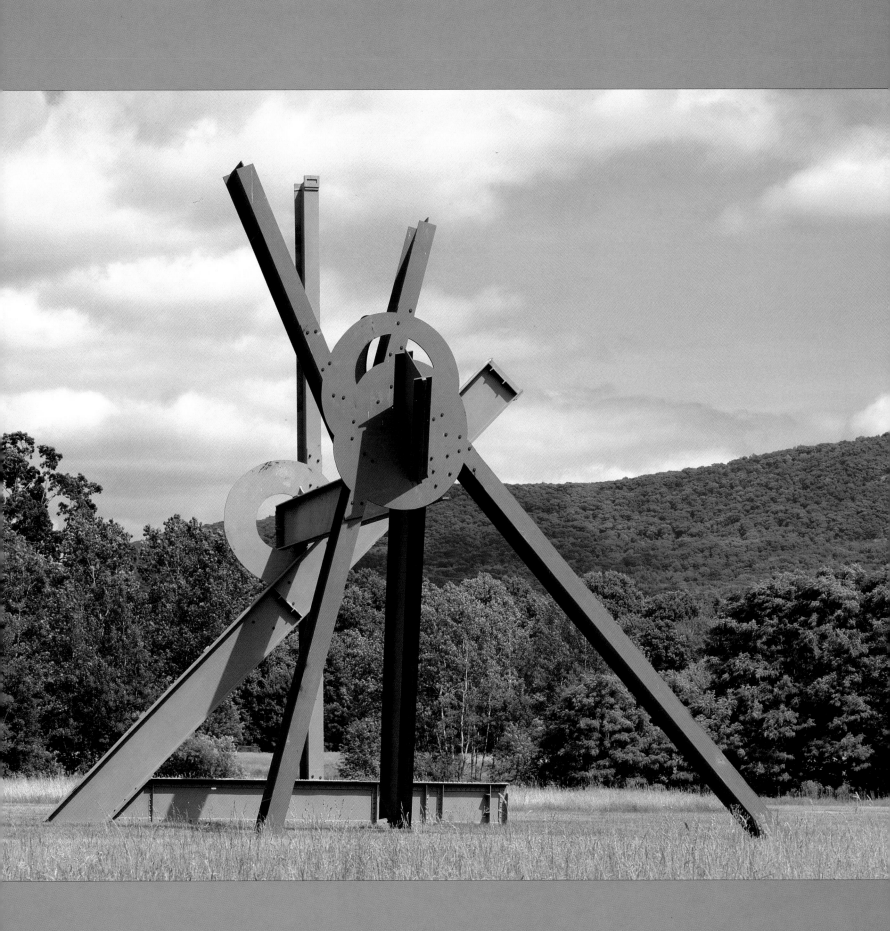

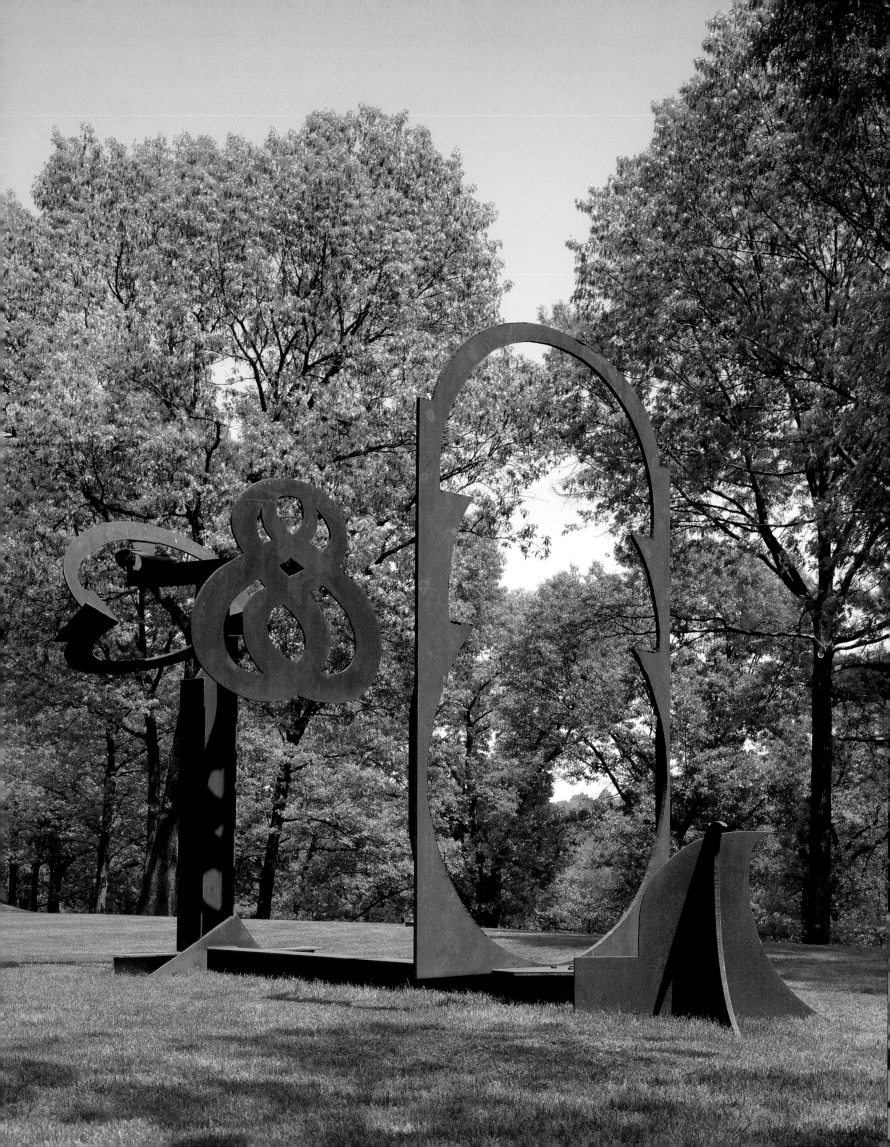

Storm King Art Center provides a leafy setting for OAXACA, 1992.

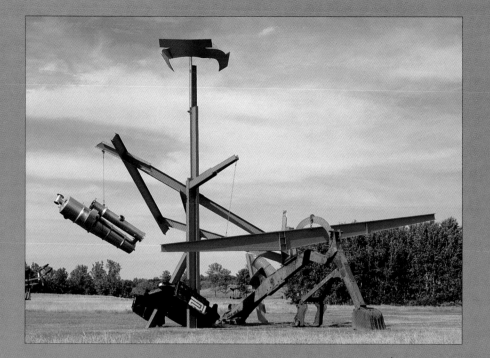

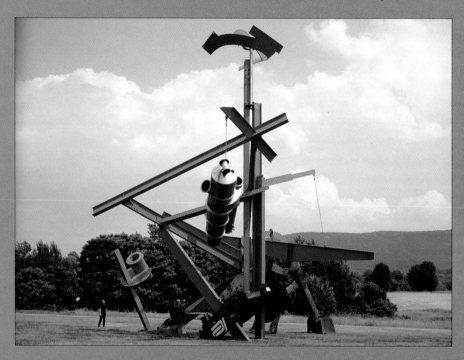

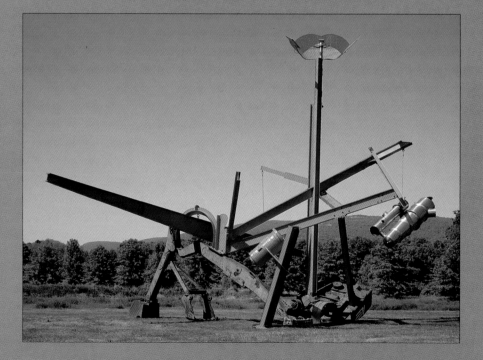

The thrusting red I-beams of BEPPE, 1978–95, sit on a mass of rusted machine parts while supporting a large triangular form and a stainless steel tank that is seemingly suspended in the air.

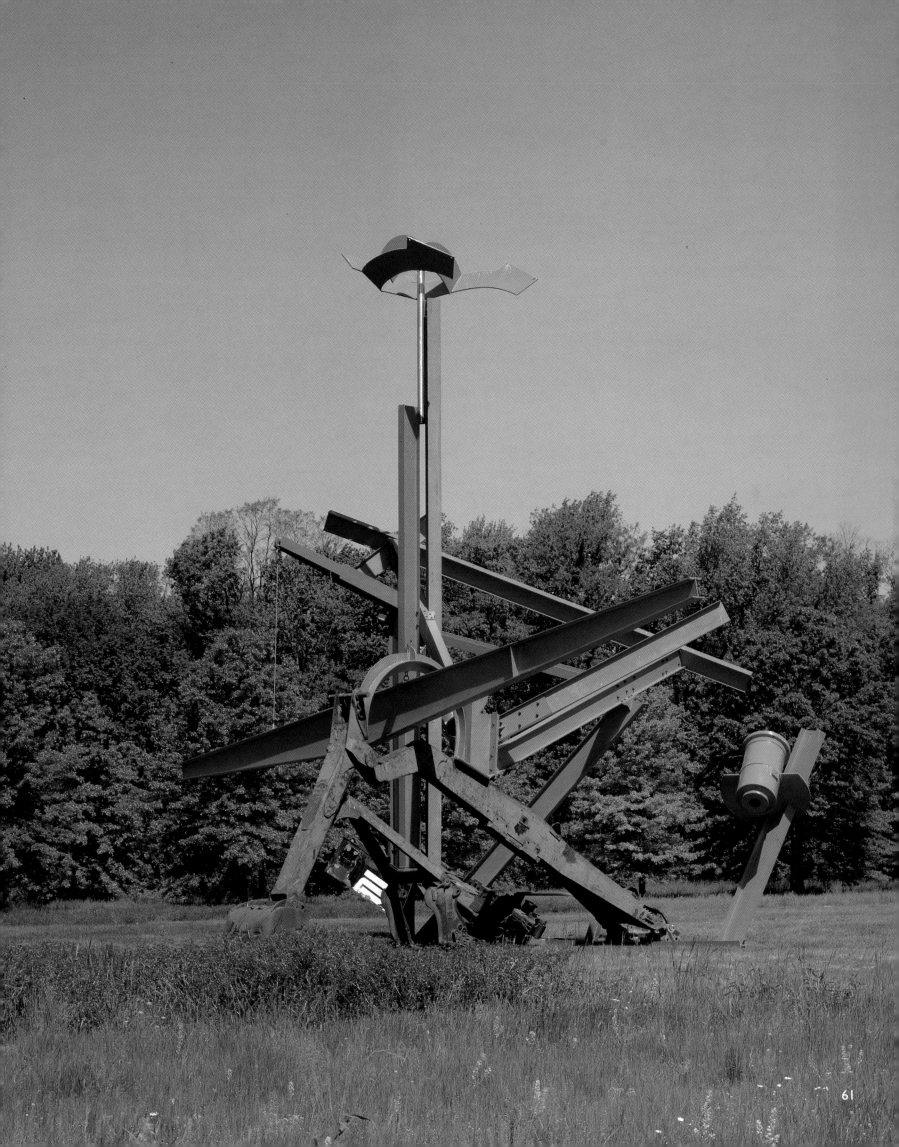

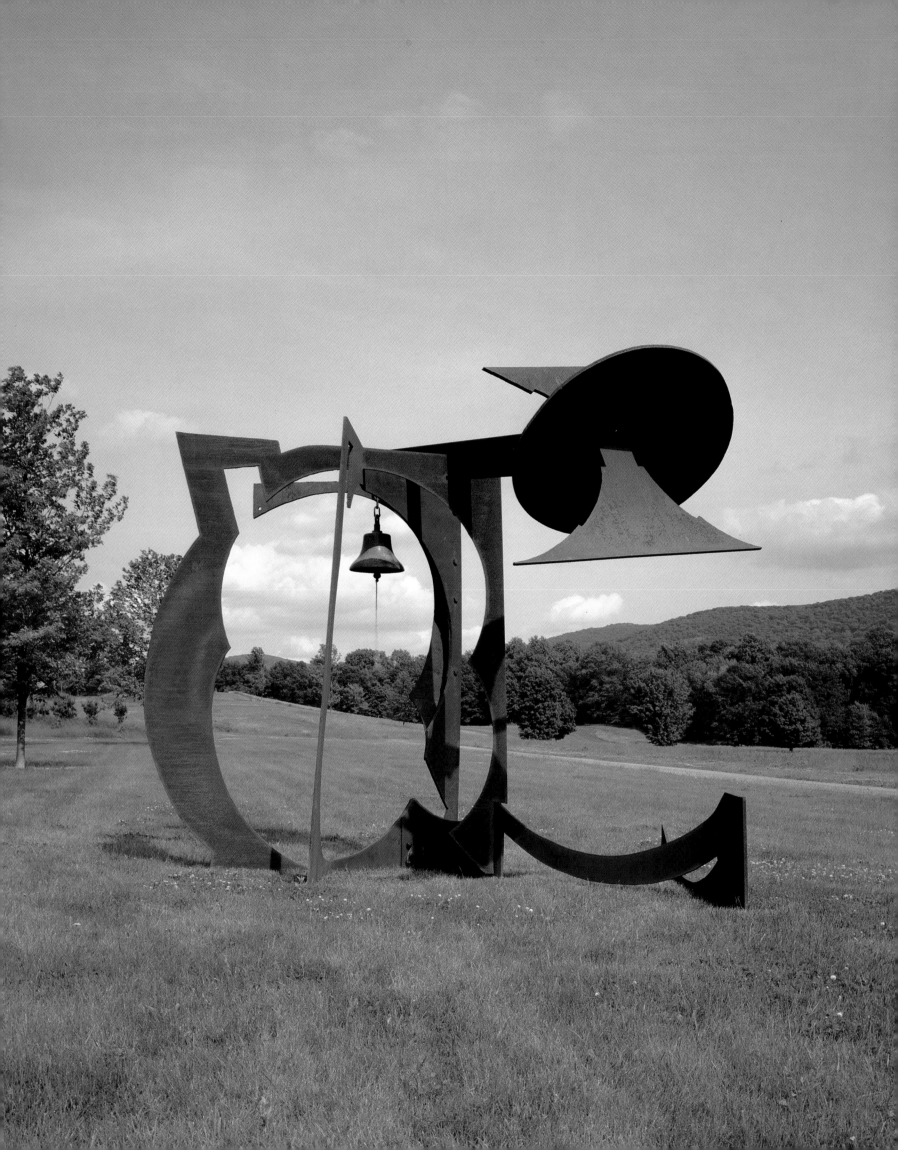

In FOR CHRIS, 1991, the bell,
situated in the portal,
is the only moving element.

63

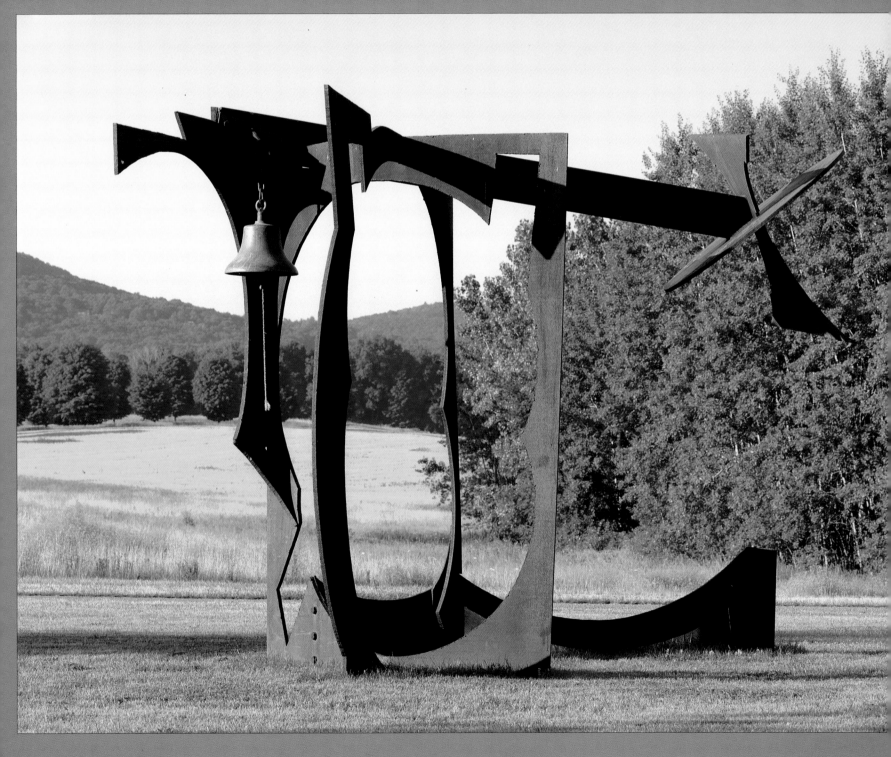

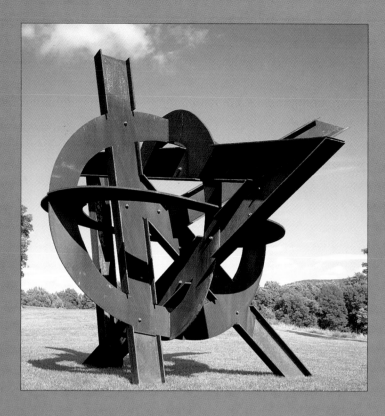

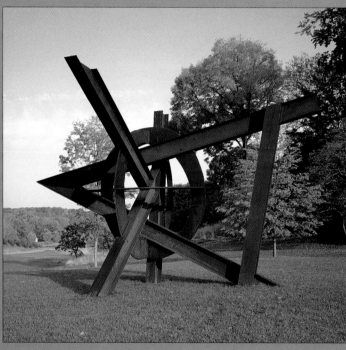

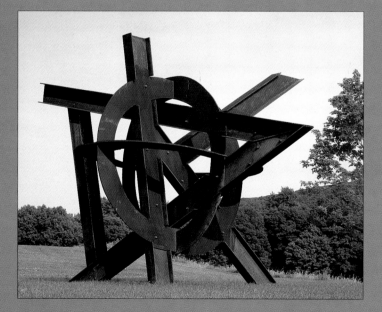

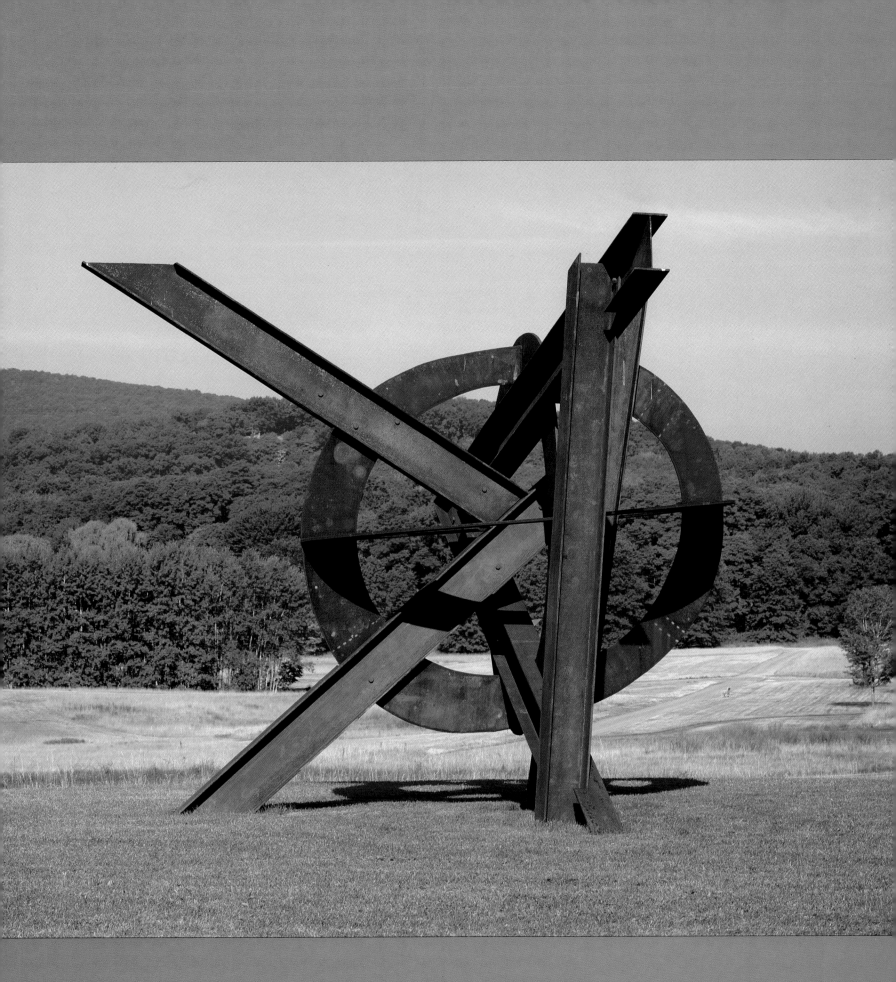

AURORA, 1992–93, is an intricate gyroscope of fixed shapes . . .
that offers breathtaking horizons from every vantage point.
—Kathi Norklun. Woodstock Times, September 7, 1995.

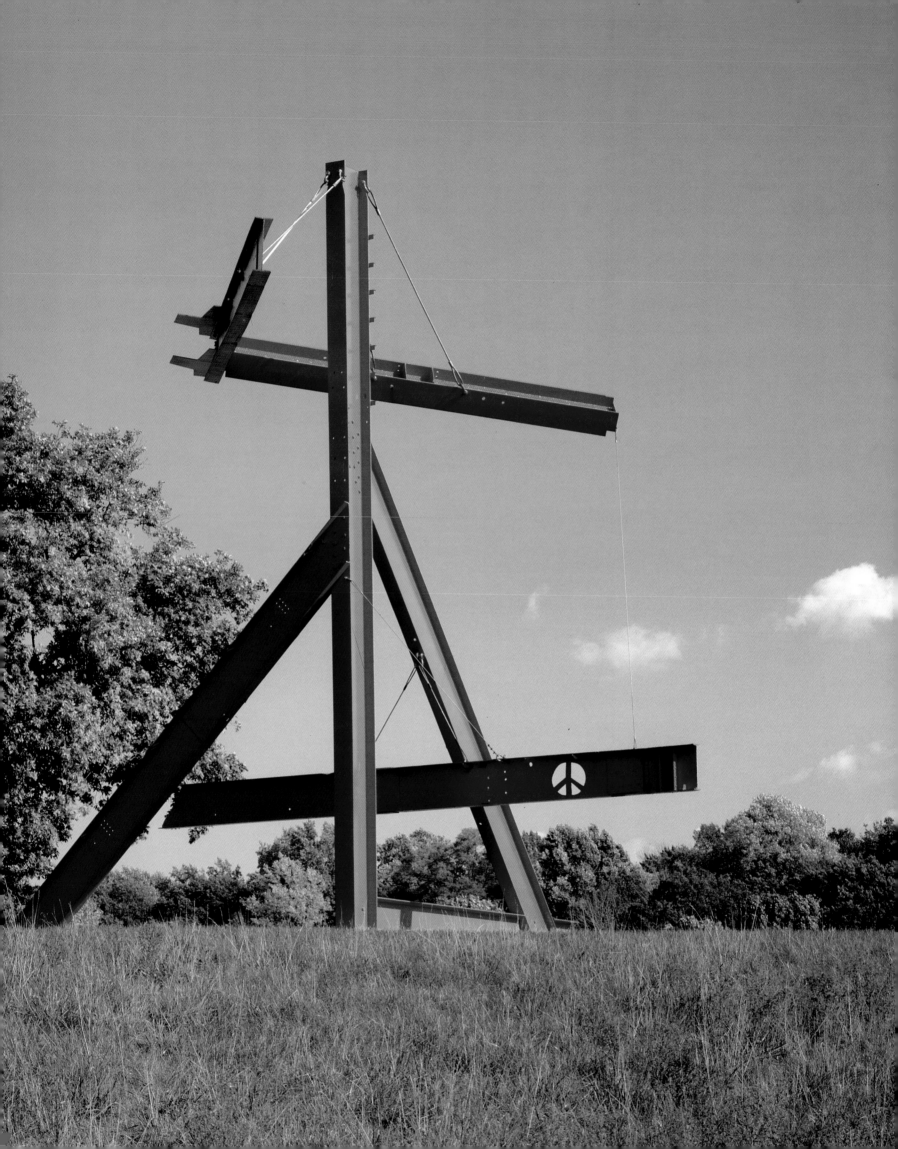

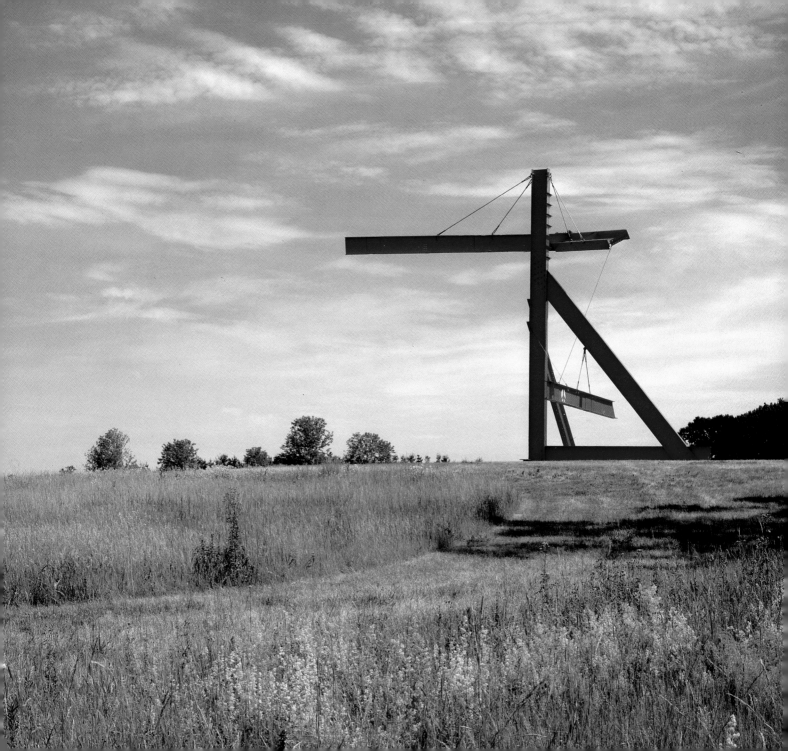

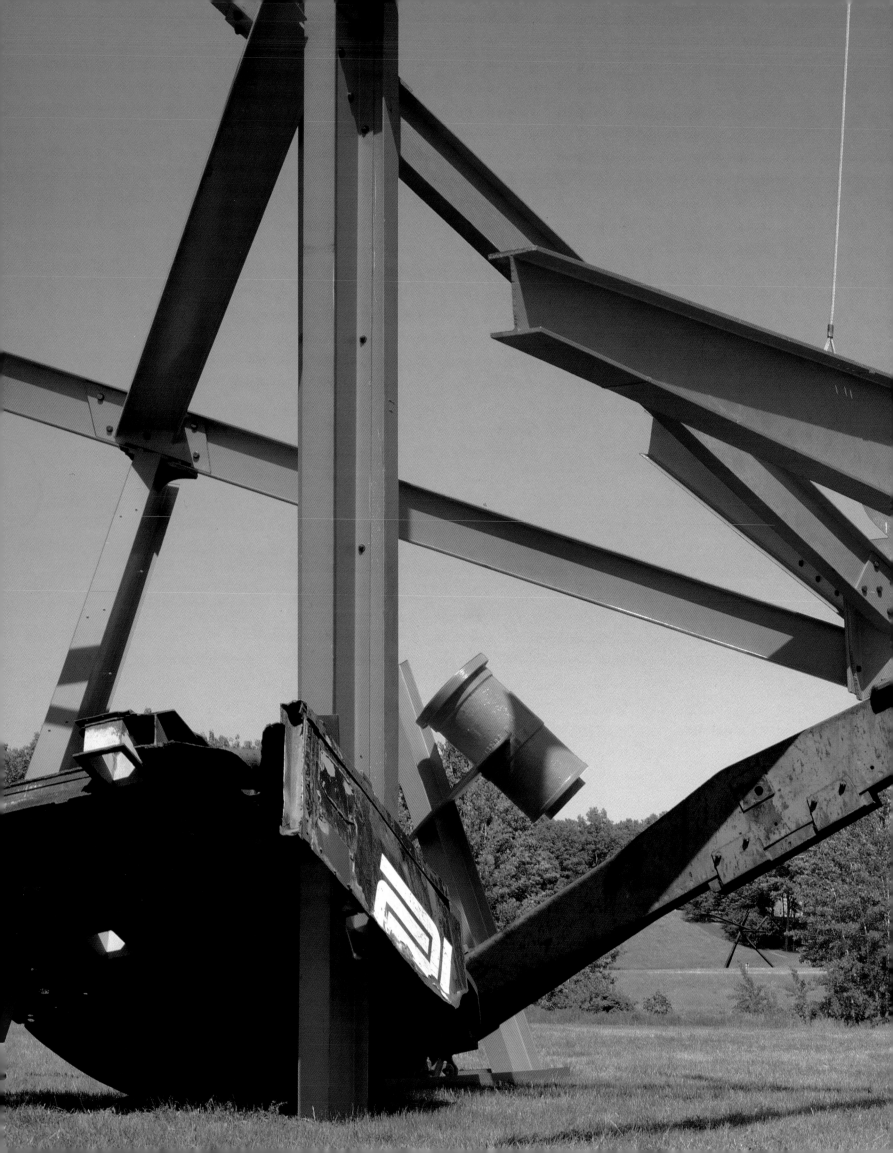

BEPPE, 1978–95

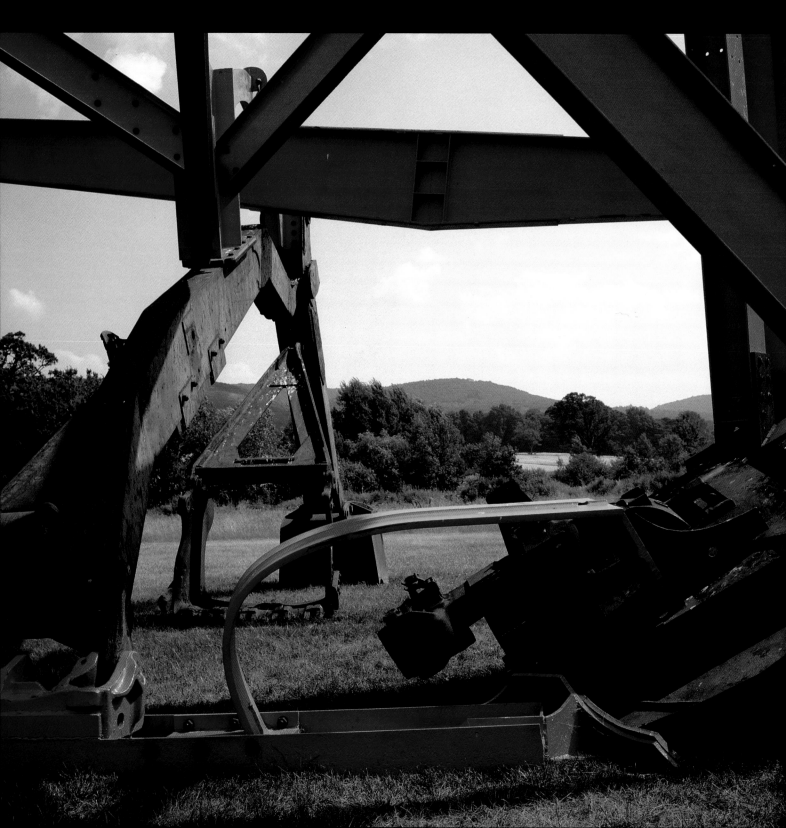

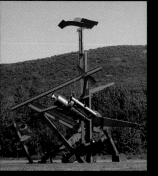

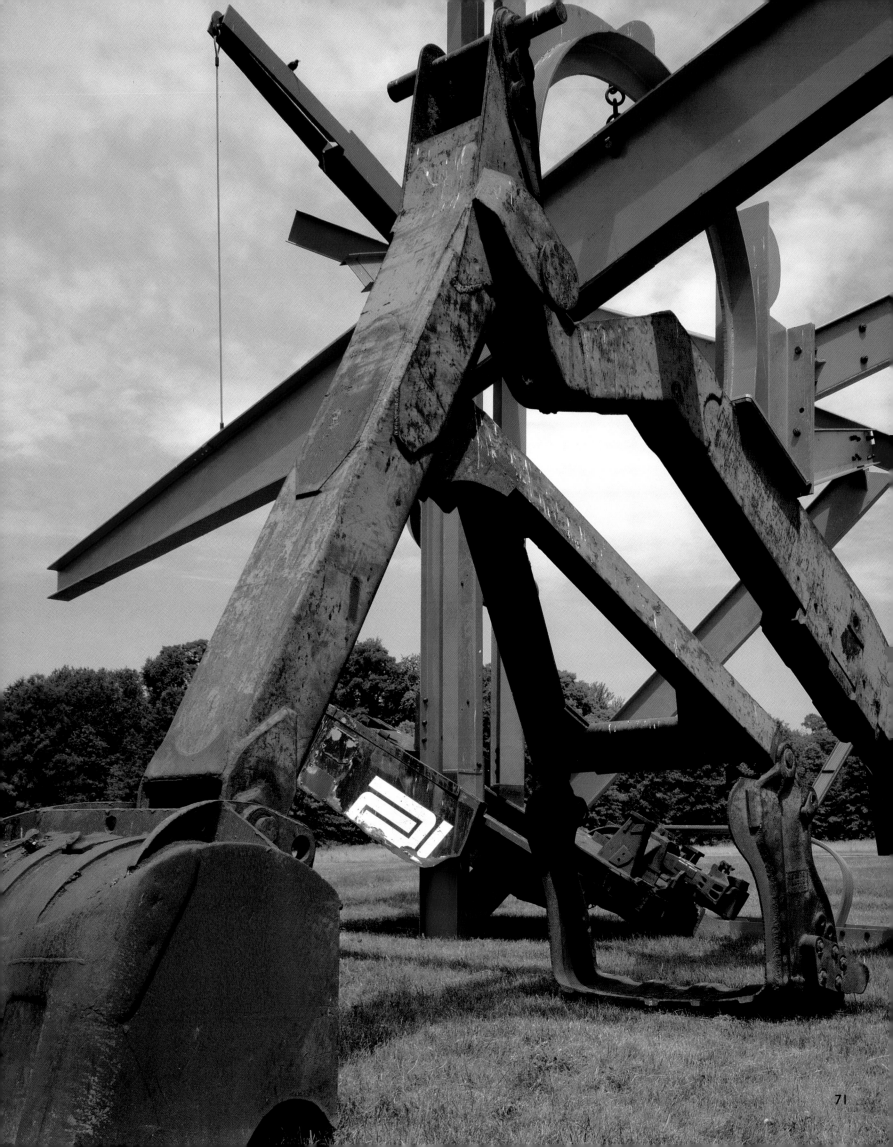

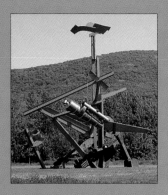

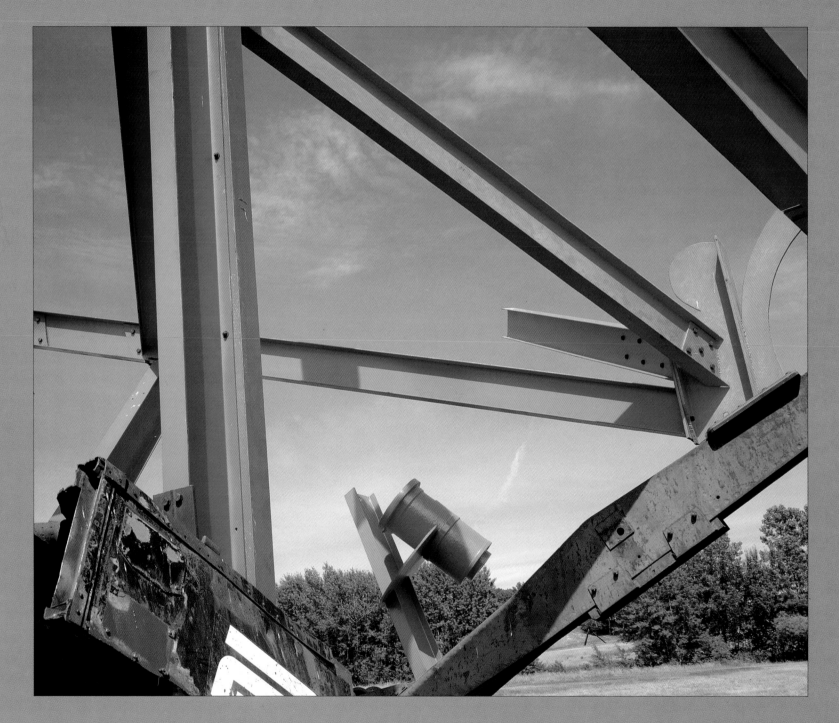

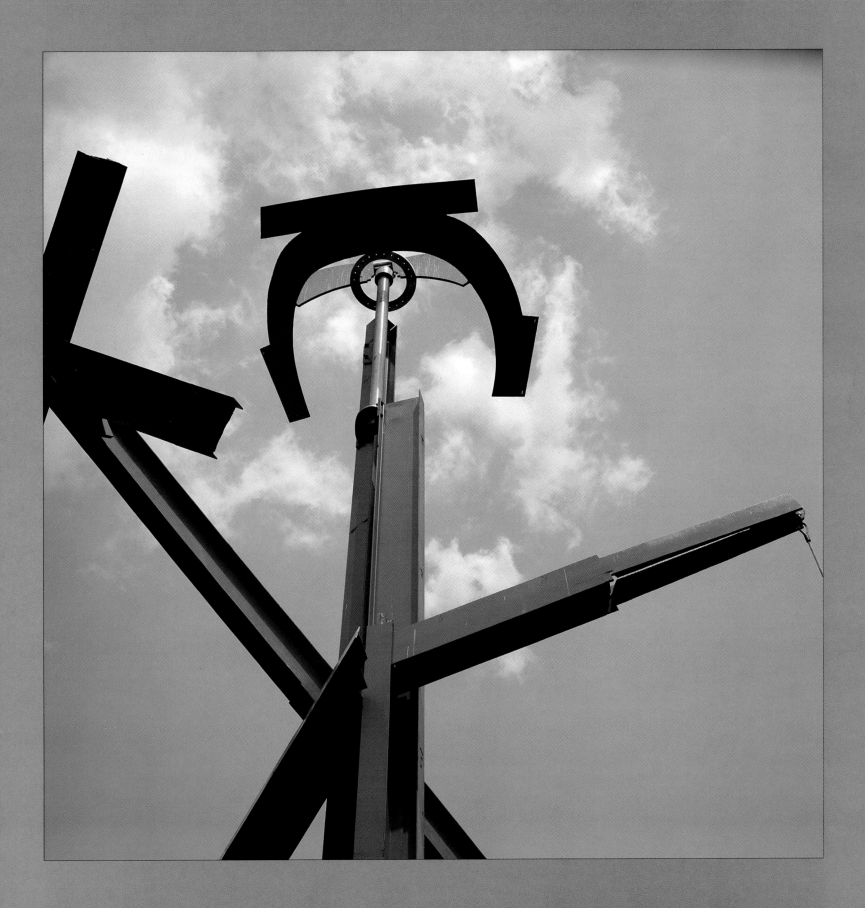

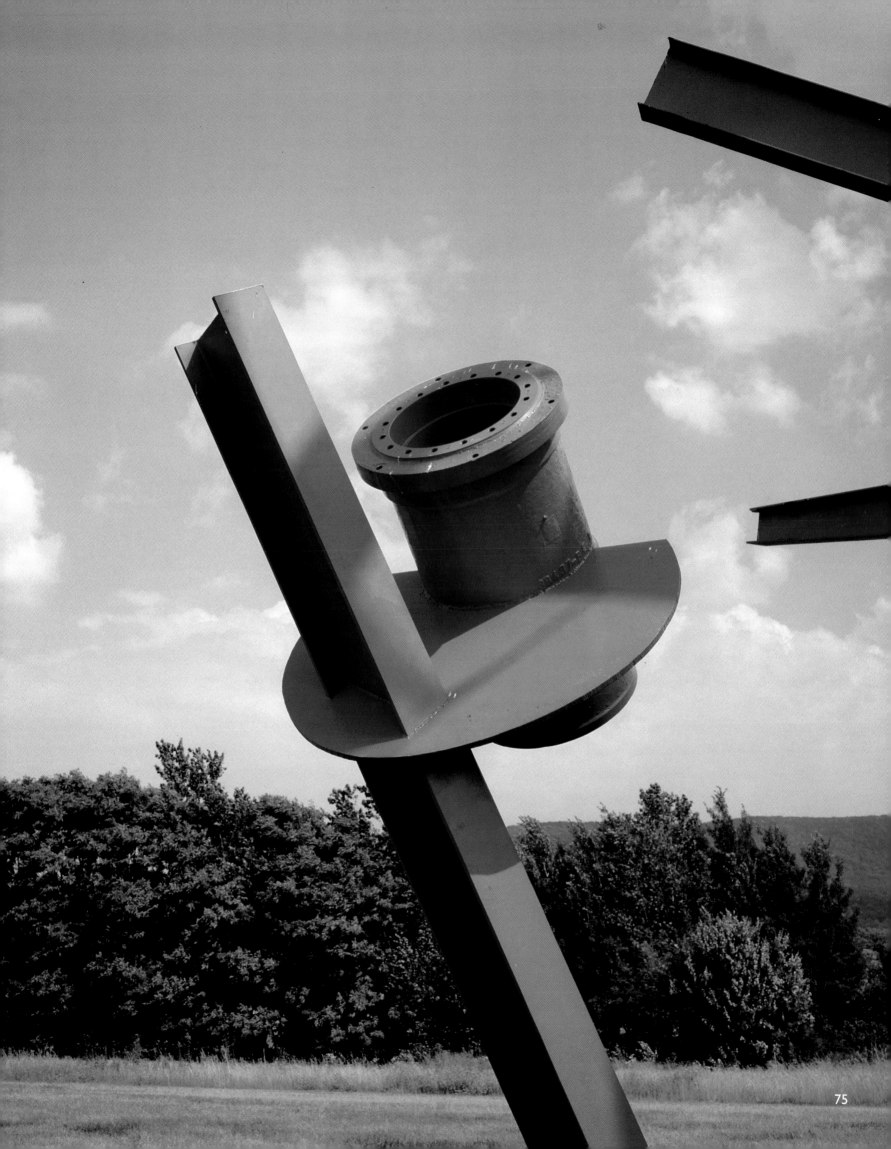

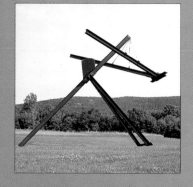

MON PÈRE, MON PÈRE, 1973–75; "The points where the I-beams touch down have to be riveted into place, held by subterranean plugs that keep the work from digging or speading."
—Kathi Norklun. Woodstock Times, September 7, 1995.

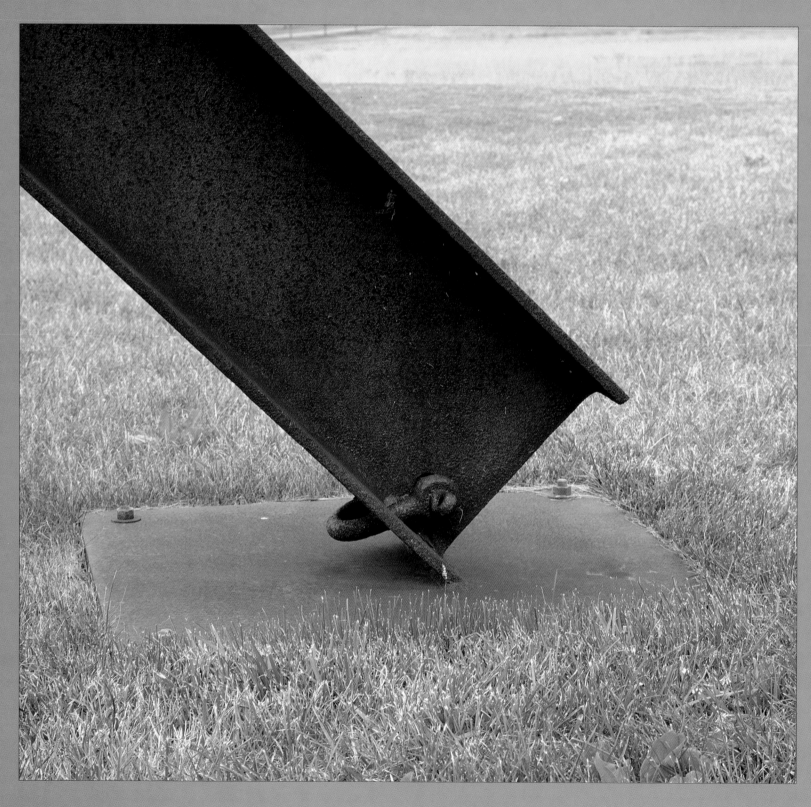

The lyrical moving element of the top
echoes the rigid base of SCYTHIAN, 1978–95.

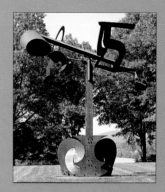

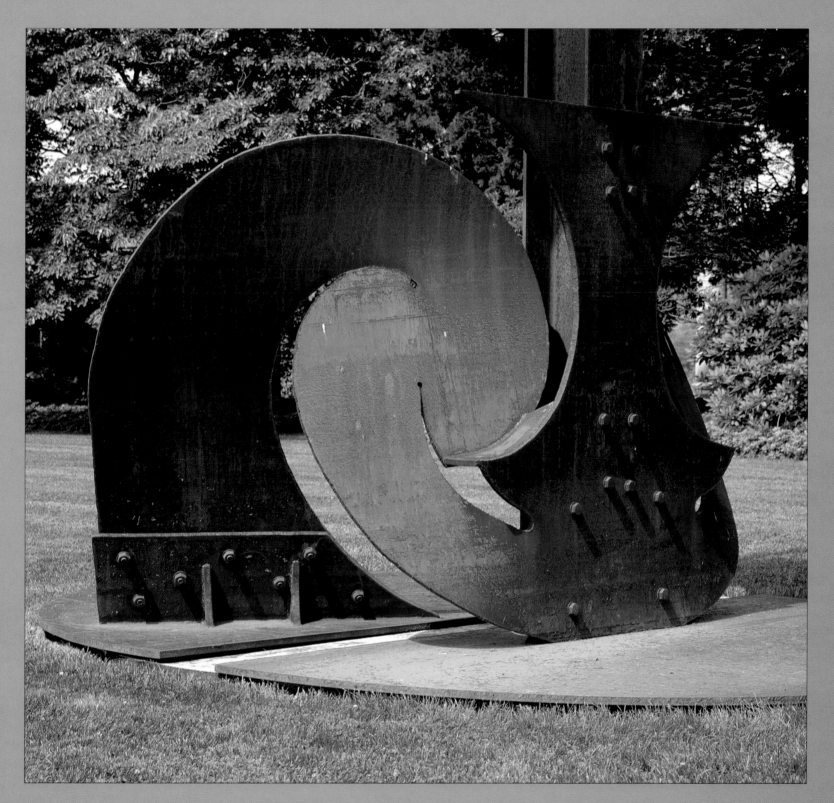

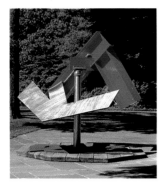

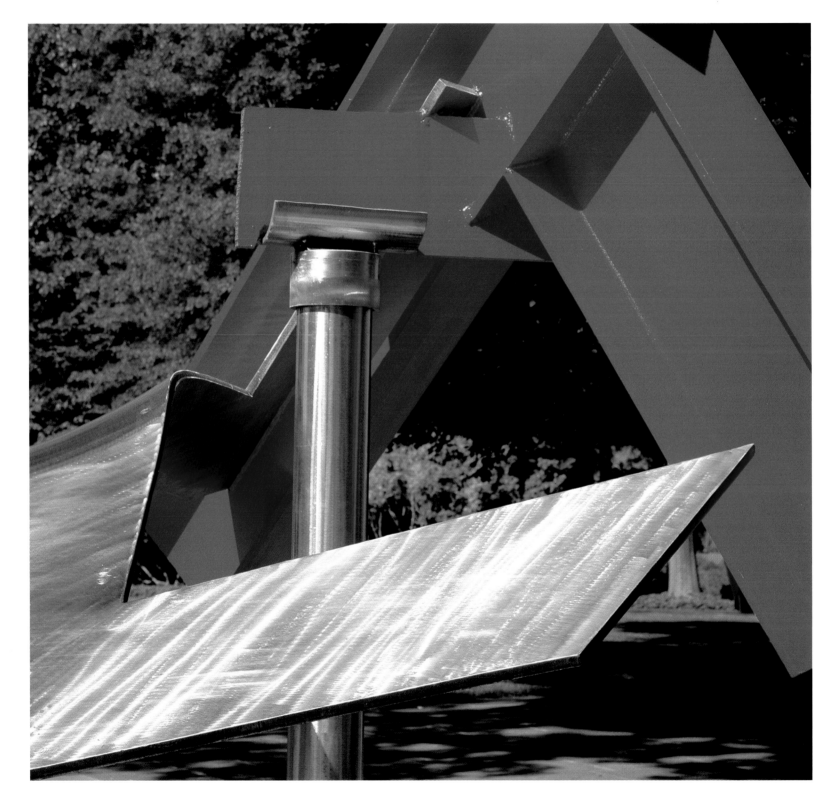

"SQUARE ROOT OF TWO, 1994, consists
of an angle of red I-beams
pointing upward, one of whose arms
is pierced by a contrasting
stainless-steel arrow swooping downward.
Both elements pivot
on a stainless-steel column
whose base is a cutout steel plate."
—Irving Sandler.

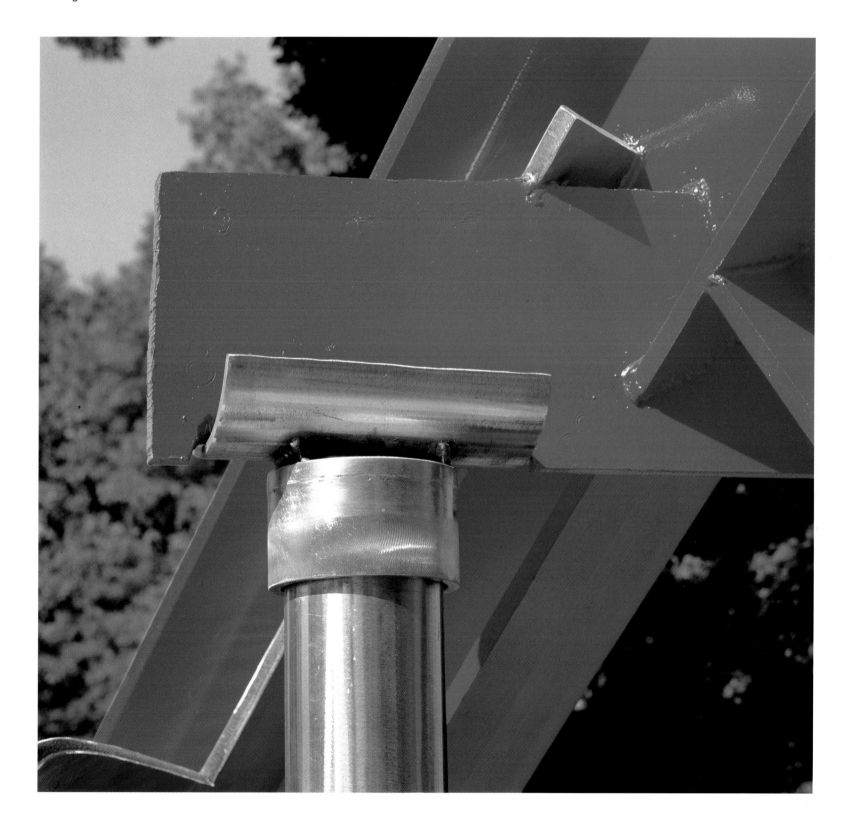

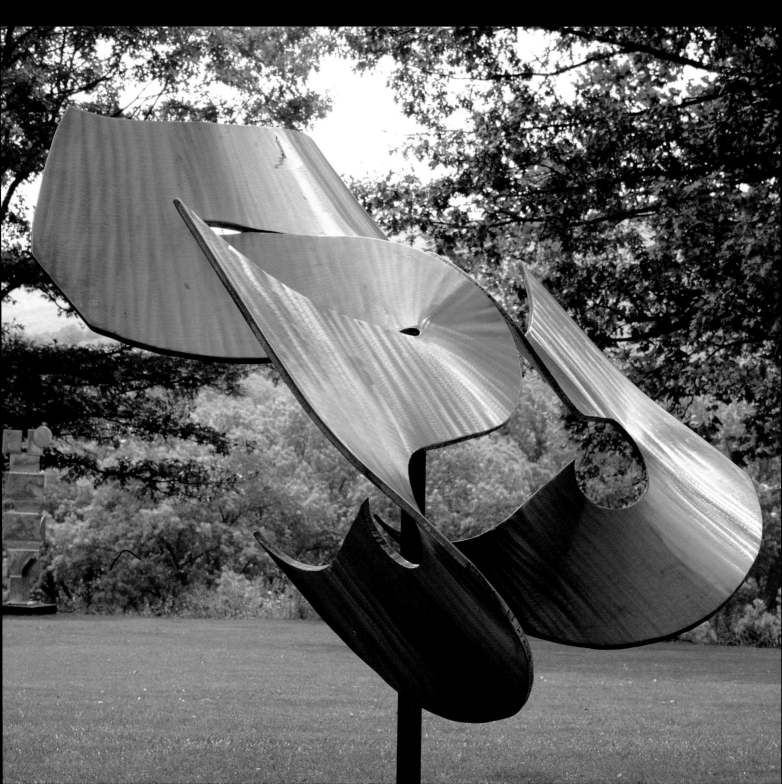

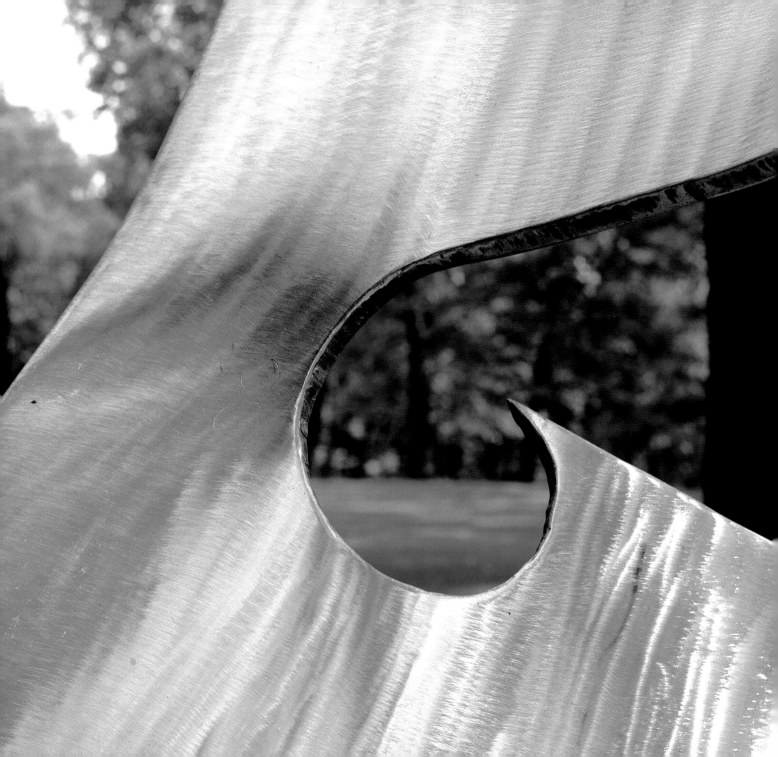

MOTHER PEACE, 1969–70,
*"My sculpture is painting
in three dimensions . . . "* —Mark di Suvero

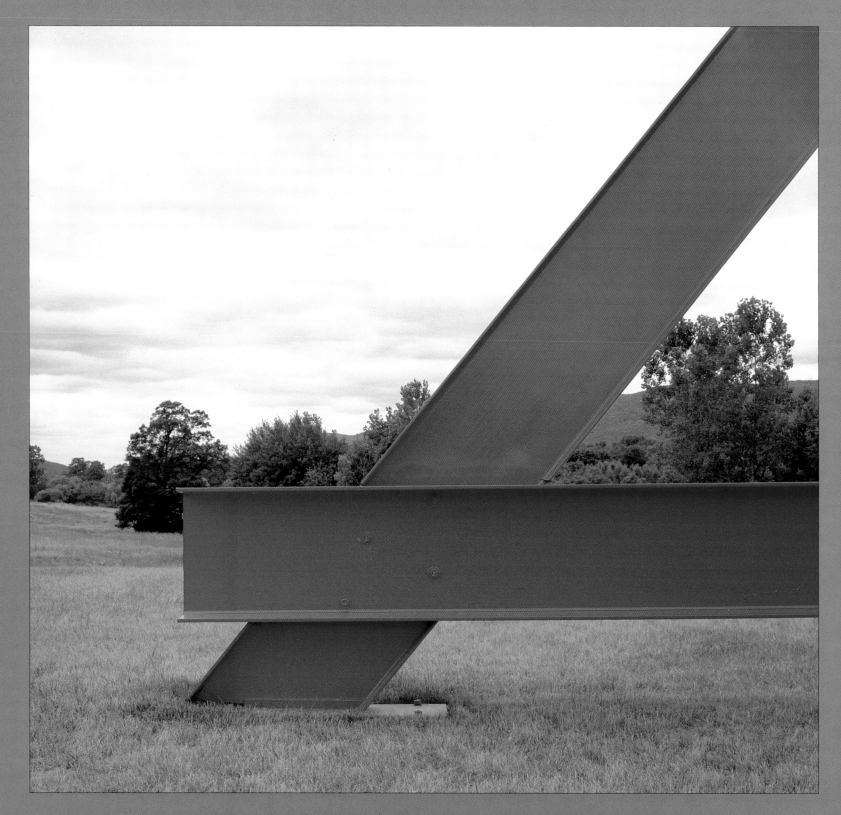

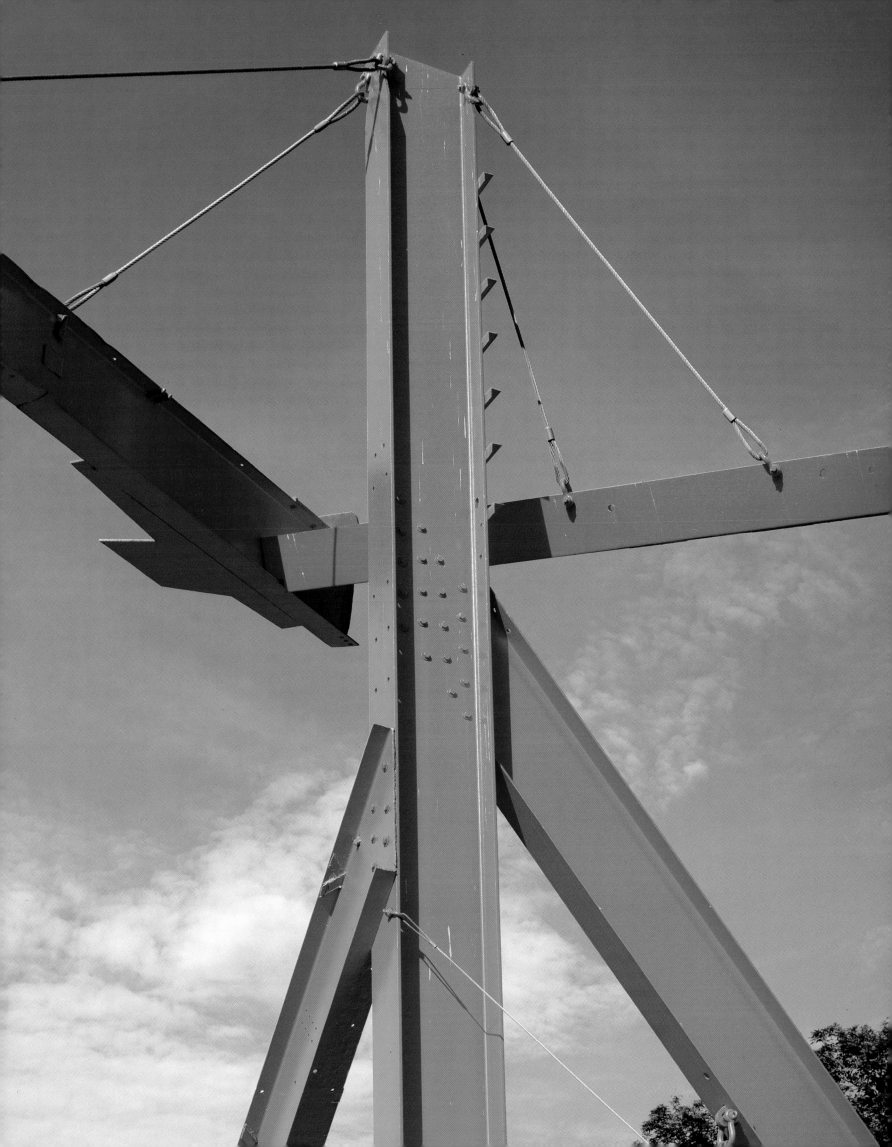

Protesting the Vietnam War,
Mark di Suvero torchcut
the ban-the-bomb symbol
into a suspended I-beam
of MOTHER PEACE, 1969–70.

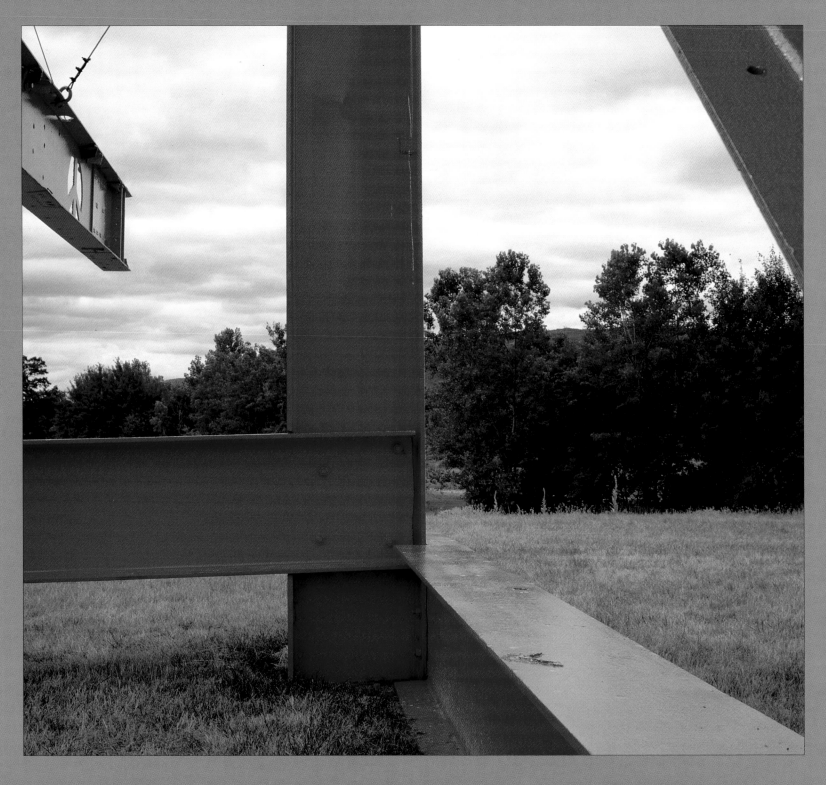

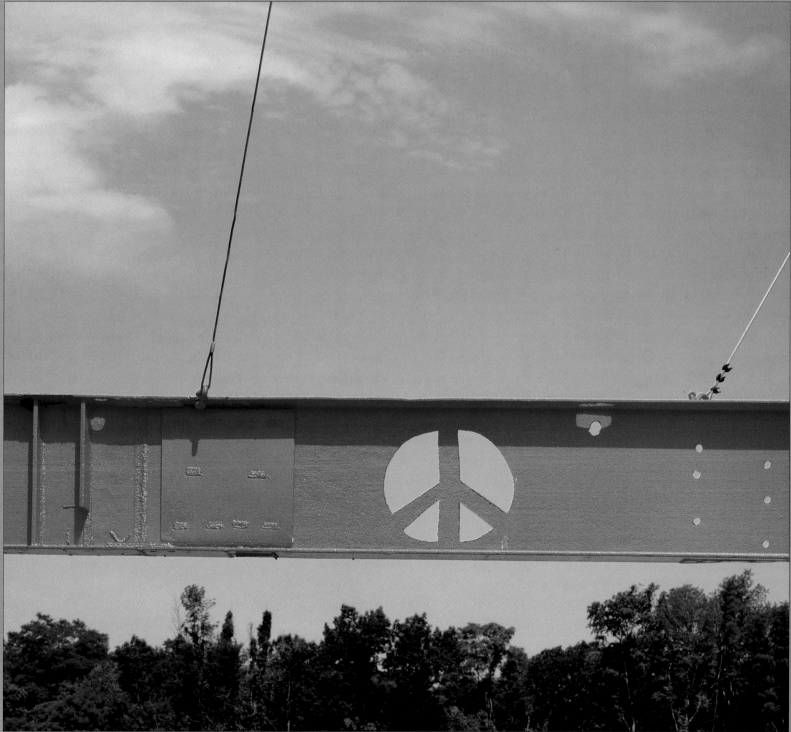

Interactions

BEPPE, 1978–95, OLD BUDDY (FOR ROSKO), 1993–95, JOHNNY APPLESEED, 1989–93, FOR CHRIS, 1991.

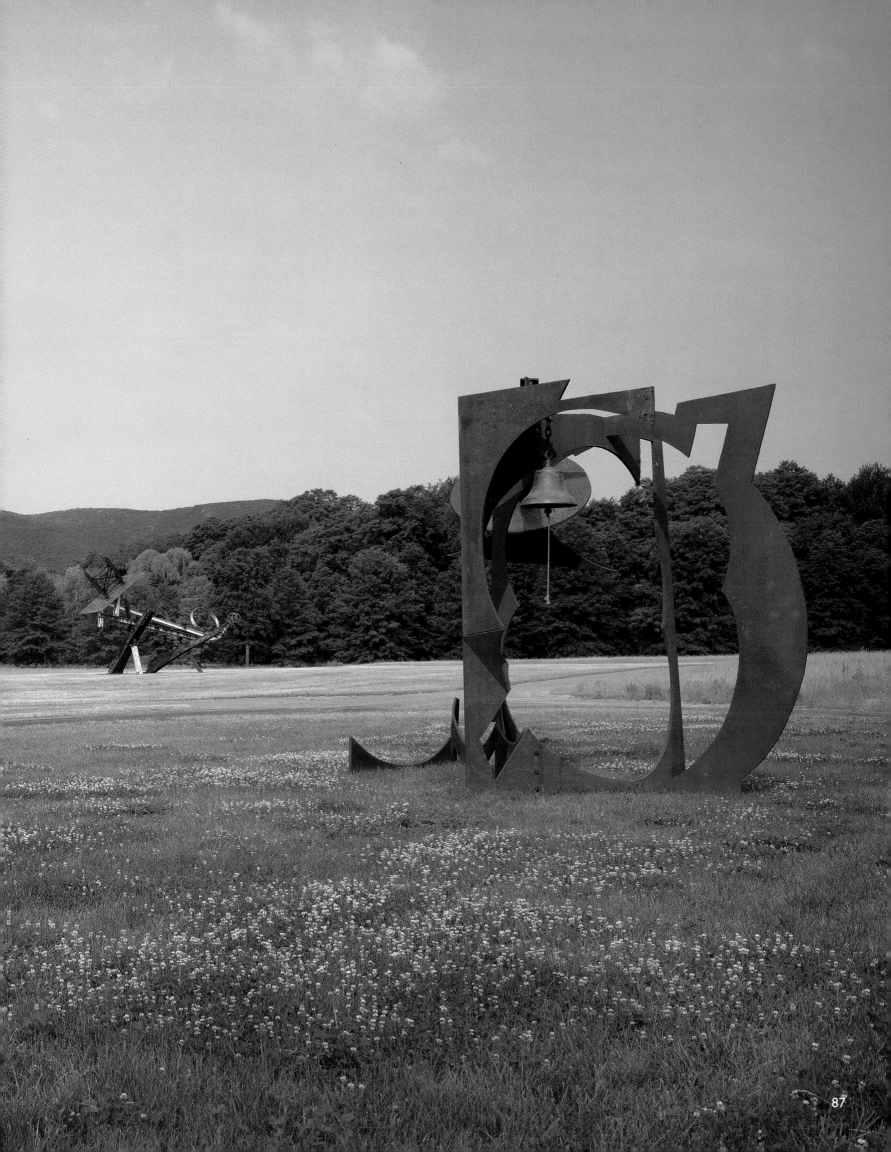

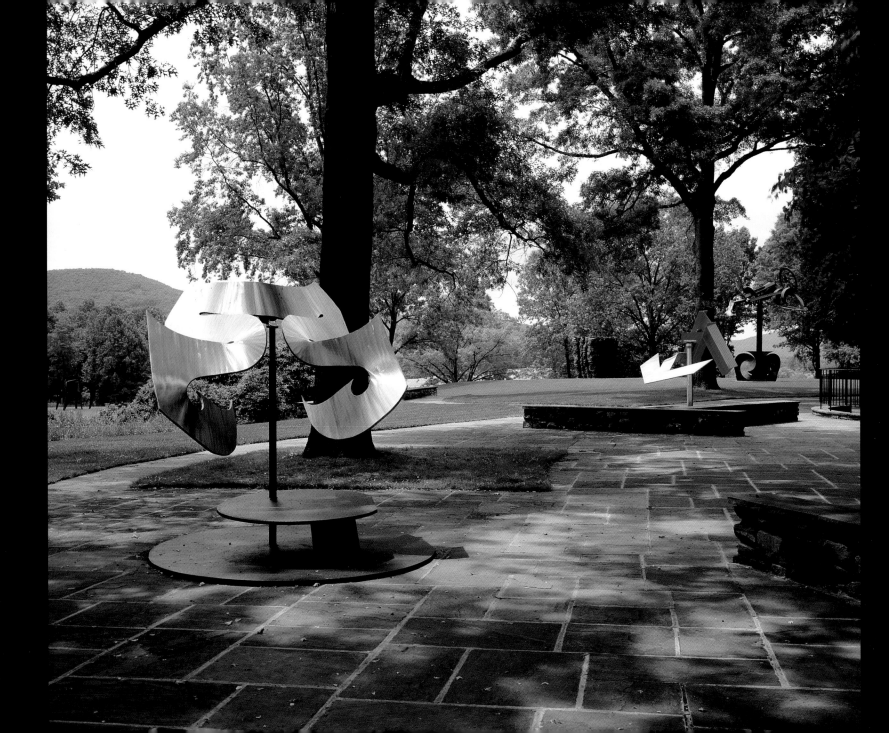

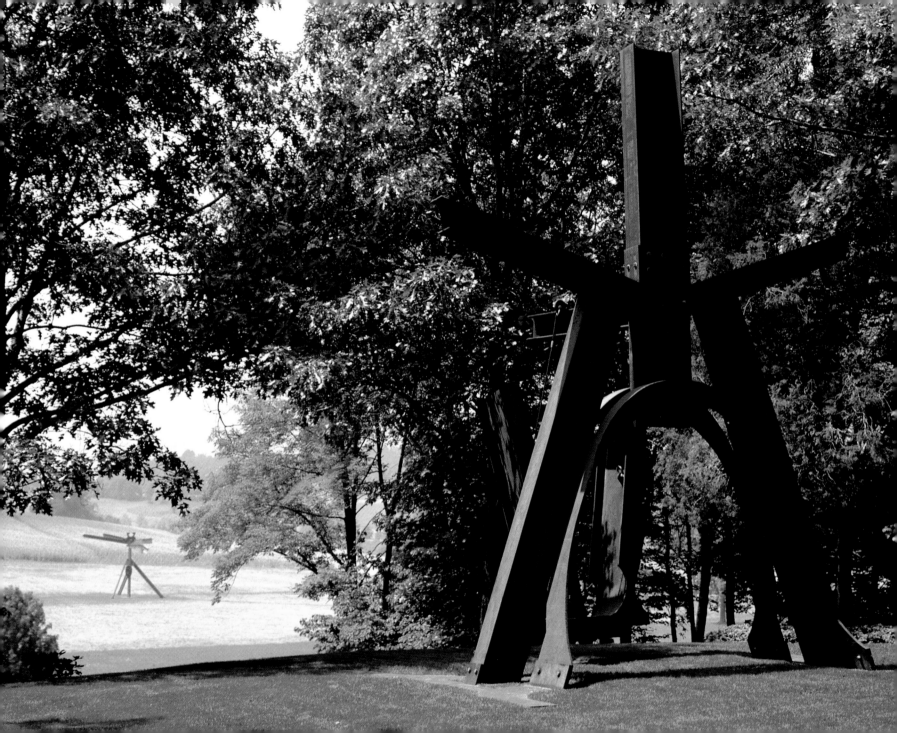

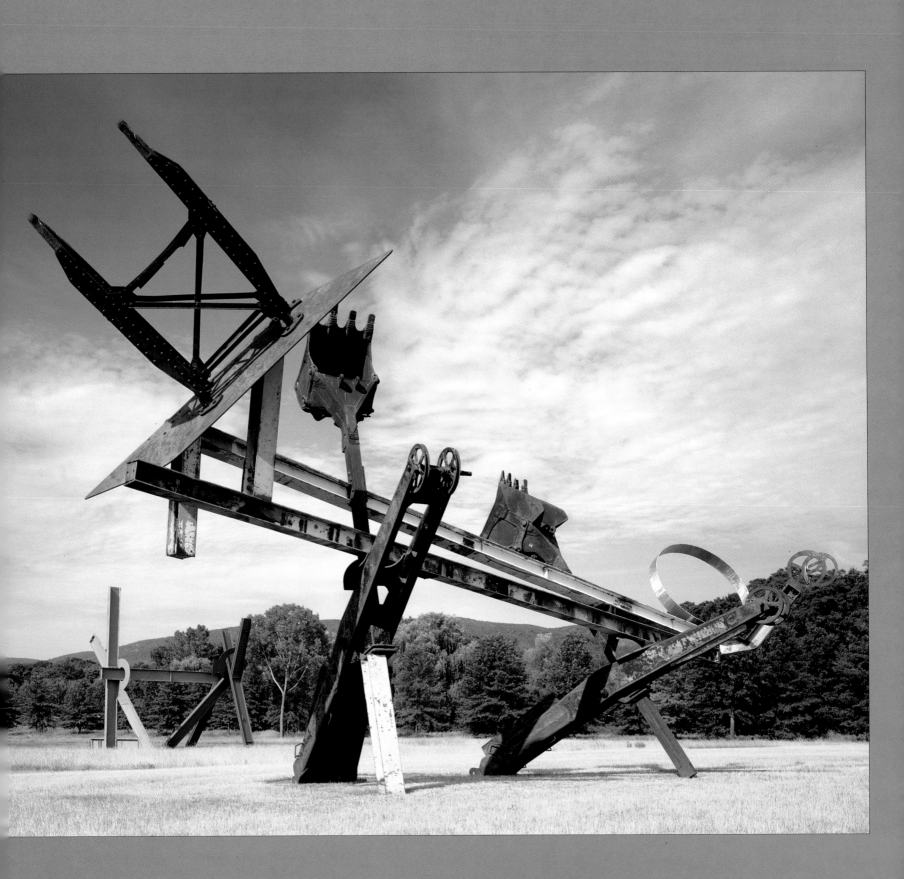

OLD BUDDY (FOR ROSKO), 1993–95, and JOHNNY APPLESEED, 1989–93.

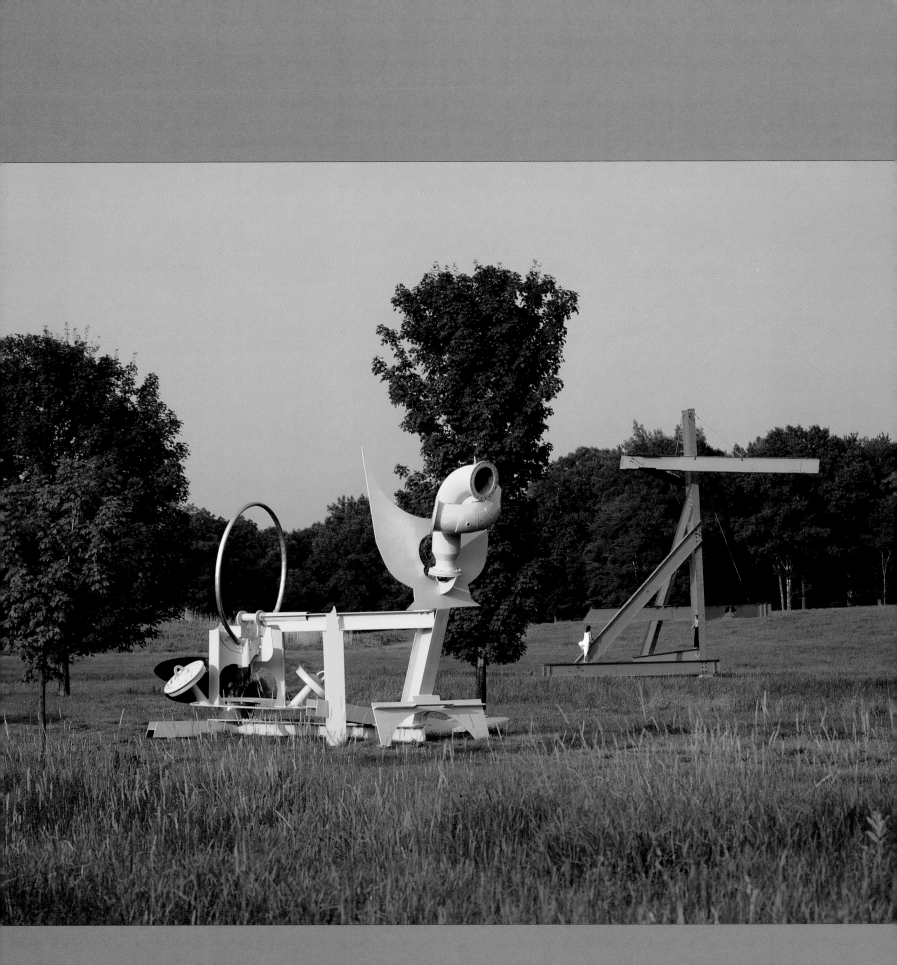

In 1985 SUNFLOWERS FOR VINCENT, 1978–83, and MOTHER PEACE, 1969–70, stood close to each other in the south meadow.

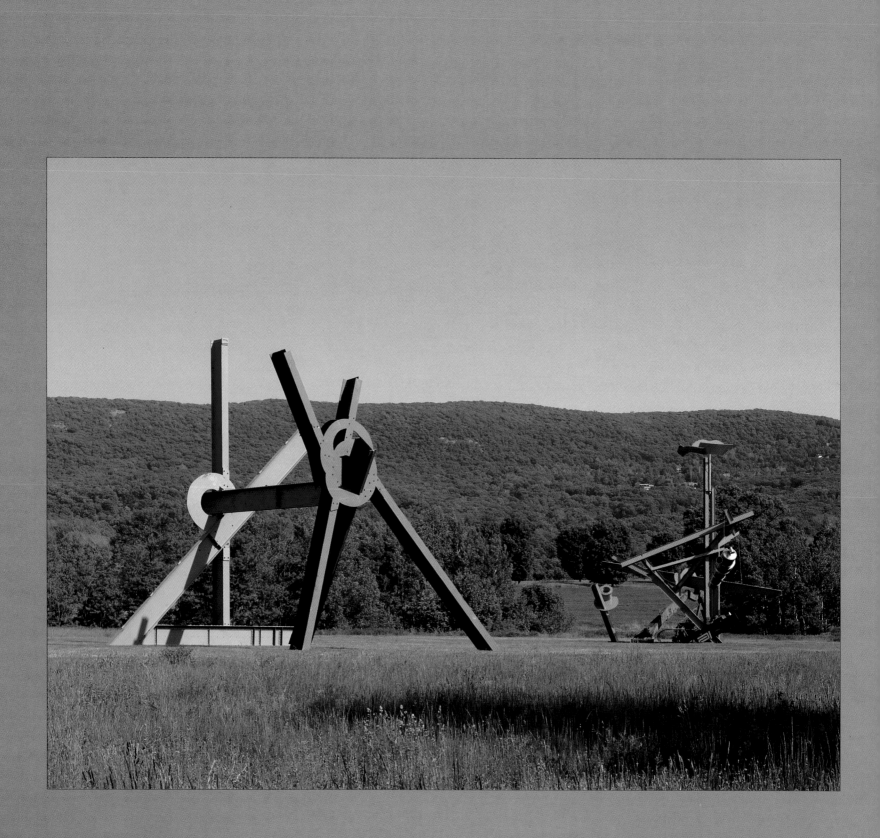

OLD BUDDY (FOR ROSKO), 1993–95, and BEPPE, 1978–95.

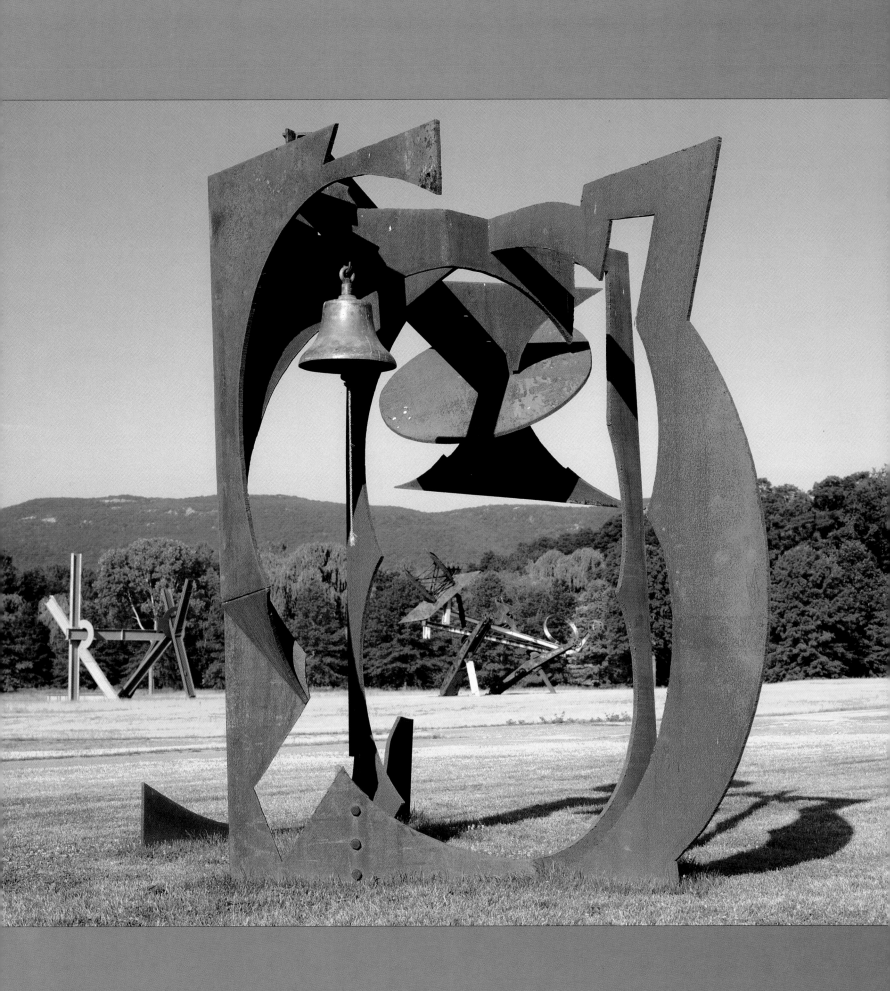

FOR CHRIS, 1991, in the foreground with OLD BUDDY (FOR ROSKO), 1993–95, and JOHNNY APPLESEED, 1989–93 beyond.

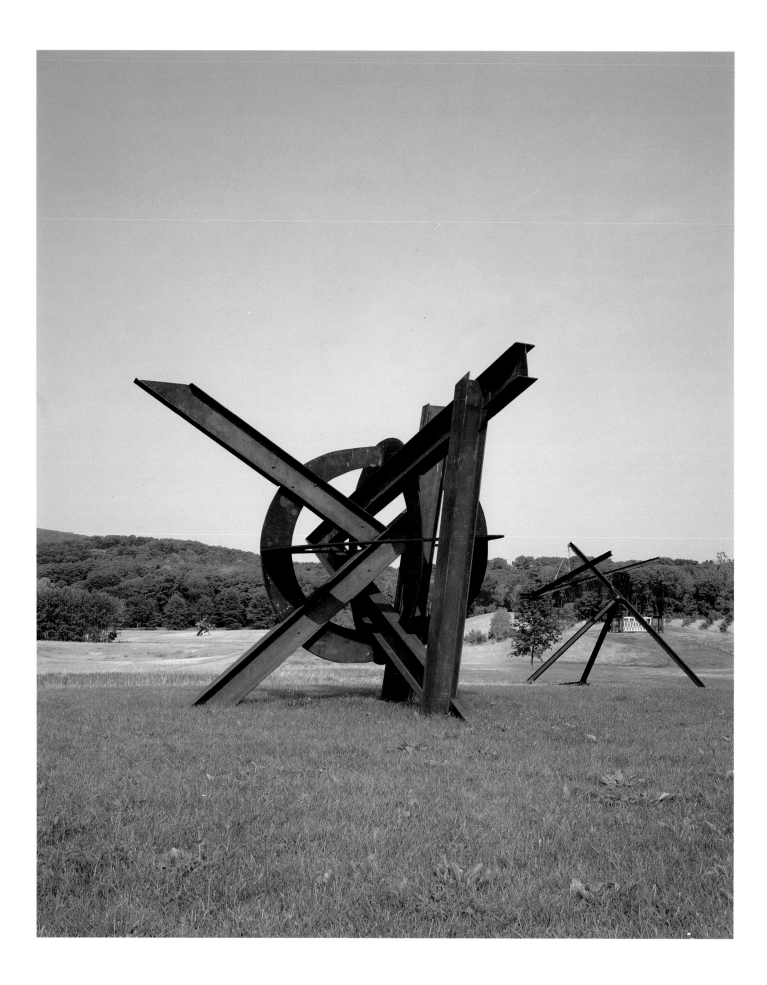

Left: AURORA, 1992–93, and MON PÈRE, MON PÈRE, 1973–75.
Right: BYGONES, 1976, with MAHATMA, 1978–79, in the distance as exhibited in 1985.

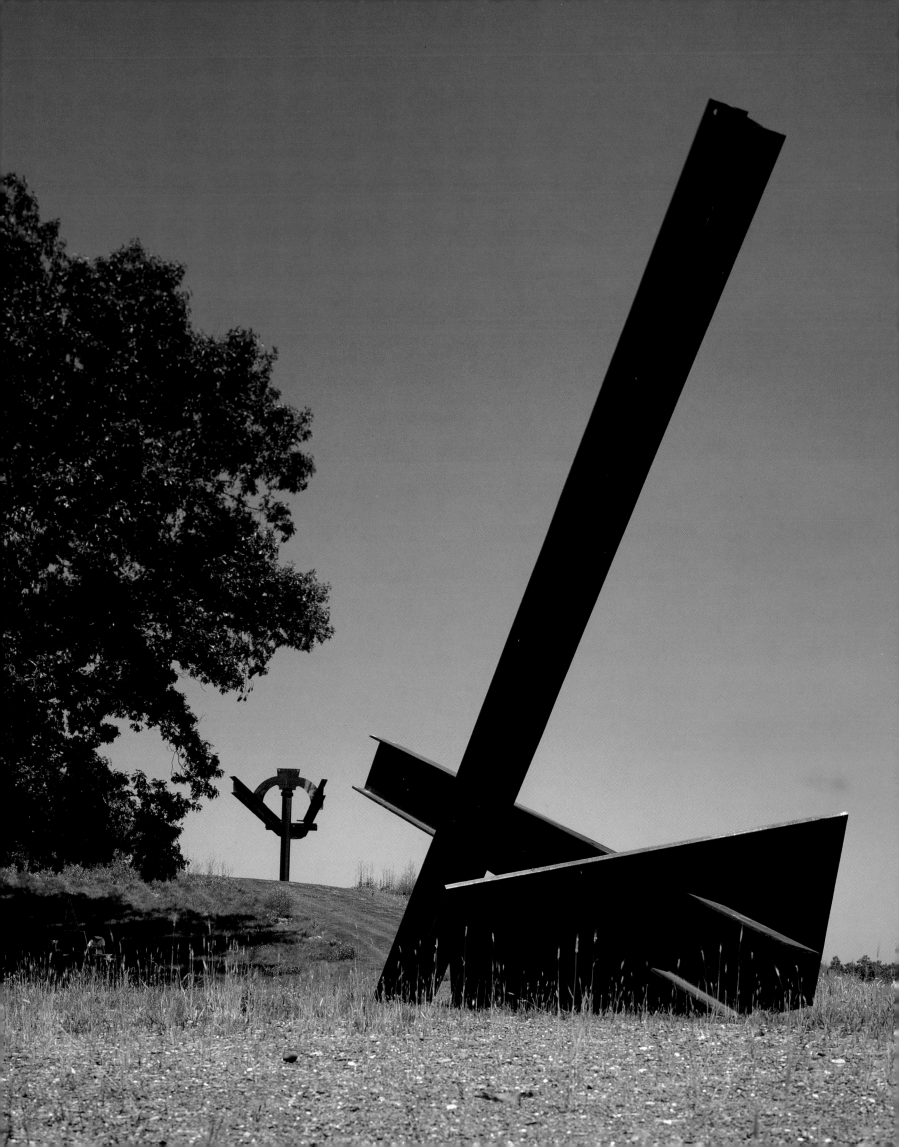

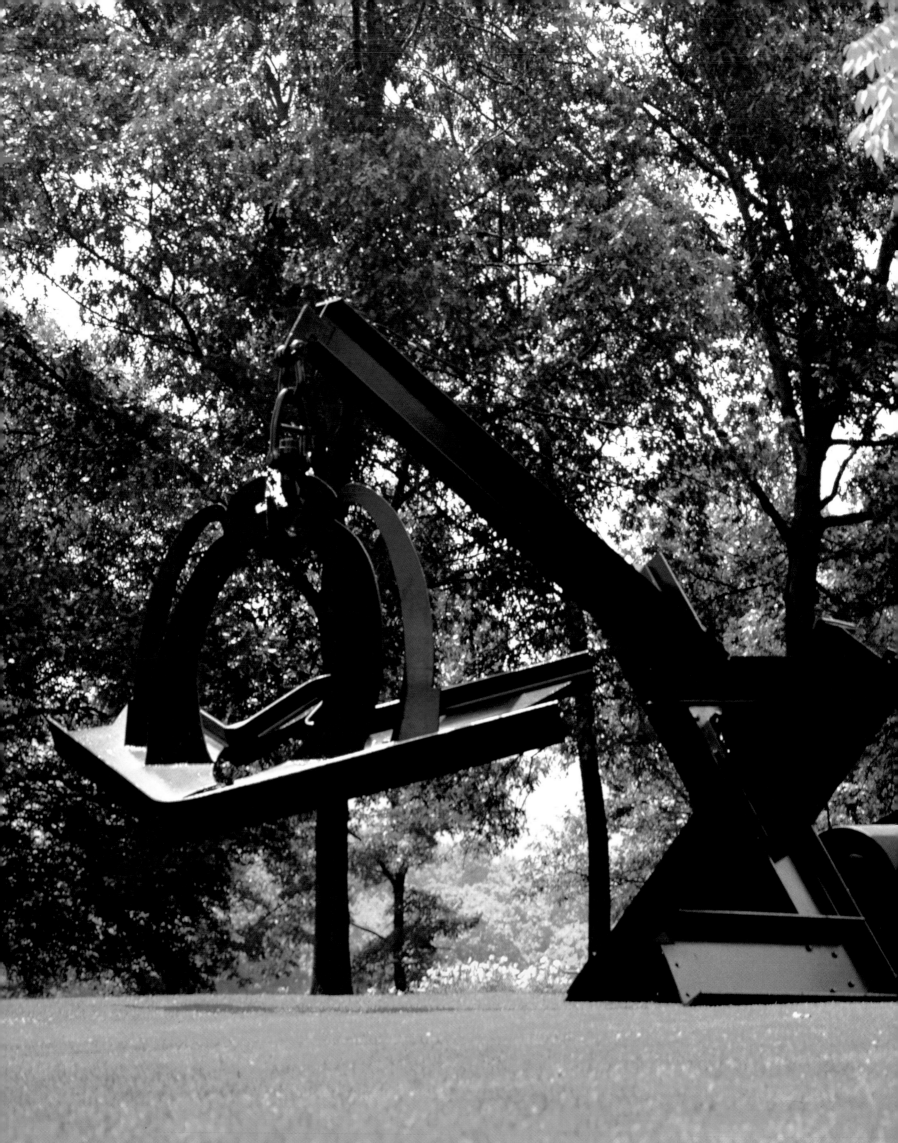

"I make my work
for people."

—Mark di Suvero

SHE, 1977–78

in the foreground

with ARIKIDEA, 1977–82,

and MAHATMA, 1978–79,

in the 1985 exhibition.

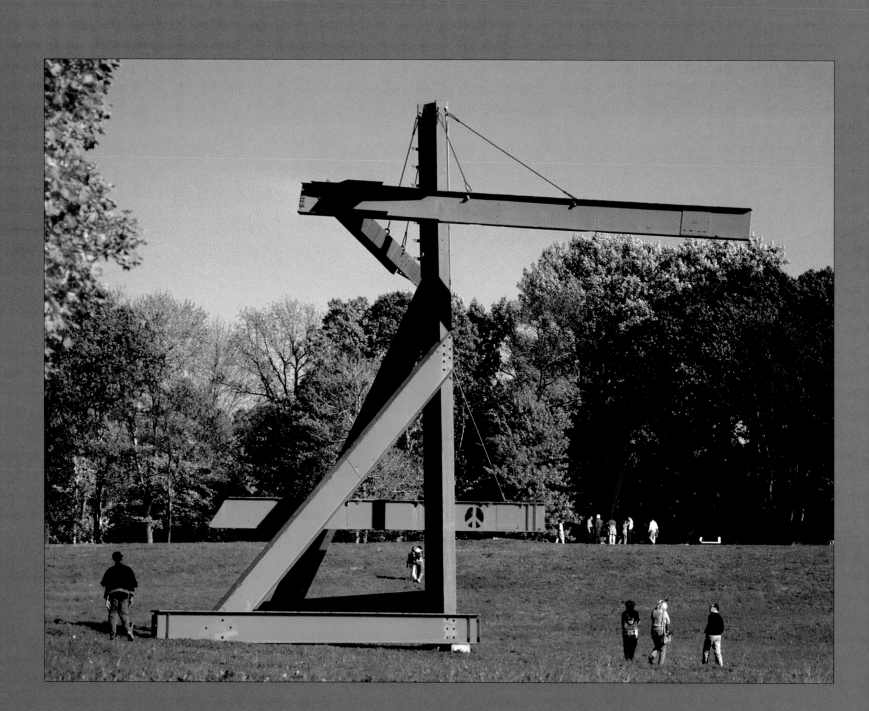

Above: MOTHER PEACE, 1969–70,
with YES! FOR LADY DAY, 1968–69, in the shadowy background.
Right: OLD BUDDY (FOR ROSKO), 1993–95.

"My sculpture . . . has an element of motion or pivoting,
which invites the viewer to physically participate."
—Mark di Suvero.

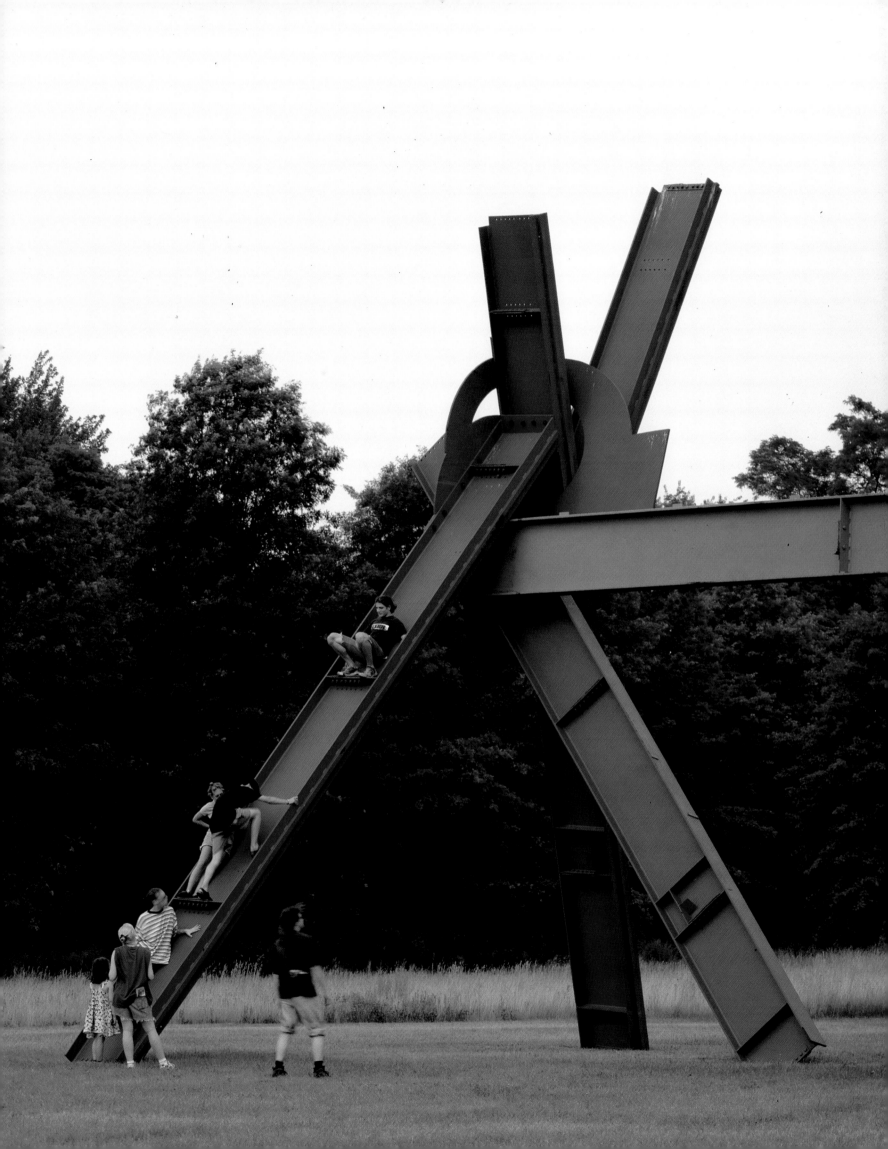

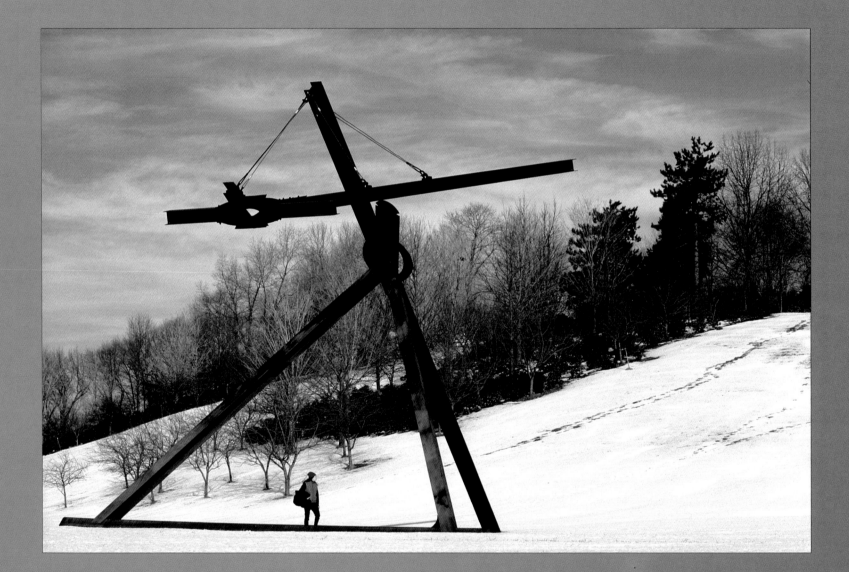

Left: *MON PÈRE, MON PÈRE, 1973–75,*
on first arrival in 1976.
Right: *JOHNNY APPLESEED, 1989–93.*

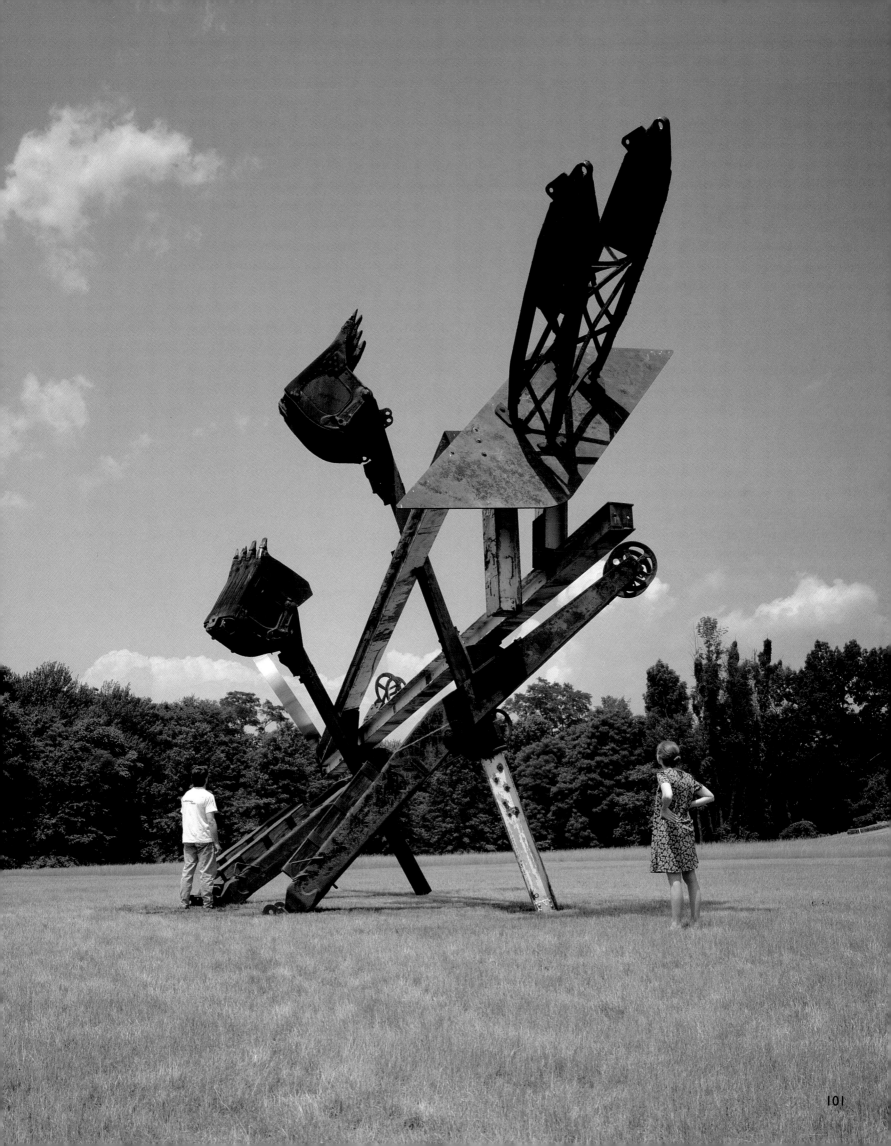

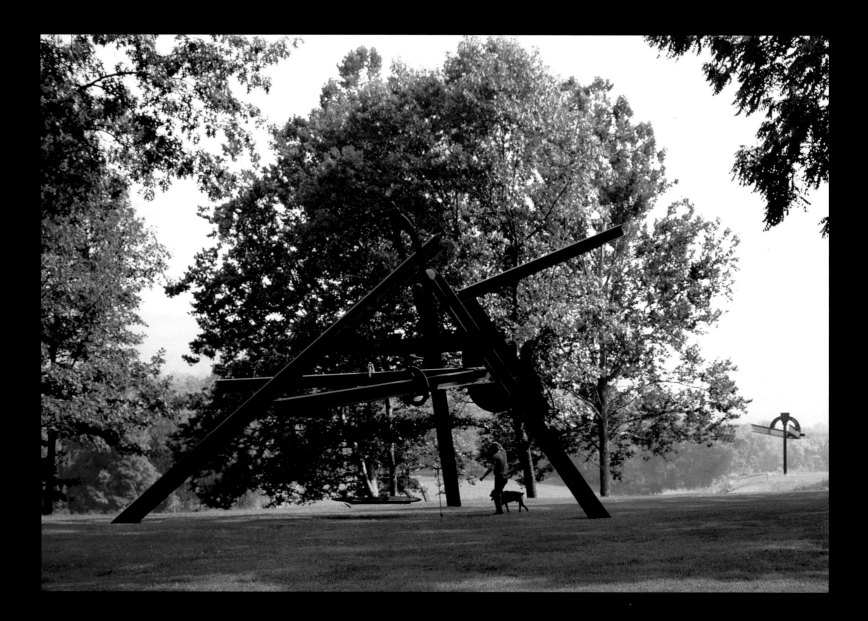

Spring 1985. Mark di Suvero and Rosko
strolling under ARIKIDEA, 1977–82, with MAHATMA, 1978–79, seen in the distance.

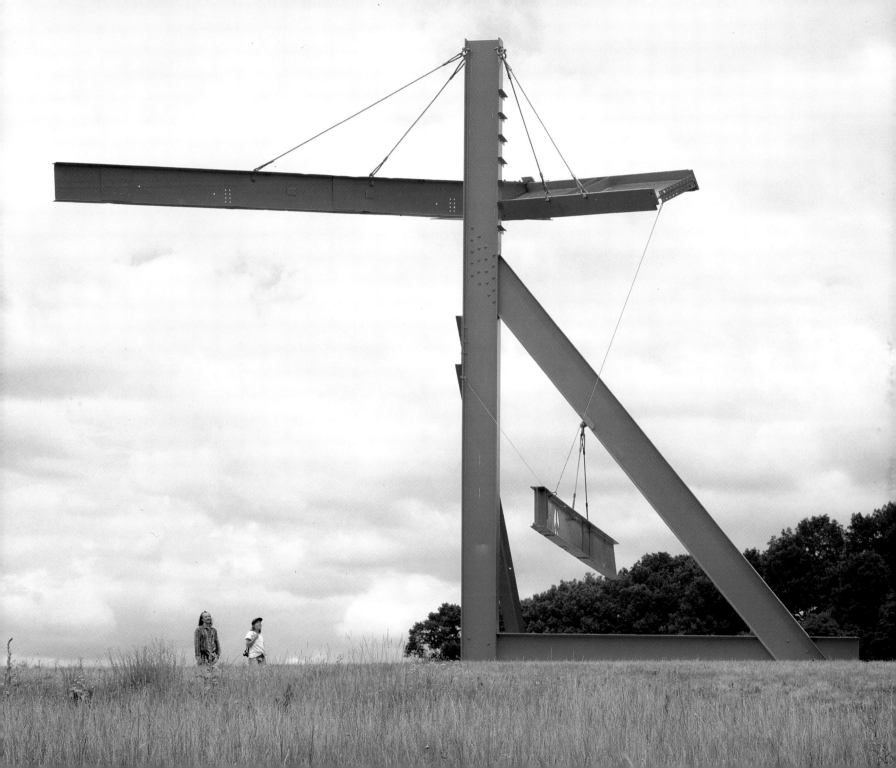

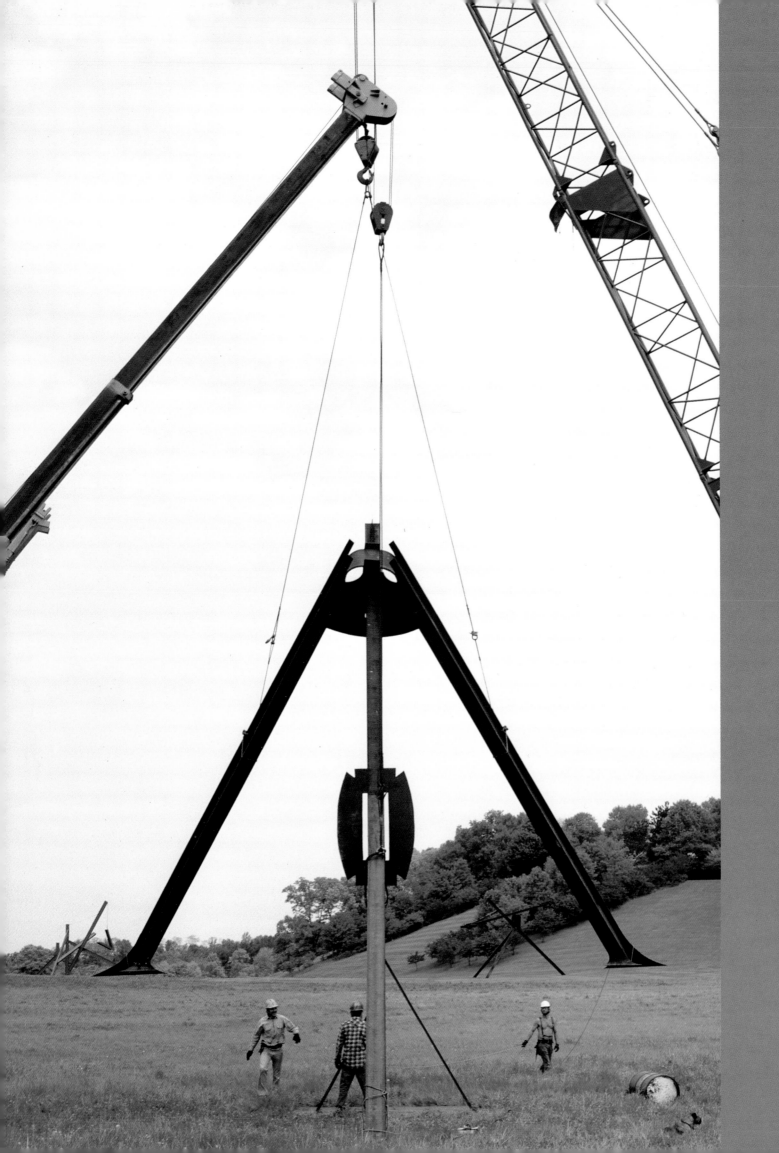

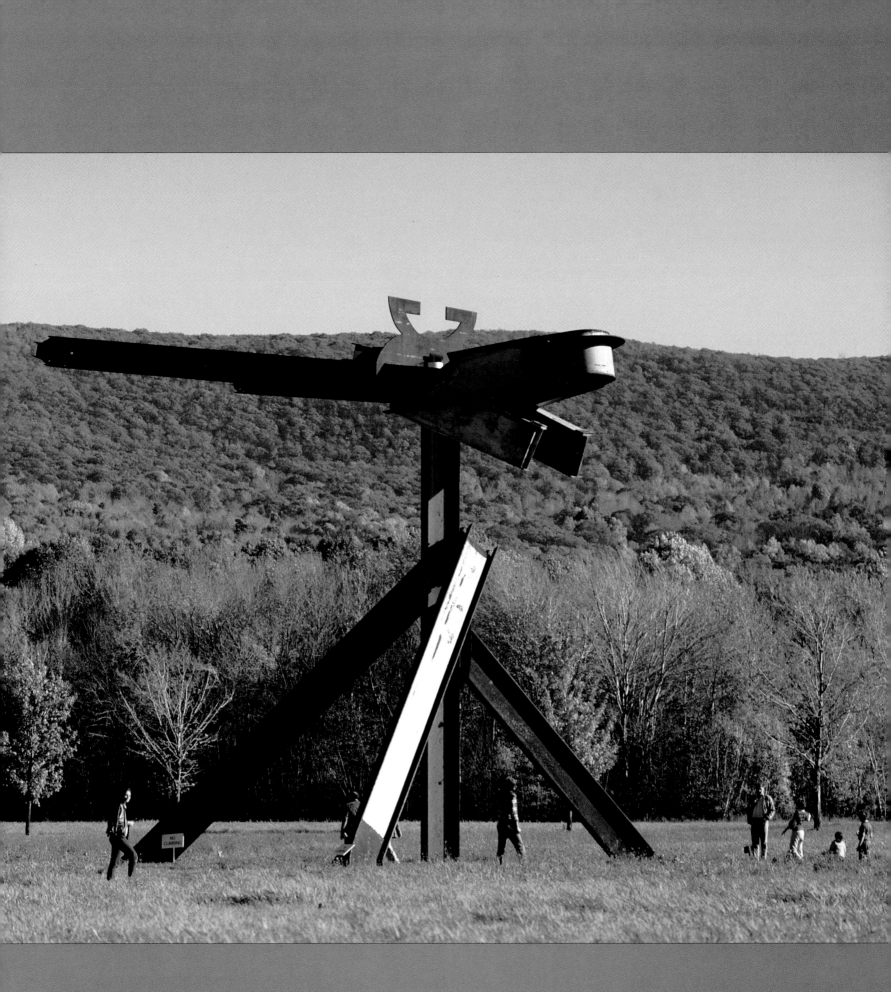

Spring 1985:
di Suvero and two members of his crew
install HURU, 1984–85, which,
once assembled, dominates the autumnal landscape.

The Seasons

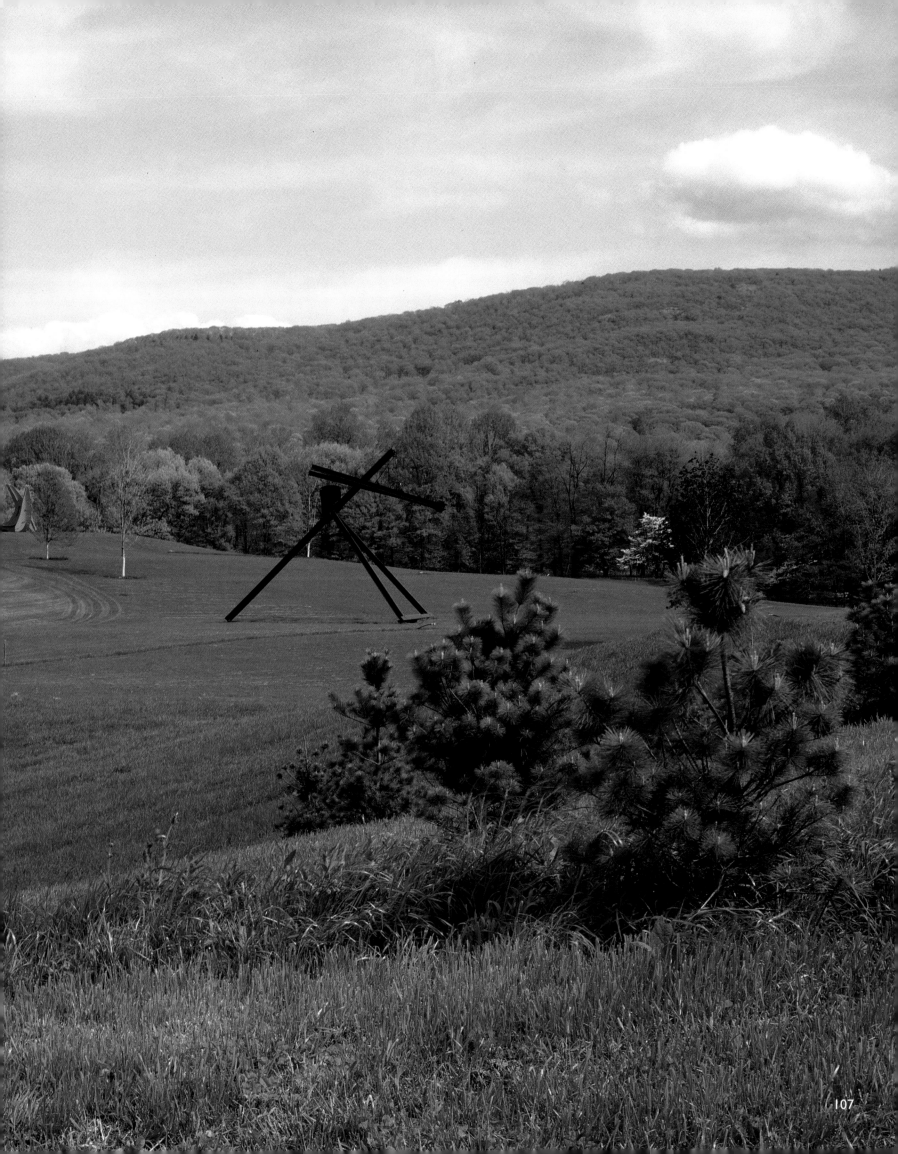

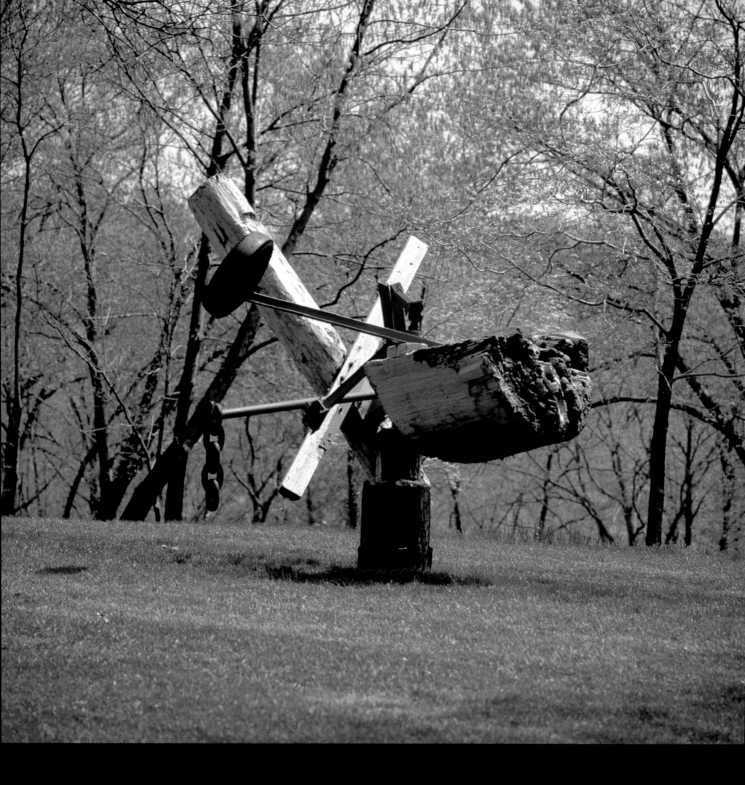

In 1976, PRE-COLUMBIAN, 1965,

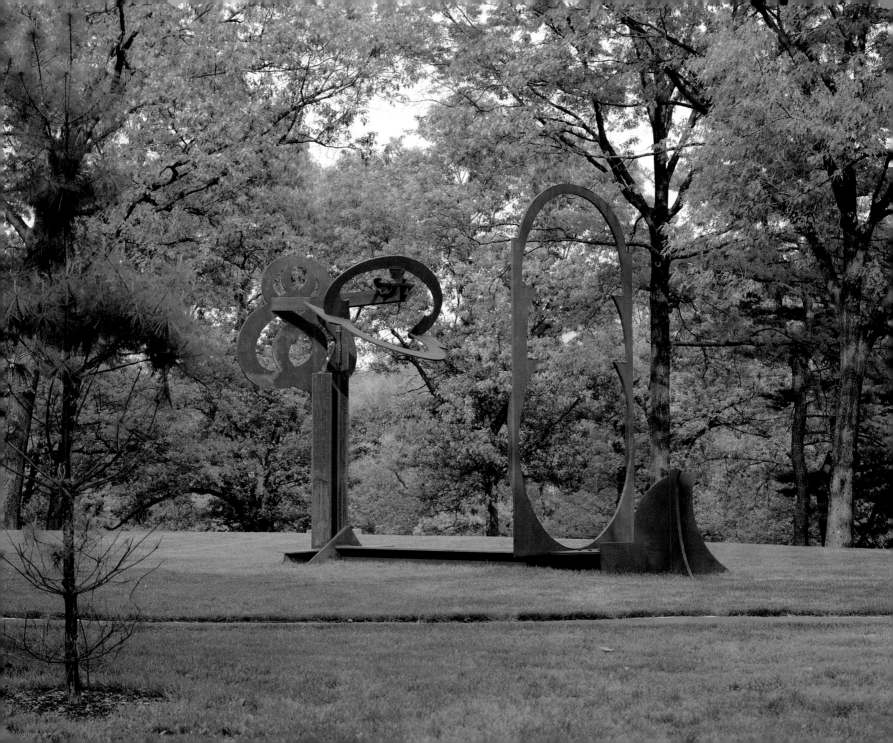

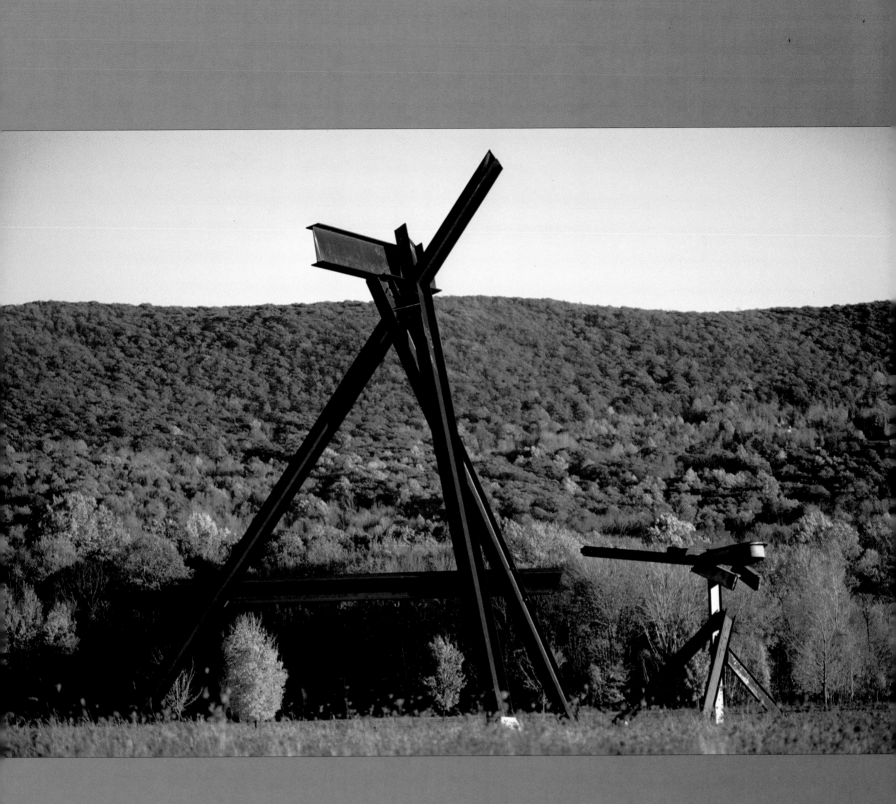

October 1985. ATMAN, 1978–79, and HURU, 1984–85, at left,
and BYGONES, 1976, at right, easily dominate the autumn landscape.

"His constructions are unabashedly celebratory humanist monuments."—Irving Sandler.

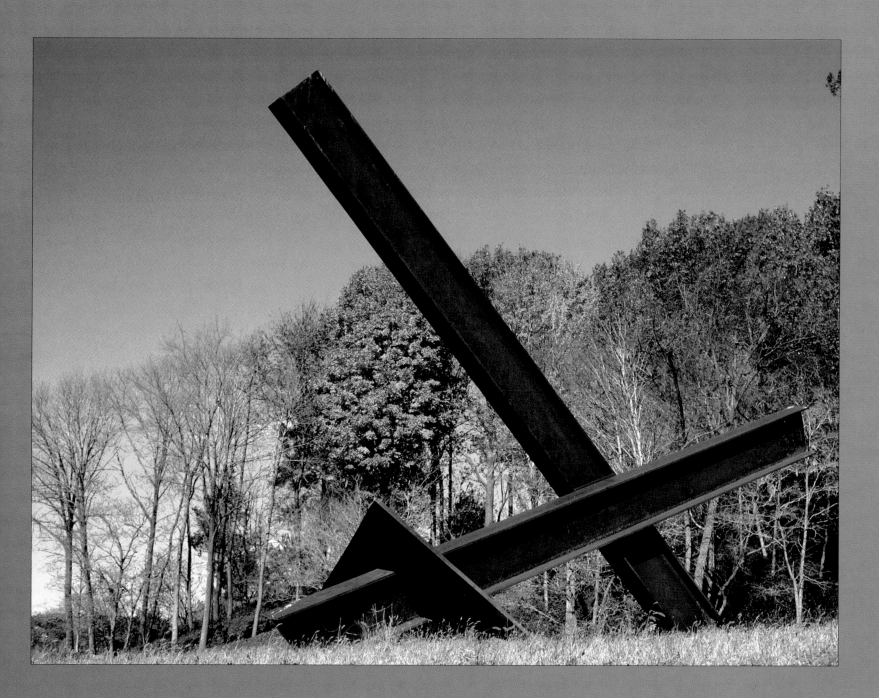

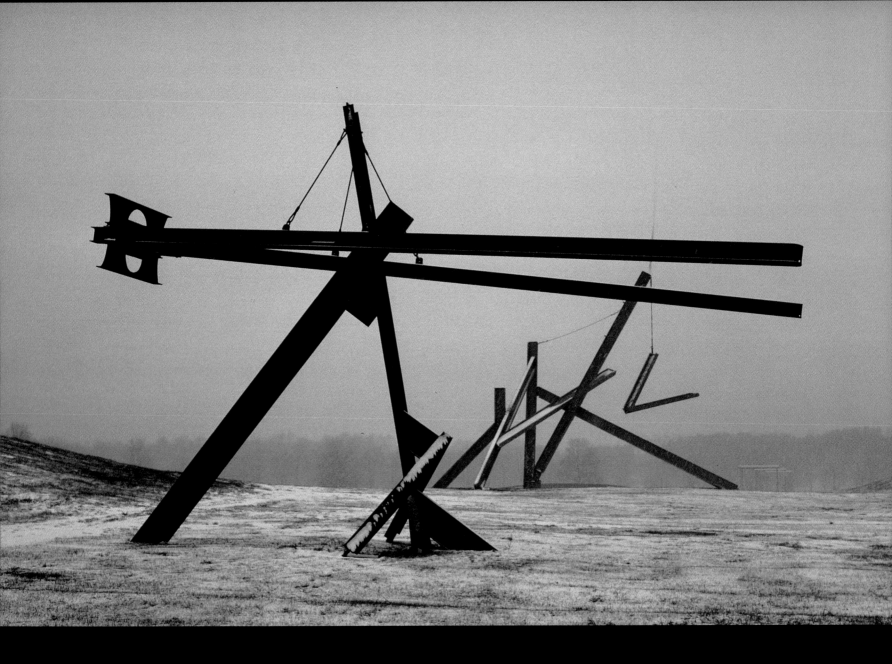

Left: IK OOK, 1971, and ARE YEARS WHAT? (FOR MARIANNE MOORE), 1967,
in Storm King's winter setting of 1976.
Right: ARIKIDEA, 1977–82, with SHE, 1977–78, in the background, in 1985.

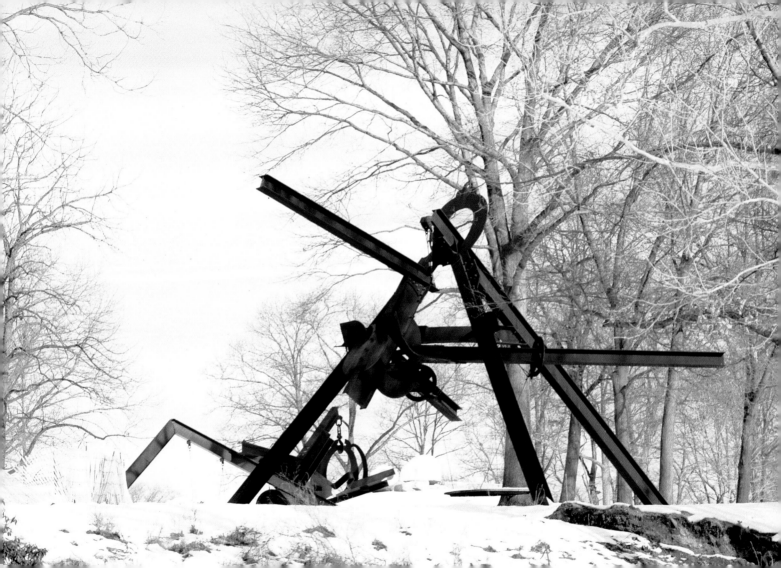

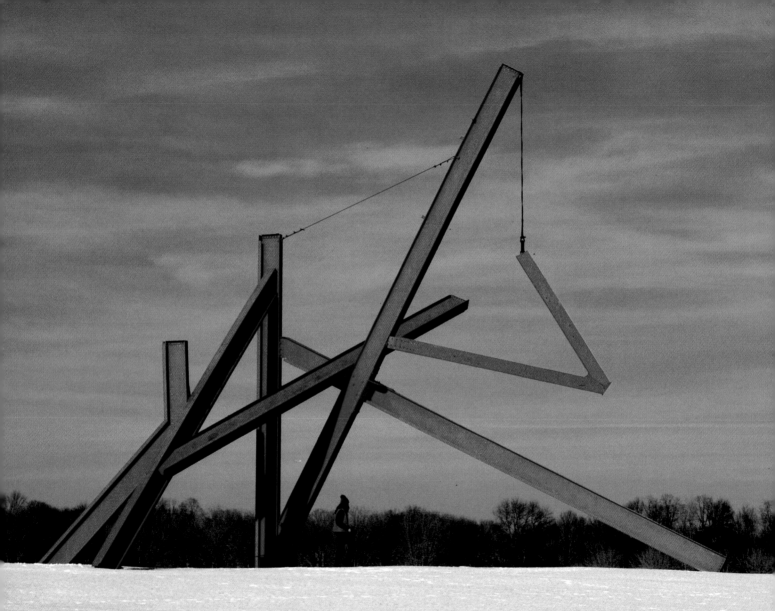

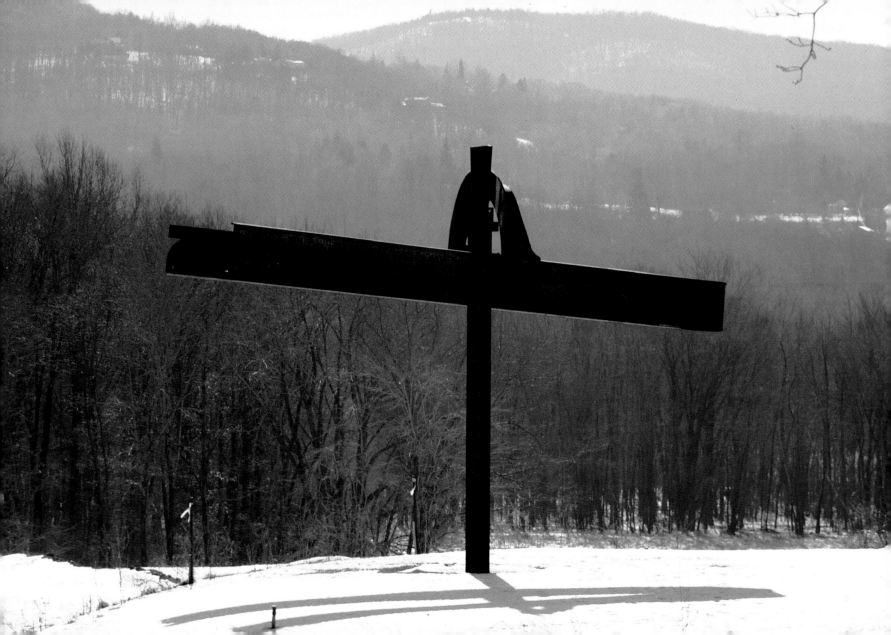

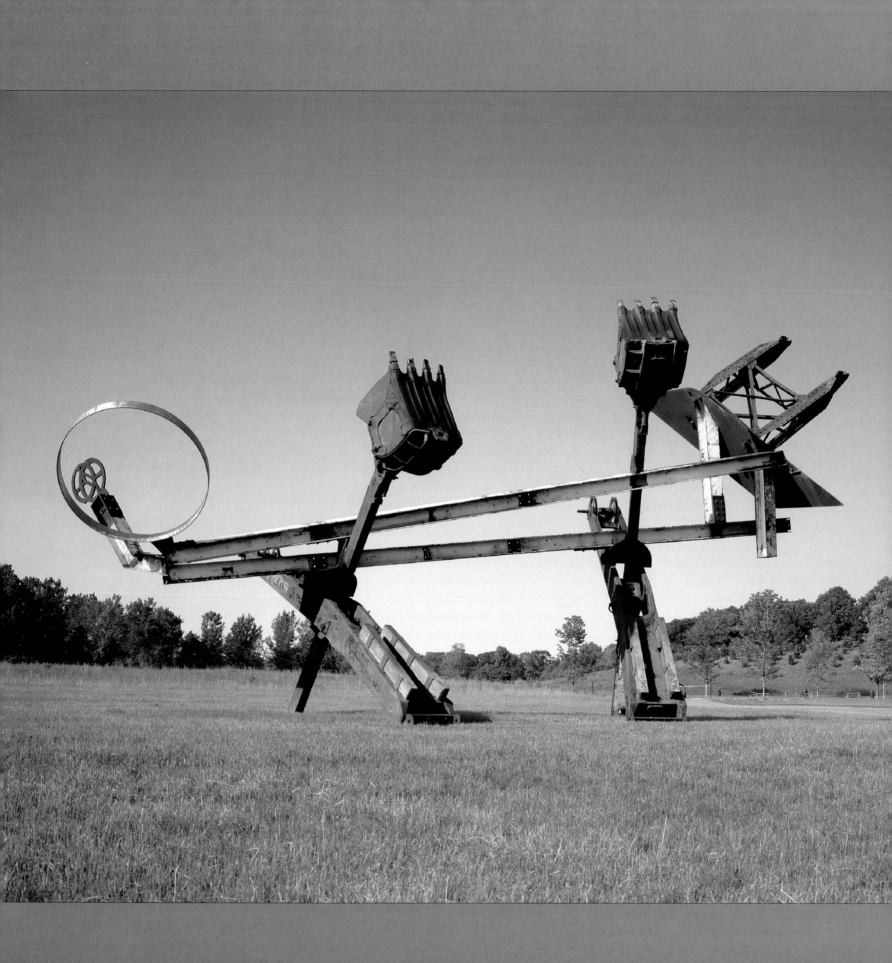

JOHNNY APPLESEED, 1989–93. " . . . an exuberant steel dinosaur
whose limbs are the arms of salvaged steam shovels."
-Michael Kimmelman, New York Times, July 14, 1995.

Unless otherwise indicated, each art work is lent by the artist, Oil & Steel Gallery, and Gagosian Gallery.

Dimensions for the paintings are provided in inches, height preceding width.

Dimensions for the sculptures are provided in feet and inches, height preceding width preceding depth.

Neutronstar, 1978–82
Oil on canvas
72 1/4 × 64 in.

Origin, 1978–82
Oil on canvas
94 1/2 × 190 1/4 in.

Beppe, 1978–95
Steel painted orange, steel, and stainless steel
45 ft. × 52 ft. × 50 ft.

Scythian, 1979–95
Steel
23 ft. × 24 ft. × 12 ft. 11 in.

Nux, 1988–92
Steel
4 ft. 5 1/2 in. × 6 ft. 7 in. × 3 ft.

Johnny Appleseed, 1989–93
Steel and stainless steel
23 ft. 6 in. × 22 ft. × 44 ft.

Masks of the Book, 1990
Steel
4 ft. 10 in. × 5 ft. 7 in. × 3 ft. 1 3/4 in.

For Chris, 1991
Steel
11 ft. 3 in. × 16 ft. × 10 ft. 3 in.

Han, 1991
Steel
6 ft. 4 1/2 in. × 4 ft. 5 in. × 4 ft. 5 in.
Private collection, courtesy Gagosian Gallery
(On exhibition in 1995 only)

Tools with Dreams, 1991–92
Steel and stainless steel with wood base
9 ft. 4 in. × 6 ft. 6 in. × 5 ft. 3 in.

Homage to Cobblers, 1992
Steel and stainless steel
4 ft. 3 in. × 3 ft. 10 in. × 2 ft. 8 in.

Idéogramme Lunaire, 1992
Steel
2 ft. 2 1/4 in. × 2 ft. 5 1/2 in. × 1 ft. 7 in.

Oaxaca, 1992
Steel
14 ft. 9 in. × 16 ft. 5 in. × 6 ft. 7 in.

Page 2, 1992
Steel
2 ft. 11 in. × 3 ft. × 1 ft. 7 in.

Aurora, 1992–93
Steel
16 ft. 4 in. × 19 ft. 6 in. × 26 ft.
Lent by Gagosian Gallery

Old Buddy (For Rosko), 1993–95
Steel painted gray and red-brown
40 ft. × 60 ft. × 48 ft.

Acla Cuna, 1994
Stainless steel and steel
7 ft. 3 in. × 8 ft. 8 in. × 7 ft. 5 in.

Square Root of Two, 1994
Stainless steel, steel painted red, and steel
9 ft. 2 in. × 9 ft. × 8 ft.

This publication features many illustrations of Mark di Suvero's sculptures other than the ones listed in the 1995–96 exhibition checklist.

Foremost are *Mother Peace* and *Mon Père, Mon Père,* installed at the Art Center in 1976 as two of five sculptures lent to Storm King by the

artist. These works became part of the museum's permanent collection in 1981 as a gift from the Ralph E. Ogden Foundation.

In 1985 Storm King Art Center mounted a comprehensive retrospective of di Suvero's sculptures and drawings.

Several works from that exhibition are illustrated in this volume.

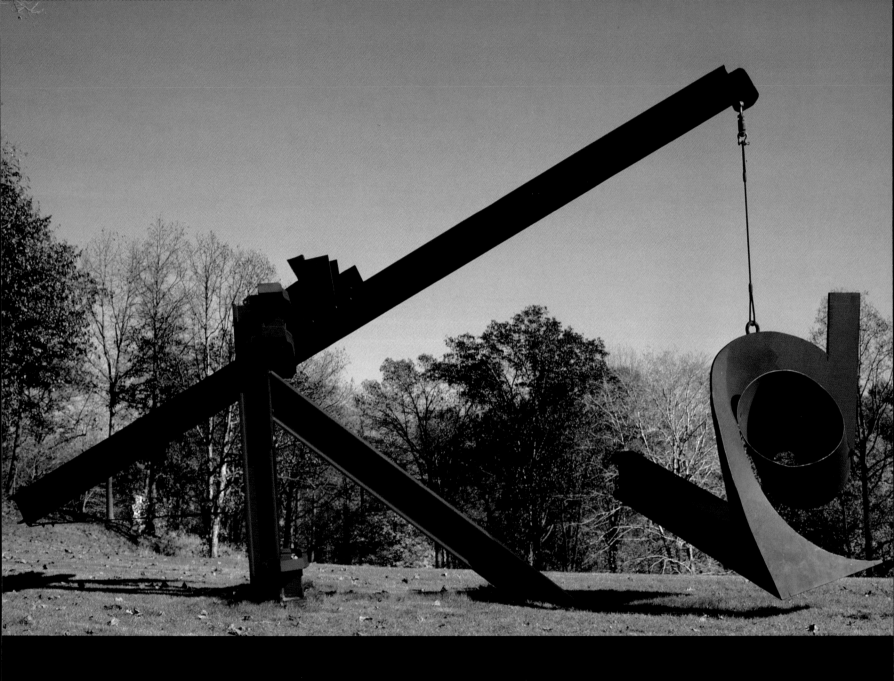

*SISTER LU, 1978–79, in 1985. " . . . much as his huge works are powerful,
they are also graceful, at times whimsical, and full of subtle surprises."*
—*Irving Sandler.*

Biography

1933
Born in Shanghai, China, on September 18, 1933, to Italian antifascist parents.

1941
Family immigrates to the United States and settles in San Francisco.

1951–53
Works as a house painter and boatbuilder and sails the California coast single-handedly.

1953–54
Attends San Francisco City College. Studies philosophy and fine arts.

1954–55
Attends the University of California, Santa Barbara. Studies sculpture with Robert Thomas. Lives in a tree house and begins painting.

1955–56
Attends the University of California, Berkeley. Studies sculpture with Stephen Novak and drawing with Beate Wheeler. Receives B.A. in philosophy.

1957
Moves to New York City.

1958
Participates in first group exhibition at the March Gallery, New York City. Sculpts in wood.

1960
Is confined to a wheelchair for a year after job-related accident results in paraplegia. First one-person exhibition at Green Gallery in New York City, where he continues to exhibit on a regular basis. Hailed by critics as a trailblazing artist.

1961–62
Works in steel from his wheelchair.

1962
With others, establishes the Park Place Gallery, the first artists' commune in the area now known as SoHo. Exhibits there in group shows through 1967.

1966
Utilizes a crane for the first time in constructing his sculptures. Designs and helps to erect the *Peace Tower* in Los Angeles as a protest against the war in Vietnam.

1969
Teaches at the University of California, Berkeley.

1971
Leaves the United States in protest against the Vietnam War and lives in Eindhoven, the Netherlands.

1972
Teaches at the International University for Art in Venice.

1973
Moves to Chalon-sur-Saône, France.

1975
Exhibits at the Jardin des Tuileries, Paris. Returns to the United States for his first one-person museum exhibition in the United States at the Whitney.

1976
Founds the Athena Foundation, New York City.

1985
Establishes Socrates Sculpture Park, Long Island City, New York.

1988
With others, originates La Vie des Formes, Chalon-sur-Saône.

Mark di Suvero maintains studios in Petaluma, California; Long Island City, New York; and Chalon-sur-Saône, France.

Solo Exhibitions

1960
The Green Gallery, New York, N.Y.

1964
Park Place Gallery, New York, N.Y.

1965
Dwan Gallery, Los Angeles, Calif.

1966
Park Place Gallery, New York, N.Y.

1967
Park Place Gallery, New York, N.Y.

1968
LoGiudice Gallery, Chicago, Ill.

1972
Stedelijk Van Abbemuseum, Eindhoven and City of Eindhoven, the Netherlands
Wilhelm-Lehmbruck Museum, Duisburg, Germany

1972–74
City of Chalon-sur-Saône, France (in cooperation with Centre National de Recherche, d'Animation et de Création pour les Arts Plastiques, Le Creusot, France)

1975
Jardin des Tuileries, Paris, France
Whitney Museum of American Art, N.Y.

1979
ConStruct, Chicago, Ill.

1980–81
Ace Gallery, Venice, Calif.

1983
Oil & Steel Gallery, New York, N.Y.
Esprit Park, San Francisco, Calif.
1985
Oil & Steel Gallery, New York, N.Y.
Storm King Art Center, Mountainville, N.Y.

1986
Hill Gallery, Birmingham, Mich.

1987
Akira Ikeda Gallery, Tokyo, Japan

1988
Württembergischer Kunstverein, Stuttgart, Germany

1990
City of Valence, France
Galerie de France, Paris
L. A. Louver, Venice, Calif.

1991
• Musée d'Art Moderne et d'Art Contemporain, Nice and City of Nice, France
Akira Ikeda Gallery, Tokyo, Japan

1992
Chalon-sur-Saône, France
Galerie Heike Curtze, Vienna, Austria
Verein für Heimatpflege, Viersen, Germany

1993
Musée de Brest and Passerelle, France
Gagosian Gallery, New York, N.Y.
Rettig y Martínez Gallery, Santa Fe, N.Mex.
Esprit Park, San Francisco, Calif.

1994
John Berggruen Gallery, San Francisco, Calif.
IVAM Centre Julio Gonzalez, Valencia, Spain

1995
46th Biennale d'Arte, Venice, Italy
Gagosian Gallery, New York, N.Y.
Storm King Art Center, Mountainville, N.Y.

Selected Group Exhibitions

1961
The Green Gallery, New York, N.Y.

1962
The Green Gallery, New York, N.Y.
Continuity and Change, The Wadsworth Atheneum, Hartford, Conn.

1963
66th Annual American Exhibition: Directions in Contemporary Painting and Sculpture, The Art Institute of Chicago, Ill.
Park Place Gallery, New York, N.Y.

1964
Recent American Sculpture, The Jewish Museum, New York, N.Y.
Park Place Gallery, New York, N.Y.

1965
Contemporary American Sculpture, Musée Rodin, Paris, France
The Green Gallery, New York, N.Y.
Park Place Gallery, New York, N.Y.

1966
Contemporary American Sculpture Section I, assembled by the Howard and Jean Lipman Foundation and the Whitney Museum of American Art, New York, N.Y.; traveled in New York State
Art of the United States: 1670–1966, Whitney Museum of American Art, New York, N.Y.
Annual Exhibition 1966: Contemporary American Sculpture and Prints, Whitney Museum of American Art, New York, N.Y.
Park Place Gallery, New York, N.Y.
Toronto Symposium, Toronto, Canada

1967
Sculpture International, Solomon R. Guggenheim Museum, New York, N.Y.
American Sculpture of the Sixties, Los Angeles County Museum of Art, Calif.
7 for 67: Works by Contemporary American Sculptors, The St. Louis Art Museum, Mo.
Park Place Gallery, New York, N.Y.

1968

1968 Annual Exhibition: Contemporary American Sculpture, Whitney Museum of American Art, New York, N.Y.

Plus by Minus, Albright-Knox Art Gallery, Buffalo, N.Y.

Walter de Maria/Mark di Suvero/Richard Serra, Noah Goldowsky Gallery, New York, N.Y.

Documenta IV, Kassel, Germany

Martin Luther King Benefit, The Museum of Modern Art, New York, N.Y.

1969

New York Painting and Sculpture: 1940–1970, The Metropolitan Museum of Art, New York, N.Y.

1970

Monumental Art, The Contemporary Arts Center, Cincinnati, Ohio

Noah Goldowsky Gallery, New York, N.Y.

1970 Annual Exhibition: Contemporary American Sculpture, Whitney Museum of American Art, New York, N.Y.

1971

Works for New Spaces, Walker Art Center, Minn.

11th Biennale, Middelheim Sculpture Garden, Antwerp, Belgium

1973

Art in Space, Detroit Institute of Arts, Mich.

Sculpture off the Pedestal, Grand Rapids Art Museum, Mich.

American Art—3rd Quarter Century, Seattle Art Museum, Wash.

American Drawings 1963–1973, Whitney Museum of American Art, New York, N.Y.

Internationale Gartenbau-Ausstellung, Hamburg, Germany

New York Collection for Stockholm, Moderna Museet, Stockholm, Sweden

A Selection of Recent Drawings, Noah Goldowsky Gallery, New York, N.Y.

1974

Sculpture in the Park, Grant Park, Chicago, Ill.

Public Sculpture/Urban Environment, The Oakland Museum, Calif.

Drawings: Studies for Unrealized Work for the University of Nevada, University Art Gallery, University of Nevada, Las Vegas

1975

Artists Make Toys, The Institute for Contemporary Art, P.S.1 Museum and The Clocktower Gallery, New York, N.Y.

Monumental Sculpture, Janie C. Lee Gallery, Houston, Tex.

37th Biennale d'Arte, Venice, Italy

The Condition of Sculpture, Hayward Gallery, London, England

1976

Biennale of Sydney, North Sydney, Australia

California Painting and Sculpture: The Modern Era, San Francisco Museum of Modern Art, Calif.

1977

Projects/New Urban Monuments, Akron Art Institute, Ohio

California Collections, San Francisco Museum of Modern Art, Calif.

1978

Inaugural Exhibition of the Wave Hill Sculpture Garden, Wave Hill, Bronx, N.Y.

New York: The State of Art, New York State Museum, Albany

California: 3 By 8 Twice, Honolulu Academy of Arts, Hawaii

Group Show, ConStruct, Chicago, Ill.

Janie C. Lee Gallery, Houston, Tex.

1979

On Sculpture, Neuberger Museum, State University of New York, Purchase

The Prospect Mountain Sculpture Show, Lake George Arts Project, Lake George, N.Y.

1980

Homage to Picasso, Walker Art Center, Minneapolis, Minn.

American Sculpture: Gifts of Howard and Jean Lipman, Whitney Museum of American Art, New York, N.Y.

Ten Abstract Sculptures, American & European 1940–1980, Max Hutchinson Gallery, New York, N.Y.

Urban Encounters: Art, Architecture, Audience, Institute of Contemporary Art, Philadelphia, Pa.

1981

Contemporary Painting/Sculpture I, Oil & Steel Gallery, New York, N.Y.

1982

Contemporary Painting/Sculpture II + III, Oil & Steel Gallery, New York, N.Y.

20 American Artists: Sculpture 1982, San Francisco Museum of Modern Art, Calif.

1983

Sculpture: The Tradition in Steel, Nassau County Museum of Art, Roslyn Harbor, N.Y.

The First Show: Painting and Sculpture from Eight Collections, 1940–1980, The Museum of Contemporary Art, Los Angeles, Calif.

1984

Contemporary Painting and Sculpture: 1957–1984, Oil & Steel Gallery, New York, N.Y.

Painting and Sculpture, Hill Gallery, Birmingham, Mich.

1985

Sense and Sensibility, Hill Gallery, Birmingham, Mich.

Ontogeny: Sculpture and Painting by 20th Century American Sculptors, New York Studio School of Drawing, Painting and Sculpture, N.Y.

International Exhibition VII, Solomon R. Guggenheim Museum, New York, N.Y.

The Third Dimension: Sculpture of the New York School, Whitney Museum of American Art, New York, N.Y.

1986

Oil & Steel Gallery, Long Island City, N.Y.

An American Renaissance: Painting and Sculpture Since 1940, Museum of Art, Fort Lauderdale, Fla.

American Academy of Arts and Letters, New York, N.Y.

Selected Works of 20th Century Masters, John Berggruen Gallery, San Francisco, Calif.

Indoor/Outdoor Sculpture Exhibition, El Bohio Community and Cultural Center, New York, N.Y.

The Second Newport Biennial: The Bay Area, Newport Harbor Art Museum, Newport Beach, Calif.

Inaugural Exhibition, Socrates Sculpture Park, Long Island City, N.Y.

Sculpture, Hill Gallery, Birmingham, Mich.

Individuals: A Selected History of Contemporary Art, 1945–1986, The Museum of Contemporary Art, Los Angeles, Calif.

1987

Oil & Steel Gallery, Long Island City, N.Y.

Sculpture: Walk On/Sit Down/Go Through, Socrates Sculpture Park, Long Island City, N.Y.

Outside In: Socrates Sculpture Park, City Gallery, New York, N.Y.

Oil & Steel Gallery, Long Island City, N.Y.

1988

Aspects of Collage, Assemblage and the Found Object in Twentieth Century Art, Solomon R. Guggenheim Museum, New York, N.Y.

Socrates Sculpture Park, Long Island City, N.Y.

Selected Sculpture, John Berggruen Gallery, San Francisco, Calif.

Sculpture Since the Sixties from the Permanent Collection of the Whitney Museum of American Art, Whitney Museum of American Art at Equitable Center, New York, N.Y.

43rd Biennale d'Arte, Venice, Italy

1989

Oil & Steel Gallery, Long Island City, N.Y.

10th Anniversary Exhibition, Tasende Gallery, La Jolla, Calif.

The "Junk" Aesthetic: Assemblage of the 1950s and Early 1960s, Whitney Museum of American Art at Equitable Center, New York, N.Y.

A Decade of American Drawing, Daniel Weinberg Gallery, Los Angeles, Calif.

Socrates Sculpture Park, Long Island City, N.Y.

1990

Socrates Sculpture Park, Long Island City, N.Y.

Sculpture, Gagosian Gallery, New York, N.Y.

Group Exhibition, Manny Silverman Gallery, Los Angeles, Calif.

1991

Socrates Sculpture Park, Long Island City, N.Y.

1992

Socrates Sculpture Park, Long Island City, N.Y.

Akira Ikeda Gallery, Taura, Japan

Hill Gallery, Birmingham, Mich.

Table Sculpture by Modern and Contemporary Masters, André Emmerich Gallery, New York, N.Y.

Winter's Edge, Okun Gallery, Santa Fe, N.Mex.

1993

The Second Dimension: Twentieth Century Sculptor's Drawings from The Brooklyn Museum, The Brooklyn Museum, Brooklyn, N.Y.

University Art Museum, University of New Mexico, Albuquerque

1994

Le Temps d'un Dessin, Galerie de l'Ecole des Beaux-Arts de Lorient, France

Spring Equinox Exhibition, Tasende Gallery, La Jolla, Calif.

Socrates Sculpture Park, Long Island City, N.Y.

Self Portrait, David Retig Fine Arts, Inc., Santa Fe, N.Mex.

New Sculpture, L. A. Louver, Venice, Calif.

The Essential Gesture, Newport Harbor Art Museum, Newport Beach, Calif.

Another Dimension: Paintings by Sculptors, John Weber Gallery, New York, N.Y.

1995

Socrates Sculpture Park, Long Island City, N.Y.

John Berggruen Gallery, San Francisco, Calif.

L.A. Louver, Venice, Calif.

Hill Gallery, Birmingham, Mich.

Twentieth Century American Sculpture II, The White House, Washington, D.C.

Outdoor Sculptures in Public Collections

Blue Arch for Matisse, 1965. Moderna Museet, Stockholm, Sweden

Praise for Elohim Adonai, 1966. The St. Louis Art Museum, Mo.

No Shoes, 1967. High Park, Toronto, Canada

Flower Power, 1967. High Park, Toronto, Canada

Yes! For Lady Day, 1968–69. Nathan Manilow Sculpture Park, Governors State University, University Park, Ill.

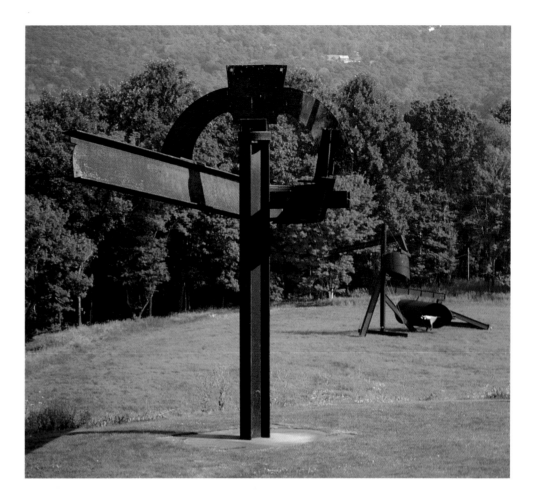

*MAHATMA, 1978–79,
and YES! FOR LADY DAY, 1968–69, in 1985.*

Mother Peace, 1969–70. Storm King Art Center, Mountainville, N.Y.

Victor's Lament, 1970. Muhlenberg College, Allentown, Pa.

Ik Ook, 1971. National Gallery of Australia, Canberra

For Roebling, 1971. The Museum of Modern Art, New York, N.Y.

Teha, 1971. Los Angeles County Museum of Art, Calif.

K-Piece, 1971–72. Rijksmuseum Kröller-Müller, Otterlo,
the Netherlands

Lover, 1971–73. Bradley Foundation, Milwaukee, Wis.

Ave, 1973. Dallas Museum of Fine Arts, Dallas, Tex.

Ange des Orages, 1973. Chalon-sur-Saône, France

Mon Père, Mon Père, 1973-75. Storm King Art Center, Mountainville,
N.Y.

Étoile Polaire, 1974. Musée de Peinture et de Sculpture, Grenoble,
France

For Handel, 1974–75. Western Washington State College, Bellingham,
Wash.

Motu Viget, 1976. Grand Rapids, Mich.

Bygones, 1976. The Menil Collection, Houston, Tex.

Eaglewheel, 1976–79. Akron Art Museum, Ohio

Pre-natal Memories, 1976–81. The Museum of Contemporary Art,
Los Angeles, Calif.

Homage to Charlie Parker, 1977. Oakland Museum of Art, Calif.

Isis, 1977–84. Nathan Manilow Sculpture Park, Governors State
University, University Park, Ill. On loan from the Hirshhorn Museum
and Sculpture Garden, Washington, D.C.

Molecule, 1977–84. Walker Art Center, Minneapolis, Minn.

Under Sky/One Family, 1978–79. Baltimore, Md.

Sister Lu, 1978–79. Baltimore Museum of Art, Md.

Atman, 1978–79. Cincinnati Art Museum, Ohio

Blubber, 1979–80. Toledo Museum of Art, Ohio

Inner Search, 1979–80. Northwestern Bank, Minneapolis, Minn.

Keepers of the Fire, 1980. Century Center, South Bend, Ind.

Pranayama, 1980–82. Baylor Medical Center, Houston, Tex.

Shoshone, 1981–82. Wells Fargo Bank Building, Los Angeles, Calif.

The Calling, 1981–82. Bluff Park, Milwaukee, Wis.

Arikidea, 1981–82. Walker Art Center, Minneapolis, Minn.

Old Glory, 1985–86. Sheldon Memorial Art Gallery, University of
Nebraska, Lincoln, Neb.

Lobotchevsky, 1987–88. Stuttgart, Germany

L'Allume, 1989–92. Bonn, Germany

Extase, 1991. Brest, France

Vivaldi, 1992. Valence, France

Spring Rain, 1992. Landesmuseum für Technik und Arbeit,
Mannheim, Germany

Sea Change, 1994–95. San Francisco, Calif.

Catalogs

Besacier, Hubert. *Mark di Suvero: Extase*. Brest, France: Ville de Brest, 1993.

Bunk, Renate Luise, and Joachim Peter Kastner. *Mark di Suvero: New Star*. Stadt Viersen, Germany: Verein fur Heimatpflege Viersen, 1992.

Carandente, Giovanni, et al. *Mark di Suvero a Venezia*. Milan, Italy: PradaMilanoArte/Charta, 1995.

Dobbels, Daniel; Anne Wilson Lloyd et al. *Mark di Suvero: Retrospective*. Nice, France: Musée d'Art Moderne et d'Art Contemporain, 1991.

Mark di Suvero. Valence, France: Ville de Valence, 1990.

Mark di Suvero: Open Secret: Sculpture 1990–92. New York: Gagosian Gallery/Rizzoli International, 1993.

Monte, James K. *Mark di Suvero*. New York: Whitney Museum of American Art, 1975.

Osterwold, Tilman, et al. *Mark di Suvero*. Stuttgart, Germany: Württembergischer Kunstverein, 1988.

Osterwold, Tilman. *Mark di Suvero a Venezia*. New York: Gagosian Gallery/in association with Richard Bellamy, 1995

Rose, Barbara, et al. *Mark di Suvero*. Valencia, Spain: IVAM (Instituto Valenciano de Arte Moderno) Centre Julio Gonzalez. 1994

Selected Articles and Reviews

Acconci, Vito H. "Reviews and Previews." *Art News* 68 (January 1970): 12.

Adrian, Dennis. "Review." *Artforum* 5 (March 1967): 55–56.

———. "Review." *Artforum* 5 (April 1967): 56.

Albright, Thomas. "San Francisco: Convulsive but Lyrical." *Art News* 76 (May 1977): 116–119.

Alloway, Lawrence. "Monumental Art in Cincinnati." *Arts Magazine* 45 (November 1970): 32–36.

———. "Art." *The Nation*, December 20, 1975, p. 670.

Ashbery, John. "Reviews and Previews." *Art News* 65 (March 1966): 13.

Ashton, Dore. "Unconventional Techniques in Sculpture." *Studio International* 169 (January 1965): 23.

———. "The Artist as Dissenter." *Studio International* 171 (April 1966): 164–67.

———. "New York Gallery Notes." *Art in America* 55 (January 1967): 95.

———. "New York Commentary." *Studio International* 174 (December 1967): 277–279.

———. "Response to Crisis in American Art." *Art in America* 57 (January-February 1969): 24–35.

Baker, Elizabeth C. "Mark di Suvero's Burgundian Season." *Art in America* 62 (May/June 1974): 59–63.

Baker, Kenneth. "Mark di Suvero: Esprit Park." *Art News* 93 (January 1994): 170–71.

———. "Di Suvero's Massings of Steel/New Sculpture." *San Francisco Chronicle*, March 19, 1994, pp. E1, 4

Berman, Art. "Sunset Strip Project: Art Tower Started as Vietnam Protest." *Los Angeles Times*, January 28, 1966, pp. 3, 24.

Bernier, Olivier. "In Nice, a Sumptuous New See-Through Museum." *New York Times*, August 26, 1990, sec. 2, p. 24.

Bourdon, David. "E=MC² à Go-Go: Ten Painters and Sculptors Form a Lively Objective." *Art News* 64 (January 1966): 22–23.

———. "What's Up in Paris." *Village Voice*, June 23, 1975, p. 92.

———. "Di Suvero's Sculpture Goes Public." *Village Voice*, November 17, 1975, p. 109.

Boyer, Brian. "Play Sculpture." *Chicago Sun-Times*, October 22, 1969, p. 40.

"Brandeis Names 9 to Receive Award for Creative Arts." *New York Times*, February 7, 1969, p. 31.

Breerette, Geneviève. "Arts: Une Certaine Image de l'Homme." *Le Monde*, September 25, 1990, p. 16.

Brenson, Michael. "Review." *New York Times*, 25 May 1984, p. C21.

———. "Review." *New York Times*, 26 October 1984, p. C26.

———. "A Sculpture Park for di Suvero's Ladders to the Sky." *New York Times*, August 25, 1985, p. 27.

———. "Bold Sculpture for Wide-Open Spaces." *New York Times*, July 21, 1989, pp. C1, 24.

———. "The State of the City as Seen by Its Sculptors." *New York Times*, August 26, 1990, p. C22.

———. "American Has a Whole French City as His Gallery." *New York Times*, August 30, 1990, pp. C15, 17.

Breton, Florence. "Un Sculpteur aux Tuileries." *Le Monde*, June 24, 1975, p. 38.

"Chalon-Paris-New York." *L'Oeil* 238 (May 1975): 81.

"Chicago Sculpture Exhibit" *Progressive Architecture* 55 (September 1973): 23.

Clair, Jean. "Operation Mark di Suvero." *Chroniques de l'Art Vivant* 45 (December 1973/January 1974): 13–15.

Cooke, Lynne. "U.S. Steel." *Art in America* 76 (October 1988): 168–171.

Coplans, John. "Los Angeles: Object Lesson." *Art News* 64 (January 1966): 40.

Crossley, Mimi. "Mark di Suvero/Leonard Contino." *Arts Magazine* 52 (May 1978): 17.

Danto, Ginger. "Valence: Mark di Suvero." *Art News* 89 (October 1990): 205.

Davis, Douglas. "Art: Egalitarian Scupltor." *Newsweek*, October 27, 1975, pp. 96, 99.

Denton, Monroe. "Eros and Catharsis." 14 (September/October 1995): 22–27.

Donadio, Emmie. "David Smith's Legacy: The View from Prospect Mountain." *Arts Magazine* 54 (December 1979): 1.

Fleming, Dean. "Interview: Mark di Suvero." *Ocular* 80 (February 1981): 32–49.

Flescher, Sharon. "The Art Scene in Long Island City, 1987." *Arts Magazine* 62 (December 1987): 20–25.

Frank, Peter. "Sculpture Yesterday/Today." *Art News* 77 (February 1978): 143.

Frankenstein, Alfred. "Di Suvero's Environment at UC Show." *San Francisco Chronicle*, November 28, 1968, p. 50.

———. "Black Rock Beams and Bones." *This World*, February 7, 1971, pp. 41–42.

Fry, Edward F. "Sculpture in the Sixties." *Art in America* 55 (September 1967): 26–43.

Geist, Sidney. "A New Sculptor: Mark di Suvero." *Arts Magazine* 35 (December 1960): 40–43.

Gibson, Michael. "Paris: The 30-Ton Show in the Tuileries." *International Herald Tribune*, June 10, 1975, p. 7.

Gibson, Eric. "Art: di Suvero and Constructivism." *New Criterion* 4 (September 1985): 55–59.

Glueck, Grace. "Bright 3-Man Exhibition: Mark di Suvero Heads List of Scupltors." *New York Times*, March 2, 1968, p. 26.

———. "Art Notes: Big Outdoor Sculpture Show." *New York Times*, June 29, 1975, p. 29.

———. "Bold Abstract Sculptures Are Sprouting in Parks and Plazas." *New York Times*, October 13, 1975, pp. 31, 42.

———. "Gallery View: Steel Has Won a Place in Sculpture." *New York Times*, November 20, 1983, pp. 29, 33.

Goddard, Donald. "Mark di Suvero: An Epic Reach." *Art News* 75 (January 1976): 28–31.

Goldin, Amy. "Requiem for a Gallery." *Arts Magazine* 40 (January 1966): 25–29.

"The Guggenheim International." *Art in America* 55 (September-October 1966): 25–43.

Haden-Guest, Anthony. "Enriching the Cityscape: di Suvero's Art Is All Over Town." *New York*, November 17, 1975, pp. 90–97.

Halasz, Piri. "Collecting for Stockholm." *Art News* 73 (January 1974): 74–75.

Harris, Paul. "Mark di Suvero." *Art News* 59 (October 1960): 44

Henry, Gerrit. "Reviews." *Art News* 72 (Summer 1973): 93.

Hess, Thomas B. "Mark Comes in Like a Lion." *New York*, December 15, 1975, pp. 94, 98.

Hoelterhoff, Manuela. "The Gallery: Steel Beams, Tires and Other Art Forms." *Wall Street Journal*, December 30, 1975, p. 8.

H[oene]. A[nne]. "Mark di Suvero, David Novros." *Arts Magazine* 40 (May 1966): 62.

Hughes, Robert. "Art: Truth Amid Steel Elephants." *Time*, August 2, 1971, pp. 48–49.

———. "Art: Energy as Delight." *Time,* December 1, 1975, pp. 50–51.

———. "The Decline of the City of Mahagony." *New Republic,* June 25, 1990, pp. 27–38.

"Intelligencer: Battery Park City's Sky-High Sculpture. *New York,* January 30, 1989, p. 8.

Jacobs, Jay. "Projects for Playgrounds: The Corcoran Competition." *Art in America* 55 (November/December 1967): 41

Johnston, Jill. "4 Sculptors, 4 Styles." *Art News* 62 (Summer 1963): 36–37, 59.

———. "Dance Journal: For America." *Village Voice*, June 25, 1970, pp. 21–22.

Judd, Donald. "In the Galleries." *Arts Magazine* 35 (October 1960): 60.

———. "Exhibition at 79 Park Place Gallery." *Arts Magazine* 38 (February 1964): 22–23.

———. "New York Letter." *Art International* 9 (April 1965): 78.

Junker, Howard. "Gallery/81: Epics in I Beams." *Quest/81* 5 (April 1981): 76–79.

Kimmelman, Michael. "Art in Greener Pastures, Outside New York." *New York Times*, May 14, 1995, p. C1.

———. "Hudson Valley Crop: Portraits and di Suvero." *New York Times*, May 14, 1995, p. C16.

King, Mary. "Celebrating Mark di Suvero." *St. Louis Post-Dispatch*, December 7, 1975, p. 5.

Klein, John R. "Idealism Realized: Two Public Commissions by Mark di Suvero." *Arts* 56 (December 1981): 80–90.

Kozloff, Max. "Art: Spectrum of Sculpture." *The Nation*, November 2, 1964, p. 316.

———. "Further Adventures in American Sculpture." *Arts Magazine* 39 (February 1965): 30.

———. "Mark di Suvero: Leviathan." *Artforum* 5 (Summer 1967): 41–46.

Kramer, Hilton. "Sculpture: A Stunning Display of Radical Changes." *New York Times*, April 28, 1967, p. 38.

———. "Mark di Suvero." *New York Times*, May 12, 1973, p. 29.

———. "A Playful Storm of Sculpture." *New York Times Magazine*, January 25, 1976, pp. 10–11, 42, 47–48, 52.

Kuh, Katherine. *Saturday Review*, 30 December 1967, 35.

Kuspit, Donald. "'The Success of Failure,' Diane Brown Gallery." *Artforum* 23 (April 1985): 92.

Larson, Kay. "Freezing Expressionism." *New York*, April 25, 1983, p. 97.

Lewis, Flora. "An American in the Tuileries." *New York Times*, May 17, 1975, pp. 29, 56.

Lichtenstein, Therese. "Mark di Suvero, Oil & Steel." *Arts Magazine* 58 (September 1983): 33–34.

Lloyd, Ann Wilson. "Take Me to the River." *Contemporanea* 3 (April 1990): 70–74.

Loercher, Diana. "Sculptures You Can Pull, Push, Sit In and Ride On." *Christian Science Monitor*, December 29, 1975, pp. 16–17.

Lord, Barry. "Siting: the problem of art in architecture." *artscanada* 26 (October 1969): 26–29.

"Los Angeles: Tower for Peace to Protest United States Policies in Vietnam." *Art News* 65 (April 1966): 25, 71.

Magowan, Elizabeth. "Mark di Suvero." *Art News* 59 (October 1960): 44, 54–55.

Marchand, Sabine. "Les Geantes du Jardin des Tuileries." *Le Figaro*, April 26–27, 1975, p. 18.

Marmer, Nancy. "Reviews." *Artforum* 4 (December 1965): 13–14.

"Master of the Monumentalists." *Time*, October 13, 1966, pp. 80–86.

McGee, Celia. "New Soundings from a Poet of Industrial Debris." *New York Times*, May 14, 1995, pp. H32, 36.

———. "Di Suvero: Still Bigger Than Life." *International Herald Tribune,* May 13–14, 1995, p. 7.

McGill, Douglas C. "Upstate Retrospective for Mark di Suvero." *New York Times*, April 18, 1985, p. C20.

Meadmore, Clement. "Symposium on Three Dimensions." *Arts Magazine* 49 (January 1975): 62–65.

"Minneapolis: The New Museum." *Art International* 15 (November 1971): 17–21.

Morgan, Susan. "Art/Mark di Suvero: Public Image." *Interview* (March 1991): 60.

Muchnic, Suzanne. "Art: Poetry in Motion." *Los Angeles Times*, December 30, 1990, pp. 3, 82.

Nadelman, Cynthia. "Mark di Suvero: Storm King Art Center." *Artnews* 94 (October 1995): 147.

"New Talent USA/Sculpture." *Art in America* 50 (Fall 1962): 32–39.

"On Exhibition." *Studio International* 176 (December 1968): 274.

Perl, Jed. "Mostly Marden." *New Criterion* 12 (September 1993): 60–64.

Perreault, John. "On Art: Now That the War Is Over." *Soho Weekly News*, November 27, 1975, p. 18.

Petersen, Valerie. "Reviews and Previews." *Art News* 60 (Summer 1961): 13.

Piene, Nan R. "Christmas for Children." *Art in America* 53 (December 1965): 36–37.

———. "New York: Gallery Notes." *Art in America* 54 (March 1966): 124–28.

Platt, Frances Marion. "Heavy Metal." *Ulster Magazine* (Summer 1995): 44–51

"Potpourri of Protest." *Time*, March 14, 1966, pp. 101–2.

Ratcliff, Carter. "Mark di Suvero." *Artforum* 11 (November 1972): 34–42.

———. "Taking Off: Four Sculptors and the Big New York Gesture." *Art in America* 66 (March/April 1978): 100–06.

———. "Artist's Dialogue: A Conversation with Mark di Suvero." *Architectural Digest* 40 (December 1983): pp. 192, 196, 198, 200.

Rauh. Emily S. "Praise for Elohim Adonai, 1966, a Sculpture by Mark di Suvero." *St. Louis Museum Bulletin* 25 (March 1968) 6.

Rose, Barbara. "A Return to the Heroic Dimension in Sculpture: Mark di Suvero." *Vogue*, February 1973, pp. 160–162.

———. "Profit Without Honor." *New York*, November 1973, pp. 80–81.

———. "On Mark di Suvero: Sculpture Outside Walls." *Art Journal* 35 (Winter 1975): 118–25.

Rosenberg, Harold. "The Nineteen-Sixties: Time in a Museum." *The New Yorker*, July 29, 1967, pp. 76–82.

Rosenstein, Harris. "Di Suvero: The Pressures of Reality." *Art News* 65 (February 1967): 36–39, 63–65.

Ruda, Ed. "Park Place, 1963–1967." *Arts Magazine* 42 (November 1967): 30–33.

Russell, John. "Irresistible Sculptures by di Suvero." *New York Times*, November 13, 1975, p. 50.

———. "All of New York is di Suvero's Gallery." *New York Times Magazine*, November 23, 1975, pp. 1, 25.

———. "Art: Sculpture Yesterday/Today." *New York Times*, November 4, 1977, p. 22.

———. "Art View: Mark di Suvero Is Back in Town." *New York Times*, April 10, 1983, pp. C31, 33.

Saunders, Wade. "Risk & Balance: Mark di Suvero." *Art in America* 71 (December 1983): 128–35.

Schulze, Franz. "The 70's: A Bedeviling Complexity Marked by Noisy Extremes of Taste." *Art News* 79 (January 1980): 37.

Seldis, Henry J. "A Tour de Force of Sculptor's Art." *Los Angeles Times*, October 4, 1965, p. 48.

Senie, Harriet. "Urban Sculpture: Cultural Tokens or Ornaments to Life?" *Art News* 78 (September 1979): 108–14.

Silverthorne, Jeanne. "Mark di Suvero, Oil & Steel Gallery." *Artforum* 22 (September 1983): 74.

Simon, Rita. "In the Galleries: Three Sculptors." *Arts Magazine* 42 (April 1968): 68.

Sofer, Ken. "Mark di Suvero, Oil & Steel." *Art News* 82 (October 1983): 175–76.

Solomon, Deborah. "On the Waterfront with Mark di Suvero." *Journal of Art* (October 1990), "View" section: 9.

Sontag, Susan. "Inventing and Sustaining an Appropriate Response." *Los Angeles Free Press* 3 (March 4, 1966) pp. 4–5.

Spencer, Charles. "Toronto Commentary: Art Boom in a Boom City." *Studio International* 174 (December 1967): 282–84.

Squiers, Carol. "New Sculpture in Grant Park." *New Art Examiner* 2 (September 1974): 2–3.

Stevens, Mark, and Hager, Mary. "Art: Sculpture Out in the Open." *Newsweek*, August 18, 1980, pp. 70–71.

Stiles, Knute. "Untitled, 1969: The San Francisco Annual Becomes an Invitational." *Artforum* 7 (January 1969): 50–55.

"Tenth Street Days." *Arts Magazine* 52 (March 1978): 23.

"Toronto's International Sculpture Symposium." *Art in America* 56 (December-January 1966): 100–102.

Thwaites, John Anthony. "Cologne." *Art and Artists* 7 (November 1972): 51.

Tuchman, Phyllis. "Sculptors Mass in Toronto." *Art in America*, 66 (September/October 1978): 15–23.

Vetrocq, Marcia E. "The Birthday Biennale: Coming Home to Europe." *Art in America*, 83 (September 1995): 72, 81.

Wallach, Amei. "A Stroll Through Sculpture." *Long Island Newsday*, June 16, 1985, sec. II, pp. 4–5.

———. "Man of Steel: di Suvero's Industrial Revolution."

Long Island Newsday, May 24, 1995, sec. II, pp. 4–5

Weinberg, Mimi. "Thunder in the Mountains: Mark di Suvero at Storm King." *Arts Magazine* 60 (February 1986): 38.

Westfall, Stephen. "Group Show, Oil & Steel." *Arts Magazine* 57 (February 1983): 38–39.

Westfall, Stephen. "Mark di Suvero, Oil & Steel." *Arts Magazine* 58 (September 1983): 39.

"Where the Militants Roam." *Time,* March 15, 1968, pp. 74–77.

Wilcock [sic], John. "Internationally Important Art Exhibit Played Down by L.A.'s Press, Radio, TV." *Los Angeles Free Press* 3 (March 4, 1966) pp. 1, 5.

Wilcox [sic], John. "Artist's Peace Tower." *East Village Other* 1 (March 1–15, 1966): 1, 13.

Wilson, William. "Art Partners Architecture." *Los Angeles Times*, September 6, 1980, sec. II, p. 5.

———. "Di Suvero—What's Right at Wrong Site." *Los Angeles Times*, July 21, 1985, p. 89.

Winter, Peter. "Germany: A Fear of Rust." *Art International* (Winter 1988): 70–72.

Wortz, Melinda. "The Nation: Los Angeles." *Art News* 80 (February 1981): 187.

Wright, Martha McWilliams. "Mark di Suvero." *Arts Magazine* 53 (January 1979): 6.

Zimmer, William. "Sculpture Then and Now." *Arts Magazine* 52 (January 1978): 24.

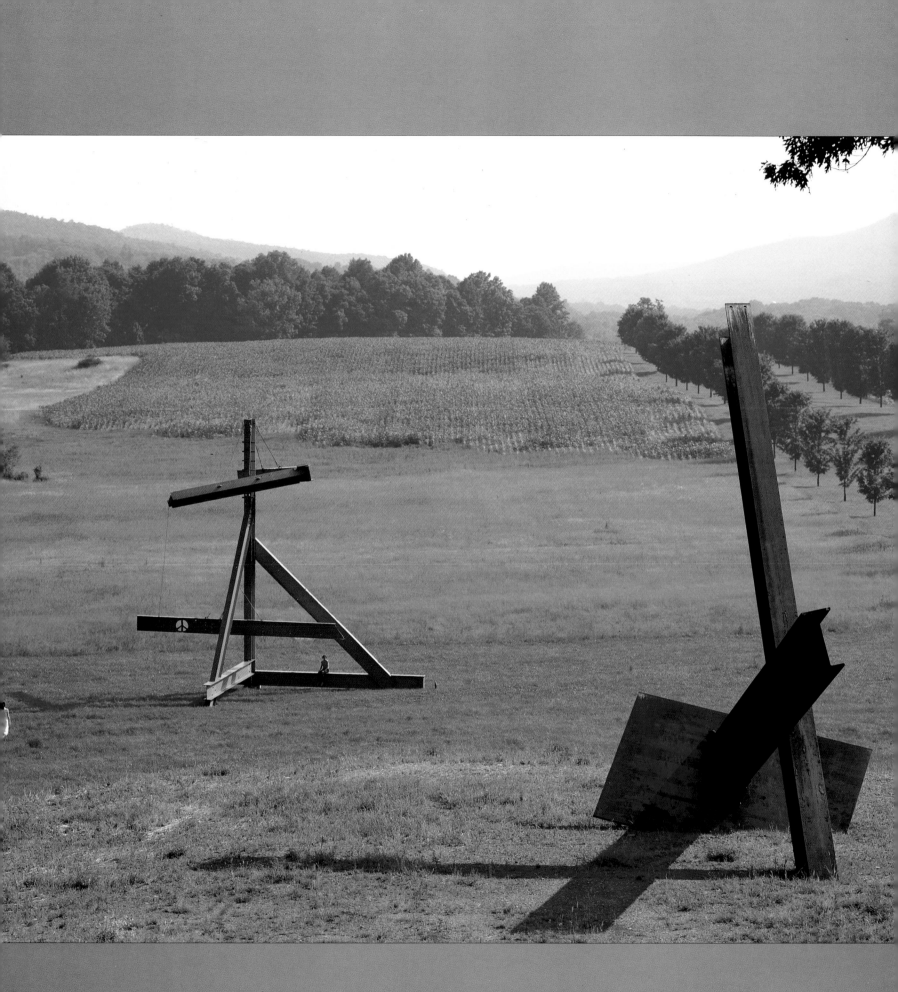

MOTHER PEACE, 1969–70, and BYGONES, 1976, in 1985.

INDEX TO WORKS ILLUSTRATED

Height precedes width precedes depth.

PHOTOGRAPHIC CREDITS

Photography by Jerry L. Thompson with the following exceptions:

Anonymous, p. 20 center

John Back, p. 40

George Bellamy, pp. 30, 89, 96–97, 98, 100, 102, 104, 105, 110, 111, 112, 113, 114, 115, 118, 123

Rudolph Burckhardt, p. 27

Ivan dalla Tana, pp. 33, 91, 95, 127

David Finn, p. 108

John Ross, p. 20 right

Steven Sloman, p. 20 left